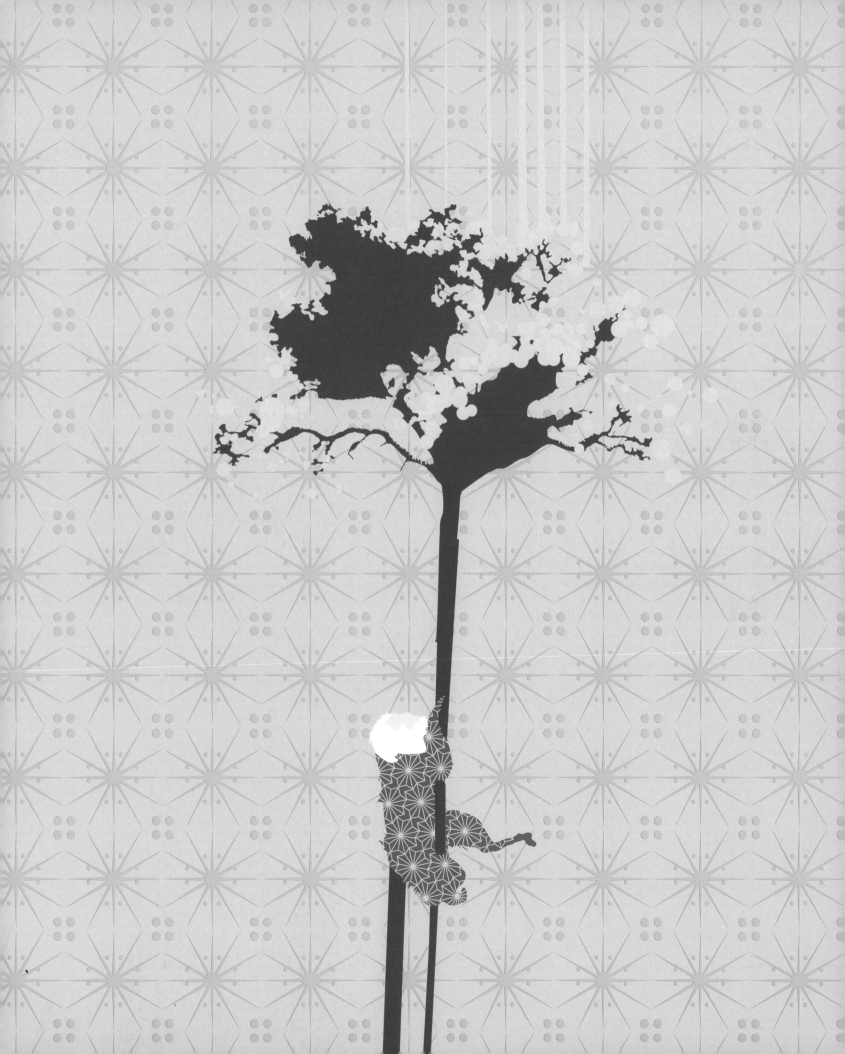

PREFACE

If there really is a real all-encompassing, cultural tendency nowadays, it is the desire for spatial experience. An example of this is the music scene where live concerts are booming. Organisers, companies and museums are trying to convey products and contents as sensorially comprehensible experiences.

Today, this development is based on a human desire to oppose or accompany the digital omnipresence of contents with real, haptic and sensorial experiences.

Quite the similar applies to the field of visual culture where several parallel developments are linked to a main theme.

THE RETURN OF THE ORNAMENT

Graphic design is the emitter and starting point of visual culture and its pursuit into the third dimension. In the middle of the 1990's, when computers became affordable und their graphical applications became easy to use, users celebrated their exclusive qualities. Vector design, plain lines and surfaces, as well as organised forms in connection with a desire for simplicity and clarity defined and dominated aesthetics.

As this trend increasingly became a monoculture, the technical development in turn also enabled an advance in aesthetics. Everyone could now afford a digital camera and photos were interwoven with digital forms using the computer. Soon the illustration - the manual realisation, the human inaccuracy, the characteristic style - was rediscovered as a virtue. Illustrations and sketches brighten up plain, industrial looking packaging giving its contents a "human" touch.

The mainly revolutionary approach of creating an anti-pole to the computer was followed by an attempt to bring new meaning to materials. Suddenly it became trendy to visually quote quotations from each significant visual design period and style; the ornament which had been so passionately condemned celebrated a real resurrection as a design element. Two-dimensional graphics, design styles and techniques are emerging from the two-dimensional and becoming sculptural objects. This occurs in writings, action figures and dolls as well as with vector graphics. Spatiality, which is often imitated at the computer, is now being realised in the real world. Techniques which only became styles due to the computer, e.g. layering and crossfading, are now transferred into the objects.

ART IS SOMETHING THAT STANDS IN A MUSEUM

Ever since Marcel Duchamps presented the 'Pissoir' in 1917 it has been possible to define art as something that stands in a museum. Art is a defined utilisation chain whose protagonists are artists, gallery owners and curators, and at the end of which one can find collectors and museums. The most important thing about art is a hermetically sealed system. Since everything can be art, special importance is given to the explanation of artwork - the linguistic channelling of the utilisation chain.

Today, artists are involved in art mainly because they love to create, and not because of their interest in fighting through the different layers of the art business. Quite often works of extraordinary artistic quality come into existence in the context of design, advertising und entertainment. These works already function as a pacemaker for the art business - just as art was once the pacemaker for popular culture.

Visual culture is therefore the shamefaced catchword for this creative content, which is indeed created outside the art business, but assumes the role of the more intelligible social functions of art. This is the reason why numerous galleries and museums today use, in a manner which can often only be described as arrogant and ignorant, what graffiti culture has explored and developed. The collector and the museum do not pay for the artwork.However, art marketing together with biographies and interpretation will continue to put collectors and museums under pressure until the paying customers finally surrender their money. Because at the end of the day it is only interpretation that transforms a urinal into artwork and a piece of paper into a

1000 dollar note. Without interpretation there is no art. Current art simultaneously defines its interpretation for its own purpose and as artwork. Installations are three-dimensional, unfolded visual messages. Most of them are illustrations or collages which have grown out of the medium. Space and the almost freely selectable size can be understood as the material extension here. Installations enable one to escape the spatial limitations of the computer screen or the white sheet of paper.

THE STREET AS A STAGE

Graffiti, street art and urban art use the street as their stage. The protagonists present themselves to the public, react to their environment and see the city as their museum. Their work does not function in the devout stillness of a white cube; they want you to discover their artwork while waiting at a set of traffic lights or walking down the street. Street art has always had the aim of occupying and capturing space. In the beginning it used graffiti or tags and later on posters and stickers. Recently, there have been more installations which spatially react to the spatial conditions and environment. Objects, ranging from small to large, are added to the actual streets, thus visualising the structure of common, day-to-day objects or sequences and handling them in a playful manner.

THE RETURN OF SALON PAINTING

By the end of the 1980's interior design was clinically dead. Since then a deep-frozen styling vacuum has been sold to trendy people instead of furniture. This has nothing to do with design; especially not if you doubt that the combination of a white wall and brightly coloured frippery which cannot be tolerated for longer than six months equals good taste. Nowhere has the term design been abused more than in DIY and furniture stores (though I would like – as far as possible – to exclude IKEA from this statement).

The inflation of exchangeable bits and pieces has now also led to a direct backlash. For a long time rooms were stereotyped and only gained a kind of life of their own due to the selection of exchangeable objects they contained. Today, rooms are assigned with special, tailor-made design characteristics and are once again being uniquely painted.

This painting focuses on the architecture and quite often creates a direct design relationship to the furniture. Rooms have not been painted in such a complete, radical and passionate manner since Gustav Klimt. The topic of nature has also been rediscovered similar to the Art Deco and Art Nouveau periods. The striking thing here is that the designers have an extraordinary sensitivity to their design work and its "limits", and can adjust it to the room's function as well as to the interest and utilisation of the beholder and user. Although the interiors are quite often opportunistic, they are always aware of the function they should fulfil. In this case, it is a clear design approach, i.e. problem solution, rather than an artistic one, at least when thought of within the framework of classical modern art – but actually it is salon painting.

If you think about all of these developments, you realise that, today, space and material promise maximum originality. Space or material (still) function as a unique feature and form a fixed point within the almost unlimited possibilities to use and copy digital contents which can be reproduced and simulated. The reason for this is that there is still no procedure, nor will there be one in the near future, to transmit or even simulate spatial impressions as being "real emotions". Material is fetish and for a foreseeable time material and space will remain those fixed points which signal the creator's real commitment which digital simulation cannot achieve. The renaissance of spatiality is therefore actually an old human atavism, a reflex, which accompanies the current loss of clarity and tries to balance it in quite a naive way.

Robert Klanten

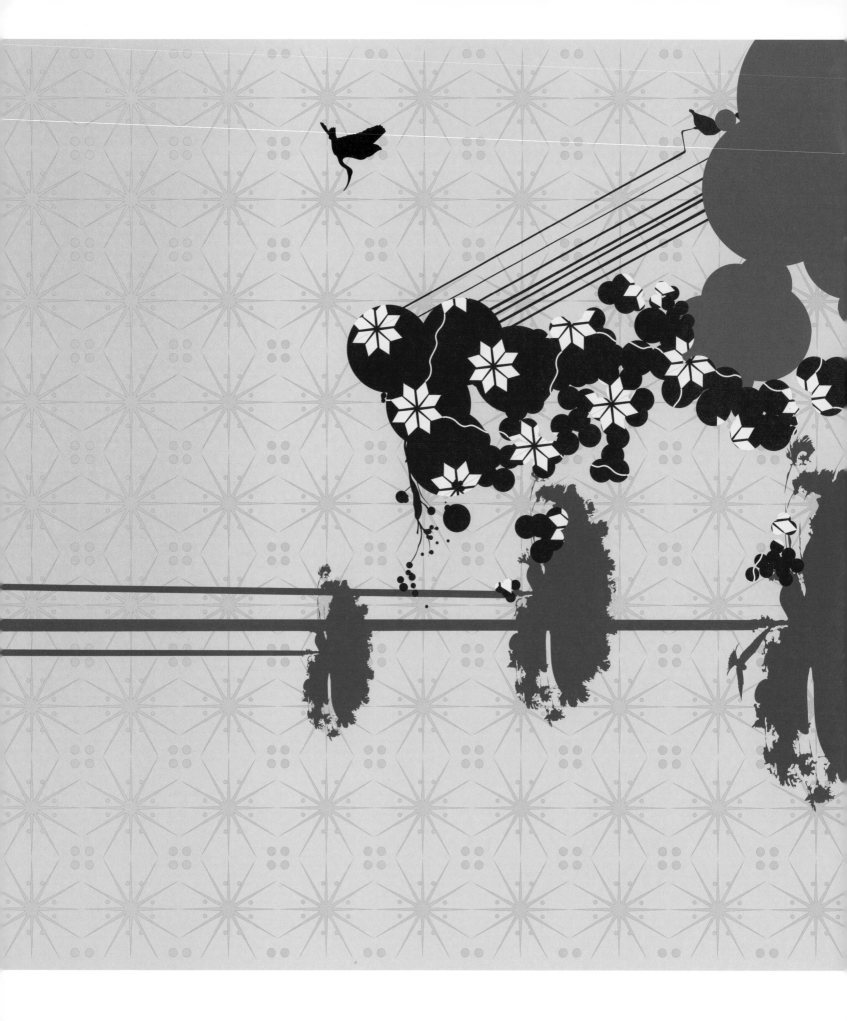

CONTENTS

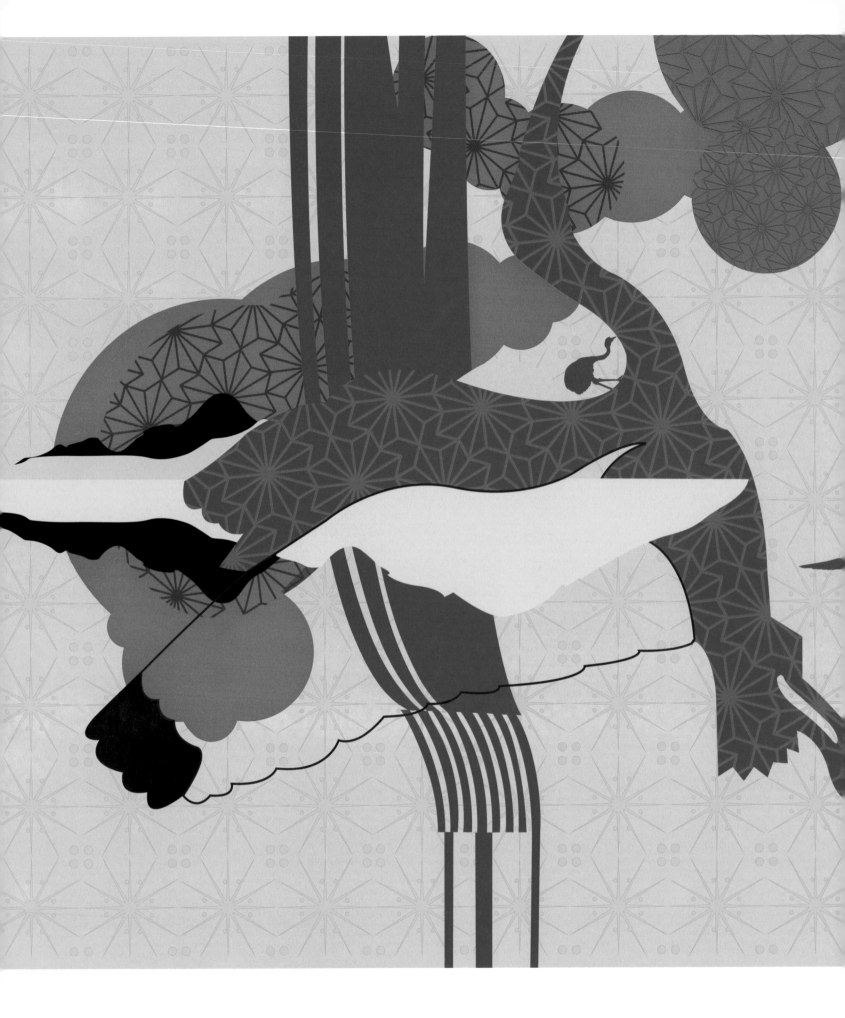

OBJECTS

A favourite turn of phrase in product design is the "graphic quality" of something. A popular design ideal is fulfilled when an object is taken out of its functional context and can be seen as an image. In the field of graphic design the opposite development has been taking place in recent years. Colours, surfaces, patterns and symbols become real and physical, pushing into the third dimension – issuing the promise, even in cases where the image remains two dimensional, – "you can touch me".

This new sense of reality is paradoxical due to developments in computer technology since the 80s. On the one hand, our desire for tactile contact has become more urgent in the face of the increasing virtualization of our world - rendered and artificial realities surround us with every step we take, so our desire to touch and feel things increases. On the other hand, due to new technologies, it is possible to combine reality with images from our imagination, allowing dreams and ideas to become real.

Both these variations on a new method of representation can be seen in this chapter. For example, the British design studio Hyperkit with its "pop-out and slot sculpture kit" tries to fulfil the desire for contact: Abstract shapes are die-cut out of cardboard in a kit that you can combine to make your own mini abstract sculptures. With the building kits sold at the Tate Britain, visitors can now reconstruct sculptures seen at the gallery step by step at home. Originally intended for children, the kit has also become popular with adults.

The bizarre cactus forest with which Jaime Hayon has created his own vision of a "digital baroque" created by aliens can be seen as an example of the other aspect of the trend; the supplementation of reality through dream visions made real. The fact that a house filled with toys is placed in the midst of his spacey artificial plants points to another aspect of the spatial quality of graphic art: It fulfils our appetite for hobbies and playfulness. Many artistically interested people have detached themselves from the functional ideals of post-war modernism. Its classic conservative style has not yet lost its relevance, but is now freely mixed and matched with pop-culture patterns. The world of toys and comics are included, as are rag dolls and action figures, successful products from the world of art and design in the past. The appeal of these playful parallel worlds is not an entirely new phenomenon: Model railways and dolls in traditional dress have already proved our innate desire for distraction. What is new is the fact that the many microcosms of popular culture – from computer games to Manga comics – are no longer relegated to dark corners, but define and influence or function as ironic commentaries of our daily lives.

Often the combination of graphic and representational stylistic elements leads to the creation of new hybrid forms with a totally different and suggestive pictorial language. When Ronan and Erwan Bouroullec reassemble their Vitra furniture for a Paris gallery, the traditional furniture catalogue can only seem boring in comparison. Examples such as these show that the graphic artist's departure from the two dimensional into 3-D makes something very desirable happen: You get noticed.

FULGURO

Fulguro - these are Cédric Decroux, Axel Jaccard and Yves Fidalgo - shares a strong interest in a kind of graphic design that includes exploring the possibilities of 3-D. *"Our working methods are all mixed. Sketching, modelling, trying different proportions, remodelling ... Most of the time, we work with photo simulations, too, taking some 2-D sketches, some 3-D models. There is no recipe - each piece of work has its own kind of process."*

This is also true for the difficulties, they say. A new project will surely include unexpected problems. *"Sometimes the deadlines are a problem. The tendency is to give less and less time. A solution can always be found, even to fit a tight schedule. It sometimes works well to be under pressure. But it can also be frustrating to lack the time that would be needed to go further into the research process."* This process includes to carefully choosing the right material. *"It happens that we start with materials we have nearby, but soon realize that they don't suit the purpose and quickly change to check other solutions. In photography, you can always cheat on the material by manipulating it on a computer. But somehow we never take this path. We are convinced that working with our hands and the right material benefits the results."*

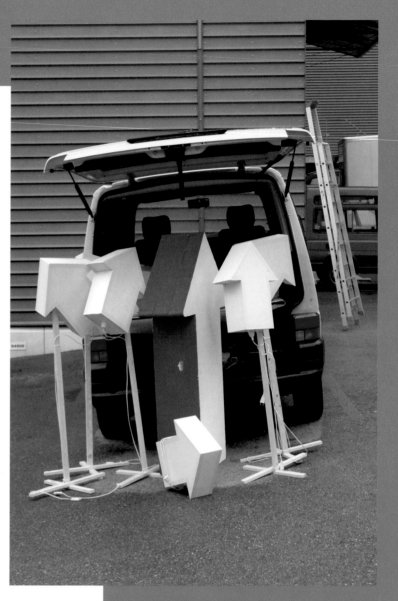

"SPOT Neuchâtel"
Communication project for SPOT,
Swiss Theatre Festival for Young Audiences
Client: Swiss Association of Theatre for
Children and Young People (ASTEJ)
Lausanne/Neuchâtel, Switzerland, 2005

"We symbolized the theatre's imaginary world by paper-modelling the landscape of Neuchâtel where the festival would take place. We used well-known codes of theatre decoration.

We worked with photography, wood sticks, colour paper, scotch-tape, coloured flash and tube lights. We learned that even simple means take lots of time setting up. We noticed that ideas often mature during this setting-up period."

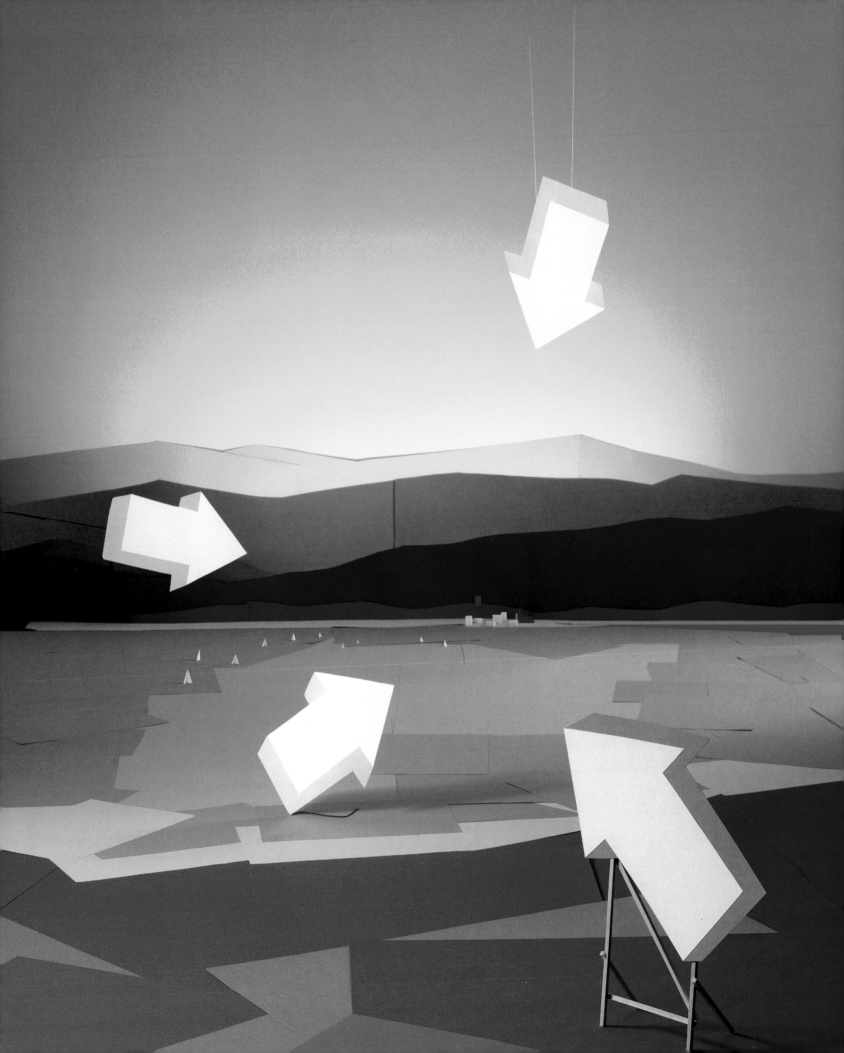

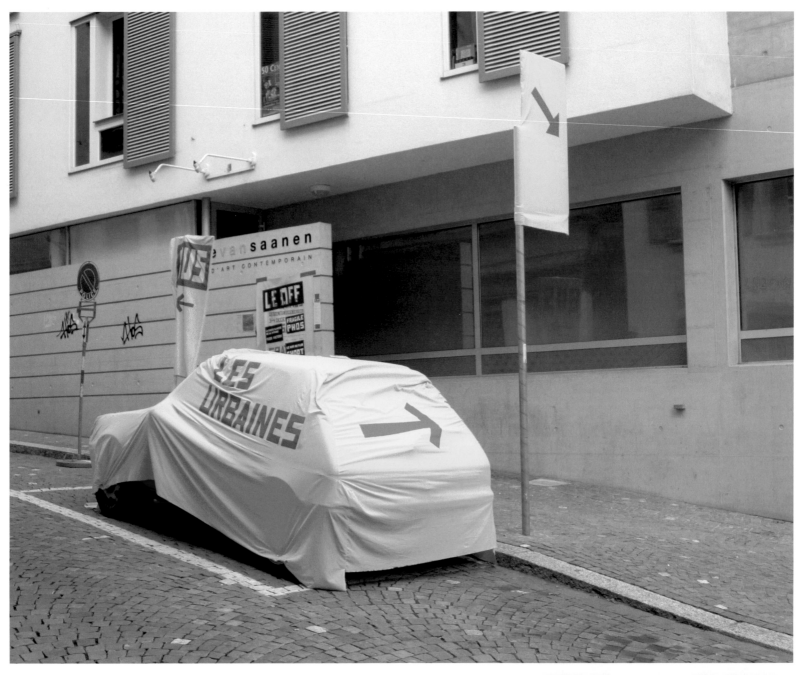

"Urbaines"
Les Urbaines, festival of young creations
Lausanne, Switzerland, 2004

"A dressmaker dressed the city for the festival's arrival. It takes place in December every year. Yellow and red seemed to be good colours for the winter. For the posters we took photos, sewed yellow fabric, red felt and various objects (some of which we made especially for that purpose).

We stuck to the bad habit of doing everything ourselves. This time we had to sew large amounts of fabric quickly with a domestic sewing machine. Homemade jobs take a lot of time. We will try not to do it again, although it makes projects more challenging."

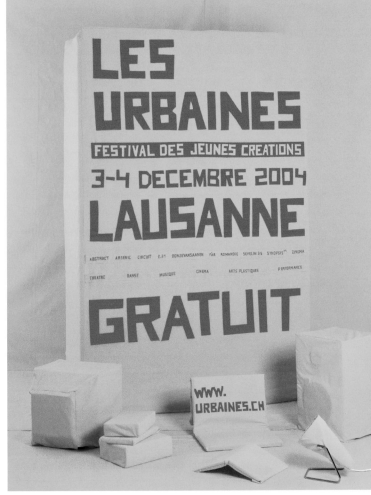

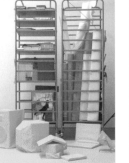
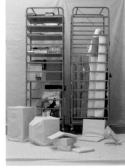
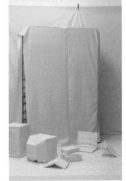

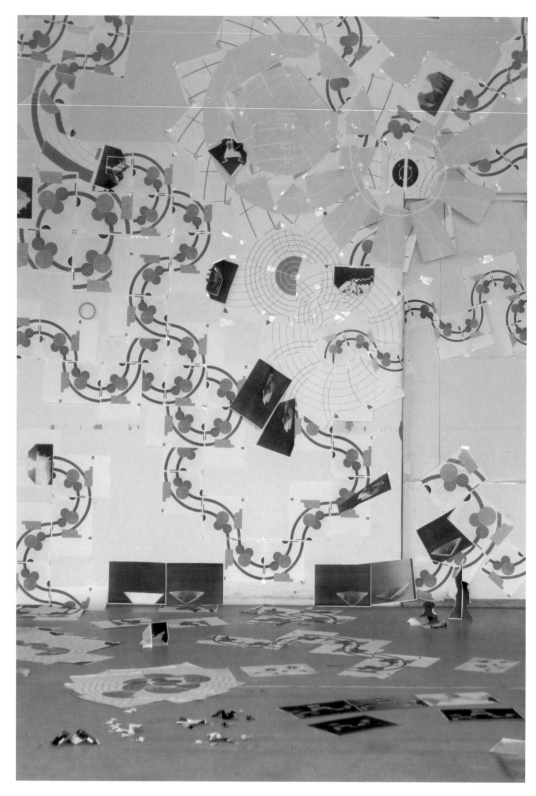

"Postvideogames exhibited"
Installation, Basta Gallery
Lausanne, Switzerland, 2003

"Postvideogames is also a set of A4-sized paper games to photocopy, cut, fold, etc. For our solo exhibition, we made the photocopying machine part of the installation. Especially for the exhibition, we designed a lamp on the theme ‚From 2-D to 3-D'. The final object is made of three sheets of plastic, screenprinted with various illustrations, and assembled of small plastic and aluminium pieces."

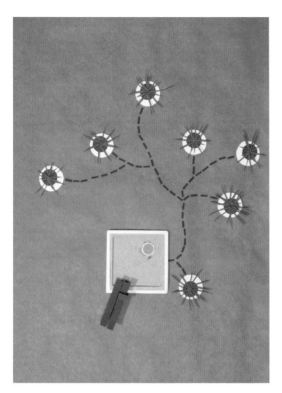

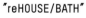

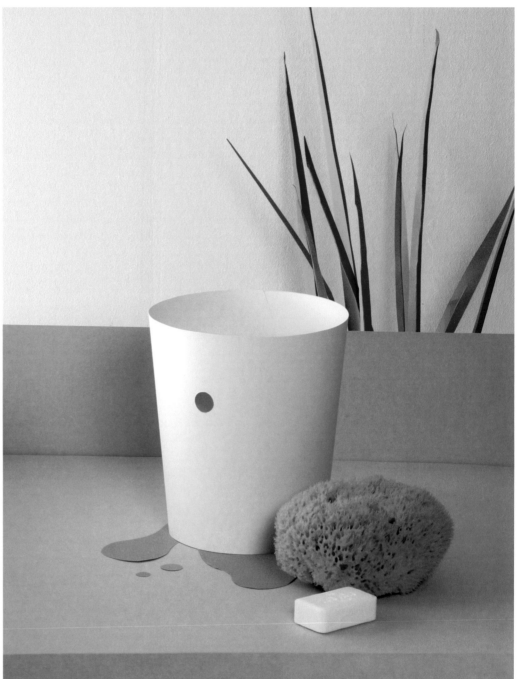

"reHOUSE/BATH"
with Thomas Jomini, architect
Research project, Lausanne/Bern, Switzerland, 2004
photos by Fulguro
installation views by Geoffrey Cottenceau

"reHOUSE is a research platform for sustainable and ethical design. reHOUSE/BATH is a new section of this platform, focusing on the bathroom, thought as a biotope where nature and mankind interact.

We had to make postcards of the displayed objects, but they were not finished. So we managed to simulate these with simple paper sheets. By using the right colours and light, we gave a good idea of the scales and proportions of the objects."

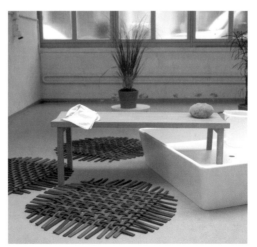

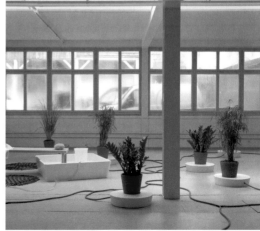

RACHEL THOMAS

Rachel Thomas lives in London, where she works as a set and 3-D designer. Her projects include fashion shows, still lifes, record covers and music videos. She regards sculpture to be one of her big influences: *"I have quite a thorough knowledge of the history of sculpture and this affects my work again and again. Modern sculpture often appropriates everyday materials in an unexpected way that I find very inspiring."*

As she works with many different materials, she has to know their qualities. *"For example, perspex scratches and attracts dust, and polystyrene breaks easily. But you learn to find ways around these problems. This is part of my job."* A place she feels very moved by is her home where she grew up. *"It is a very modern estate, built in the sixties. Everything looks the same, it is very quite and there are lots of open as well as hidden spaces I think of it as a place to dream. I have done quite a bit of work there. Once I made and photographed a pink powdered explosion behind my mum's house in between two rows of identical garages."*

Among her clients are big names such as the band Goldfrapp or the BBC. But a label she would still like to work for is the cutting-edge fashion brand Comme des Garçons. *"They always seem to take a chance and push the boundaries of what is acceptable."*

Rachel Thomas likes being a freelance artist. *"It is always great to be given freedom and to have the respect of whoever it is commissioning you. I like to think that making something new and original in a defined area is my goal. When that is encouraged and allowed to happen without too many restrictions, it is brilliant. That is my ideal."*

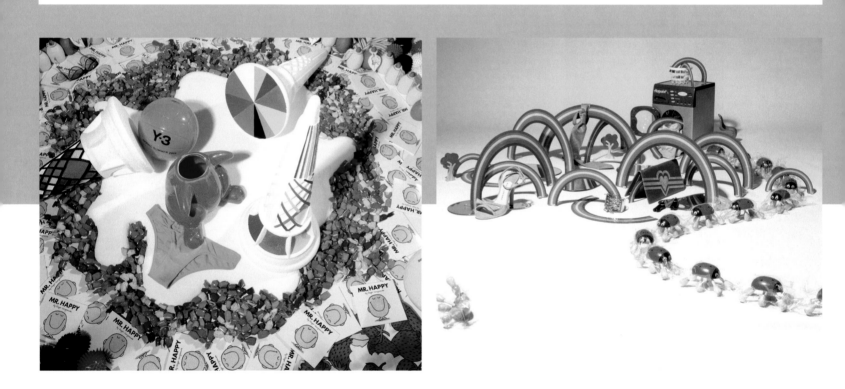

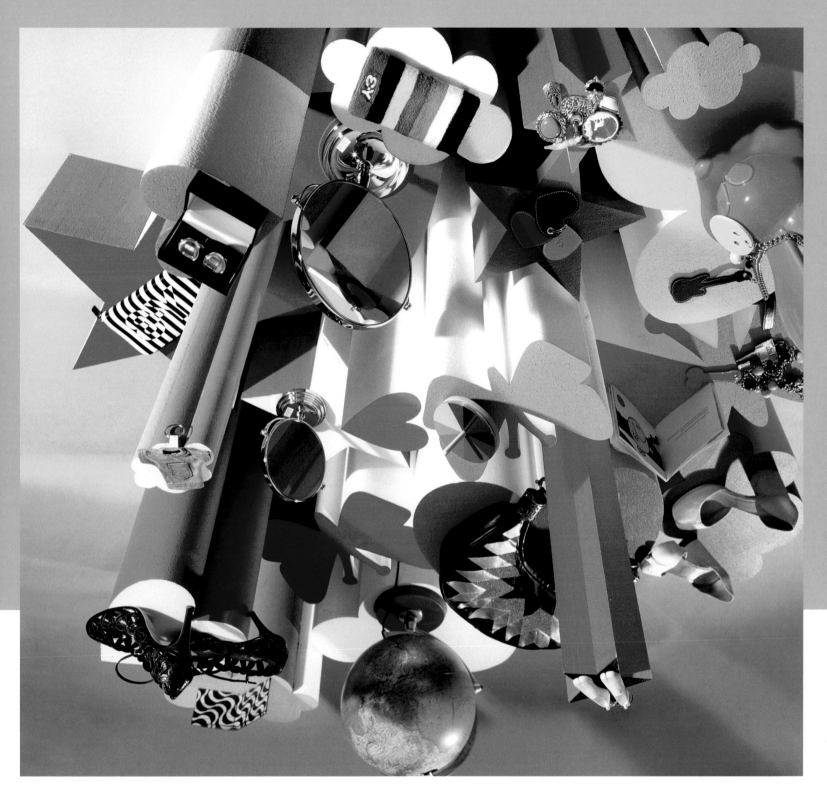

"Ta Daa"
Client: Selfridges Show Magazine,
London, UK, 2004
Photos by Ola Bergengren

"In response to the magazine's theme ‚happiness‚, I created a set that included objects, clothes and accessories from the Spring/Summer 2004 collections sold in the Selfridges department store. I designed four sets that incorporated objects I had made from scratch and objects that I had hand picked from the store, including stationery, sweets, toys, clothes, shoes and accessories to create images brimming with joy! I used perspex and polystyrene as materials to fabricate objects, and then I used ready made objects and products in repetition as elements of the set rather than as products that were separate from it.

While doing the set, I learned that it takes twice as long to get anything done when preparing a job that is shooting just after the Christmas holidays."

"The Music: Welcome to the north"
Clients: ‚The Music', Virgin Records UK,
Capitol USA, London, UK, 2004
Photos by Dan Tobin Smith

"The brief was to create imagery for The Music's second album. I collaborated with James Greenhow and Tom Skipp at the Peter Saville studio. We invented a process using 3-D objects that would generate imagery through experimentation with composition and context. I had 3-D shapes made and 2-D pieces of perspex cut into using the bands logo as a starting point and creating varying degrees of abstraction from it. Something I learned is: When dealing with perspex, never take the protective wrapping off until the very last minute."

RONAN AND ERWAN BOUROULLEC

Ronan and Erwan Bouroullec work for well-known clients like Vitra, Habitat or Cappellini. They have received a multitude of awards for their works, and their flexible and multifunctional furniture has been exhibited in several museums. *"Throughout the years, we have been developing quite a lot of projects meant to deal with an architectural scale"*, Erwan Bouroullec says, *"like our ‚algues‘ that are elements one can combine to form greater structures. In these projects, we played with an in-between scale: ‚bigger than furniture, smaller than architecture‘. But the processes and the materials come from a designer background. So we work toward architecture and sculpture, but with a ‚design attitude‘."*

Everything they do starts with a sketch. Then they continue modelling in 3-D, either at the computer or using cardboard and tape. *"The computer has become a common platform to transmit the proposed objects to the manufacturer, like technical drawings used to be. On the one hand, it enables the designers to define more of the shapes by themselves. On the other hand, it reduces the volume of discussion between the manufacturer and the designer. So while it speeds up the development process, it also tends to mute all the knowledge that used to be expressed."*

Still, Erwan Bouroullec describes dealing with the materials as *"a difficult alchemy in which we try to adjust as best as possible. The most important thing is to apply the right material to the right object. This doesn't necessarily imply always dealing with the latest material. It has much more to do with the good cultural background a material can provide."*

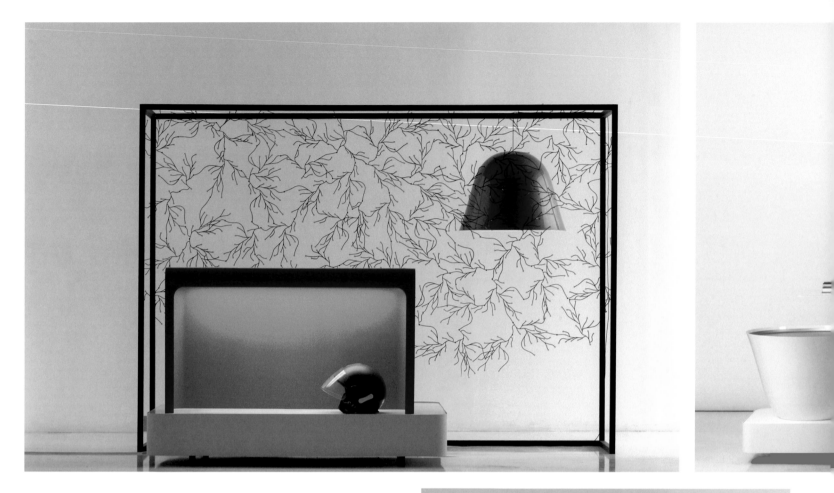

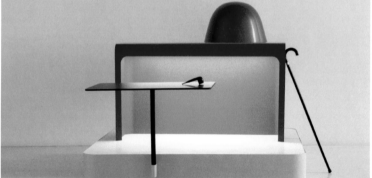

"Assemblages 250, 150, 60"
Furniture installation, Gallery Kreo
Paris, France, 2004
Photos by Paul Tahon

"Gallery Kreo in Paris is an ideal space for research because it is apart from the usual context of industry and its market. It belongs much more to the realm of contemporary art spaces than it is a traditional furniture shop. Thus, it allowed us to be free from the recurrent constraints of industry. That doesn't mean that we don't deal at all with reality here, but the field of possible research is wider.

,Assemblages' is a collection of five pieces where the same elements are used quite systematically, while playing more freely with finishes, colours and dimensions. To the basic pedestals, we added a luminous box, a lamp, a tablet and a kind of bowl. These additional elements are made of metal; some of their surfaces are lacquered or leather-clad. The lacquer is the one used in the automotive sector - ultra shiny or deep matt, sometimes colourful, or on the contrary white. Partially, we incorporated our ,algues', algae-like plastic elements that can be linked together to form textures.

Our idea was to build pieces of furniture meant to ,host' objects that one could lay on. We wanted that in the same piece of furniture each of its elements would provide a different quality or atmosphere, in order to fit the specificity that one would expose in each object. In a way, these pieces of furniture are like collectors, keen on showing and taking care of their objects."

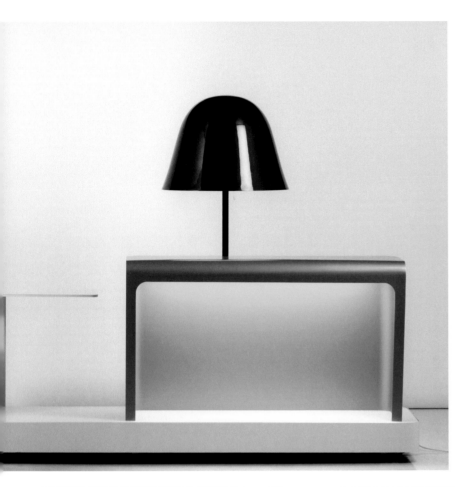

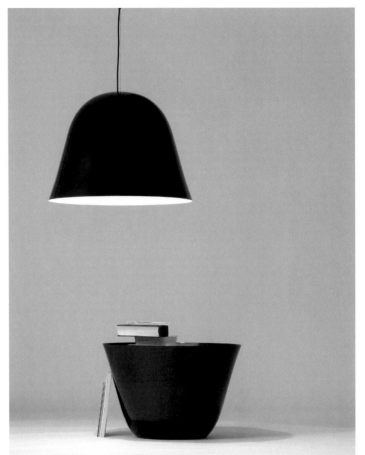

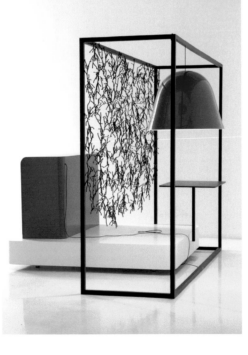

"Bells"
Furniture installation, Gallery Kreo
Paris, France, 2005
Photos by Paul Tahon

"'Bells' is a series of lamps and side tables taken from ‚Assemblages‘ for which we had developed these bell-shaped lamps. They are made out of hand-embossed copper, which is then lacquered. These high-level hand-made techniques enable us to produce objects with an incredible finish. It appeared obvious to us to extract these elements and to release them as single lamps and side-tables, which would be simpler and easier to handle than the ‚Assemblages‘.

The ‚bell‘ as a shape is simple and at the same time complex: it refers to some kind of archetype, conveying a certain softness and familiarity. On the other hand, when turned upside down, it provides the tables with a visual instability."

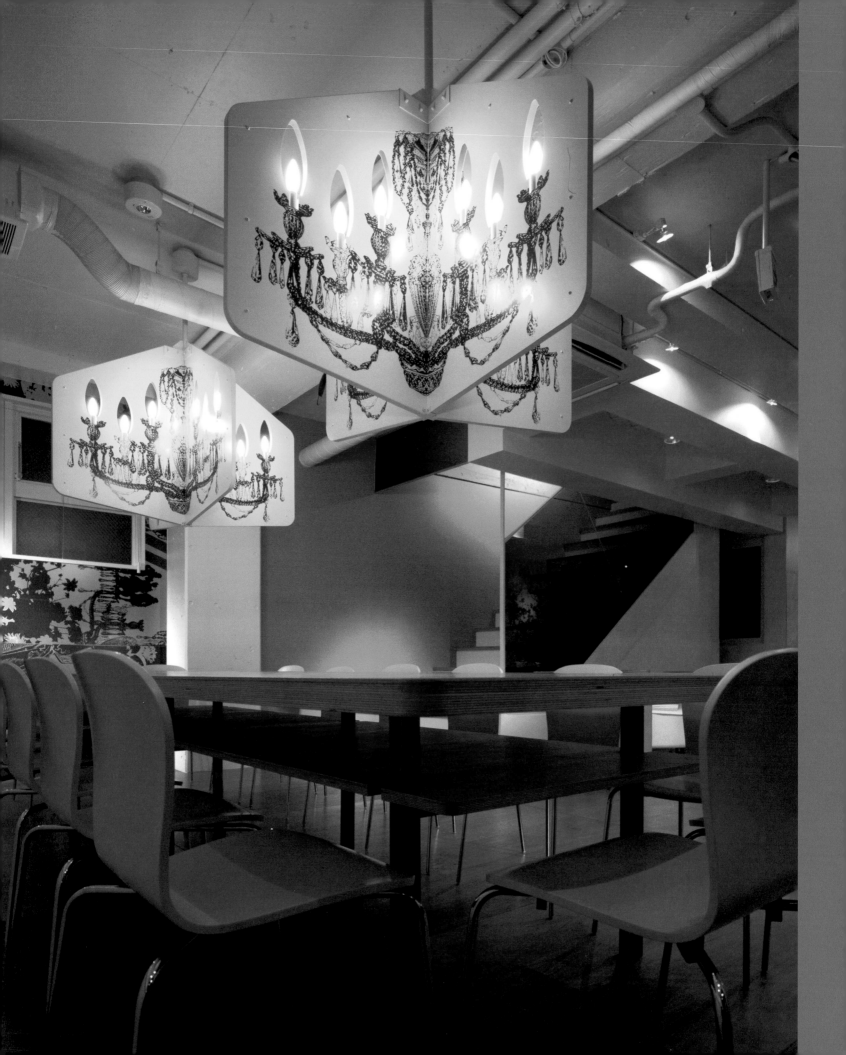

ENAMEL

Ishioka Ryoji, better known as Enamel, understands graphic design as something highly dependent on the structure of the underlying material. *"This is true for paper-printed graphic design as well as for porcelain or steel. It happens that I change the design depending on the material or texture."* He very often collaborates with interior designers; architecture and sculpture play an important role for him. *"To better judge the spatial impacts of my design, I often place print-outs in space, arrange them and take pictures with my digital camera to check if it works out."* Talking about the process of designing, Enamel speaks of three conditions he always tries to establish: *"First, the whole process from the beginning to the end should be something I intend to do. Second, my intention has to be represented sensuously, not through explanations. Third, something unexpected or unknown should happen, even if it is a small incident."*

At the moment he feels strongly attracted and inspired by the gardens and parks the sculptor Isamu Noguchi created. *"They are artificial, but at the same time they look absolutely natural. For example, he made a sculptural stone object with a slope that children can actually slide down. His idea being that children would in the long term polish the stone - which has already happened -, brings this object to perfection. It shows in a very charming way that anything you do will be widely influenced by the environment."*

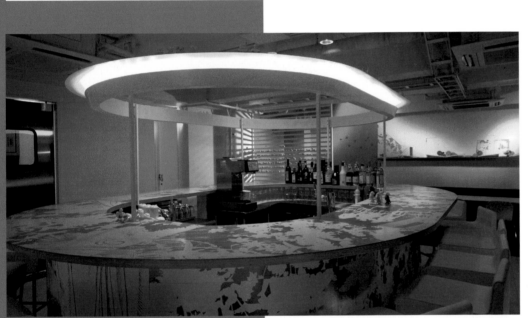

"Interior Graphic"
Omocha Cafe, Nakameguro neighbourhood,
Tokyo, Japan, 2003

"With the silk screen prints on steel I wanted to establish a kind of grotesque image within a neat and highly hygienic public space like a cafe."

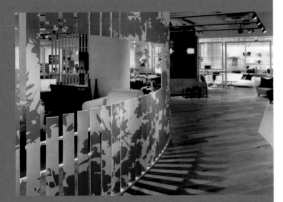
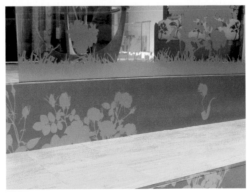
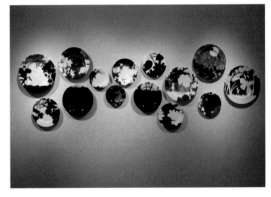

"Finerefine"
Finerefine Store by World Co., Ltd.
Interior design by ima, Tokyo
Osaka, Japan, 2005

"I did the interior graphics for the Finerefine stores in Tokyo and Osaka. The shop concept mainly targets adult women who shift to their lifestyle phase. I applied silk screen prints on wood for that - I wanted it to be not too conservative, because I dislike anything boring."

KIYOSHI KURODA

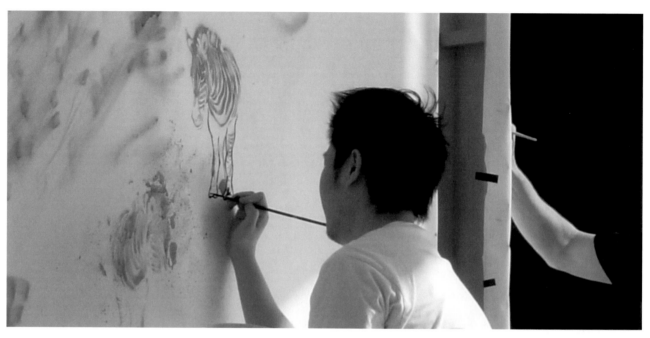

Photo by EXPO 2005 Aichi, Japan - Canada Pavilion

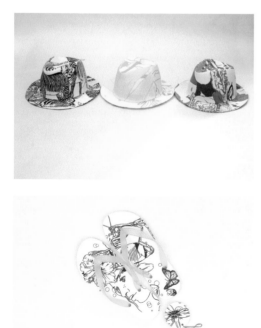

Kiyoshi Kuroda has been totally into the 2-D-centered world of ink drawing, and he still is. But with his first pieces becoming surfaces of fabrics, he decided to set one foot into that seemingly different world of objects and spaces, though at first it appeared really unfamiliar to him - and even a little risky: *"I had mostly been stuck to the particular kind of representation that comes along with line drawing, and I had worked hard to explore its range. So I was slightly afraid of destroying the world-view I associated with my drawings when I first let them grow beyond my paper sheets."*

But those doubts no longer haunt him. *"After having experienced how tantalizing it can be to switch over, I would now like to combine my artwork more often with the 3-D world's fields of activity, such as architecture or sculpture."* After all, one of Kiyoshi Kuroda's most loved sources of inspiration is also located in the outside world: *"I often go to zoos. Since I have been drawing animals a lot, I get inspired there. I never get bored watching the animals because I discover new things each time."*

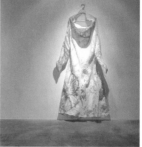

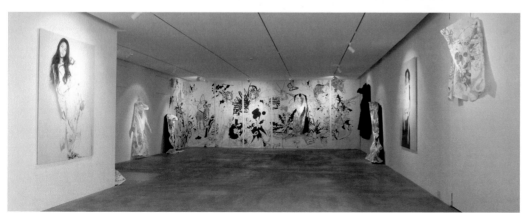

"PLUS+"
Posters, Clothes, Exhibition
Sfera Building, Kyoto, Japan, 2004

"The purpose of this joint exhibition was to present my collaboration with the textile designer Hisashi Narita. It was very exciting and pleasing to see the process of my 2-D drawings turn into 3-D clothes. For the show, models wearing the clothes were surrounded by large cotton fabrics which we imprinted with ink-jet printers."

JAIME HAYON

Being familiar with many facets of the creative business, Jaime Hayon is adept to a range of roles from curator to artist and designer. But whatever activity he is involved in, play is one of the things he considers to be essential. *"I love to play. I am interested in everything that has to do with playing, whether it's children's items or new techniques,* *I sometimes just like to play around. Playfulness also assists me to cross the borders of what can be done, to go beyond the limits. All that opens my curiosity to reach a new fantastic world."*

Though he reckons the computer is an important tool for his work, sketching his ideas out seems even less dispensable to him.

"That's what I start with. Then, with the help of my technician, I make a really perfect 3-D model out of it. But after all this, I go along with a pencil to see a craftsman. The first prototype is always generated without the support of any digital process. I like hand-made things, even in the digital era."

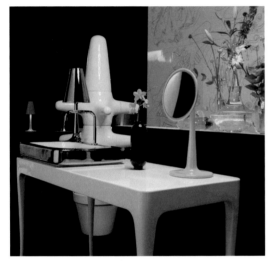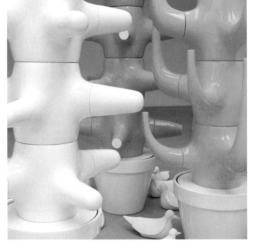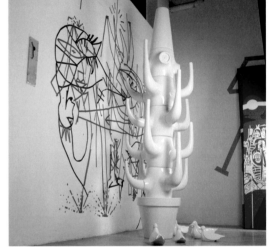

"Artquitect Hayon collection"
Barcelona, Spain, 2005

"When I did the design for this bathroom series, I wanted to make it a collection of items that could be placed anywhere in the house, more sophisticated and classy than usual bathroom components. I treat the project as an art installation, creating very personal graphics in every presentation. The most interesting thing was the collaboration with the craftsmen. I love to learn from them, they carry generations of experience with the same material."

"The Mediterranean Digital Baroque"
David Gill Gallery, London, UK
(later shown in Treviso, Italy), 2003

"The idea was to create a cactus forest made of coloured ceramics, including a central house full of toys. Around the central area I placed what I call ‚supersonic pig chairs'. Additionally, I made graphics that show how the installation arrived from another planet, moving straight into the gallery."

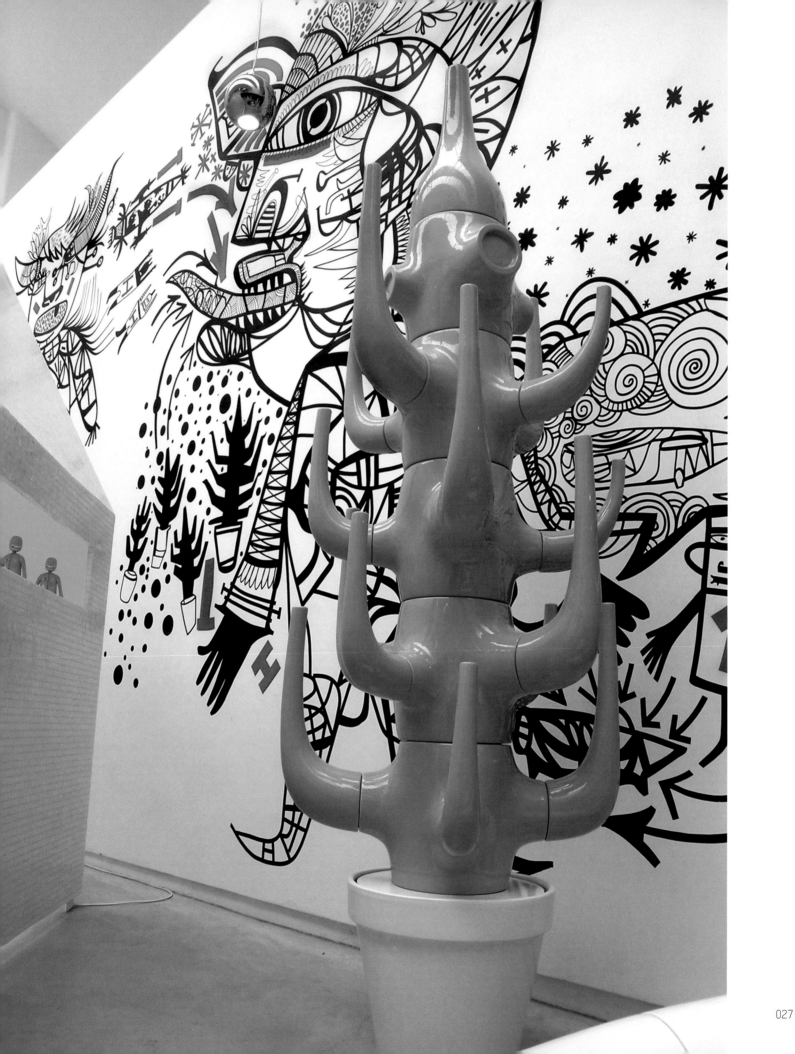

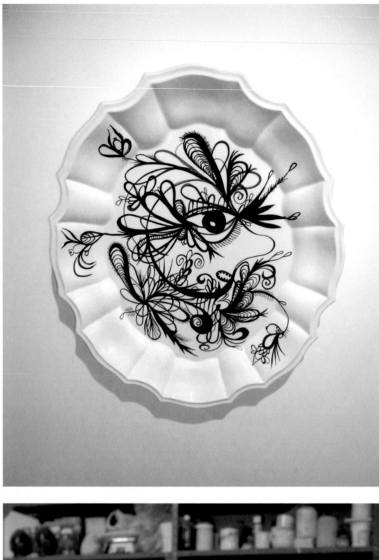

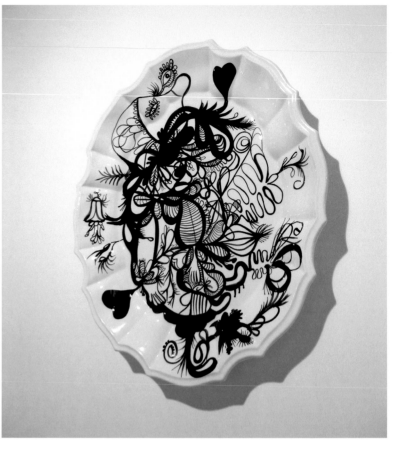

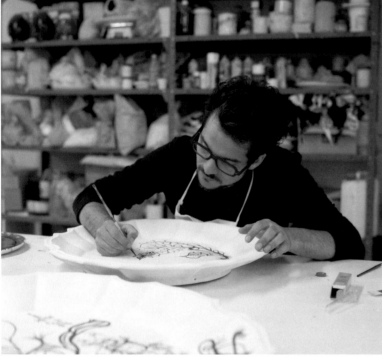

"Mon Cirque"
Barcelona, Minneapolis, New York, 2005

"With this collection, I want to start something based on my more personal side, the theme being the classical world of the circus. Items will include sofas, tables, vases, mirrors, toys and also graphics.

Until now, I have used porcelain and ceramics for almost all the new works. The table is made of carved wood and the vases are hand made and decorated with gold. The plates are hand painted and the clowns are covered by a layer of platinum.

As creative people, we do not need any authorization to develop new ideas. Sometimes, starting your own briefs is the best way to arrive at more exclusive solutions."

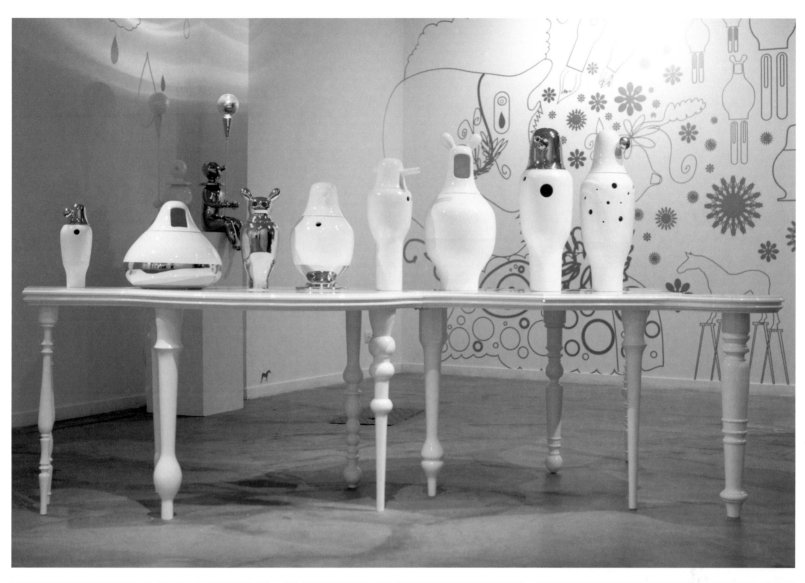

All photos by Nienke Klunder

HYPERKIT

"We are passionate about what we do", Tim Balaam and Kate Sclater agree. The work they do in their graphic design studio Hyperkit, they say, is primarily informed by their personal interests and fascinations. *"We work at any scale, from stationery and other printed matter, through to websites, exhibition design and branding."* Being conversant with different contexts like television, theatre and museum, they perceive choosing the right material as a significant issue. *"The question of whether a certain material is suitable or even available affects the way in which something is designed."*

Their inspiration for the design process comes from activities away from the studio, *"trips to places around the UK and abroad, visits to museums and galleries, architectural outings and trawling car boot sales and markets."* A project they both would enjoy realizing is to design and build their own house. *"And many of the things in it."*

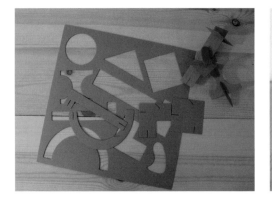 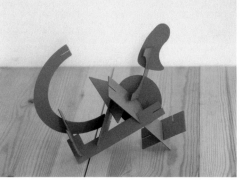

"Pop-and-slot Sculpture Kit"
Tate Britain, London, UK, 2005

"The brief was to develop an activity for children visiting the Anthony Caro sculpture exhibition. It should introduce children to abstract sculpture, be available on the art trolley and sold in the shop. We designed a kit which consisted of a number of shapes inspired by Caro's work, die-cut from a sheet of card and packaged in a bag with brief instructions. The shapes could be popped out and assembled in endless combinations to make abstract sculptures.

We learned the importance of close collaboration with the person who manufactures what you design."

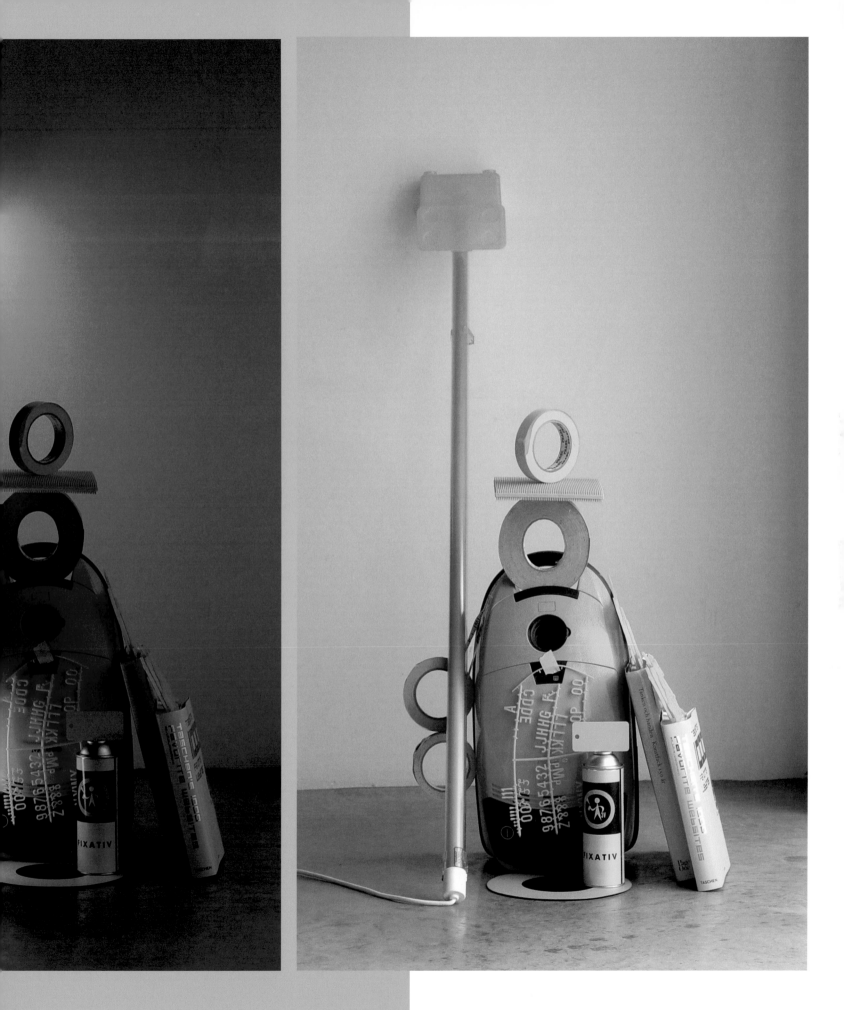

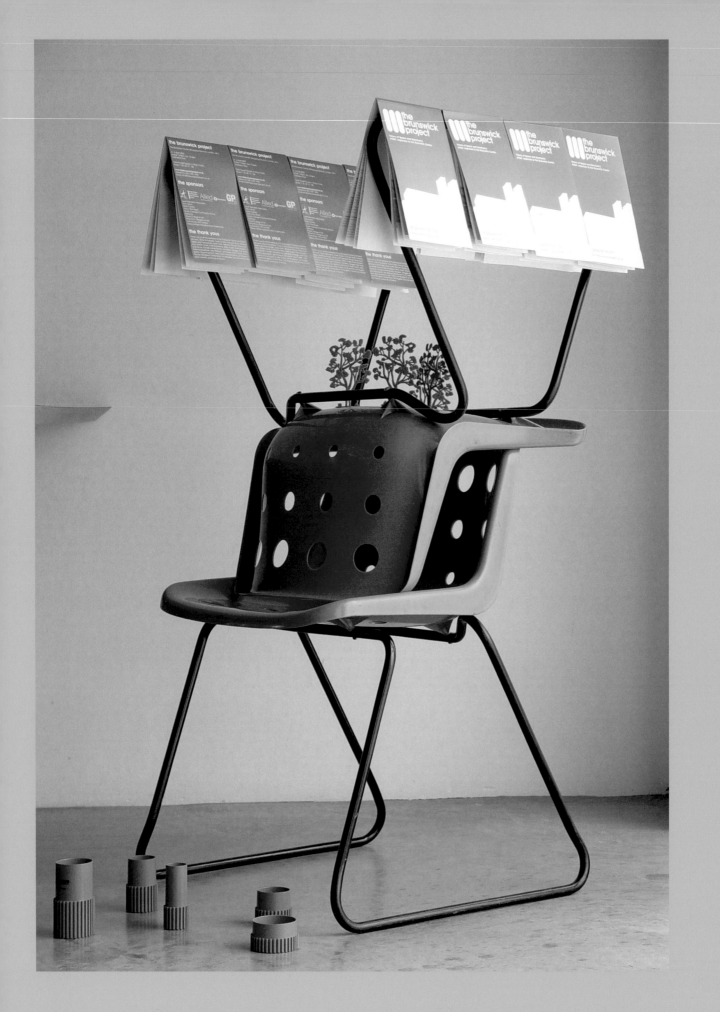

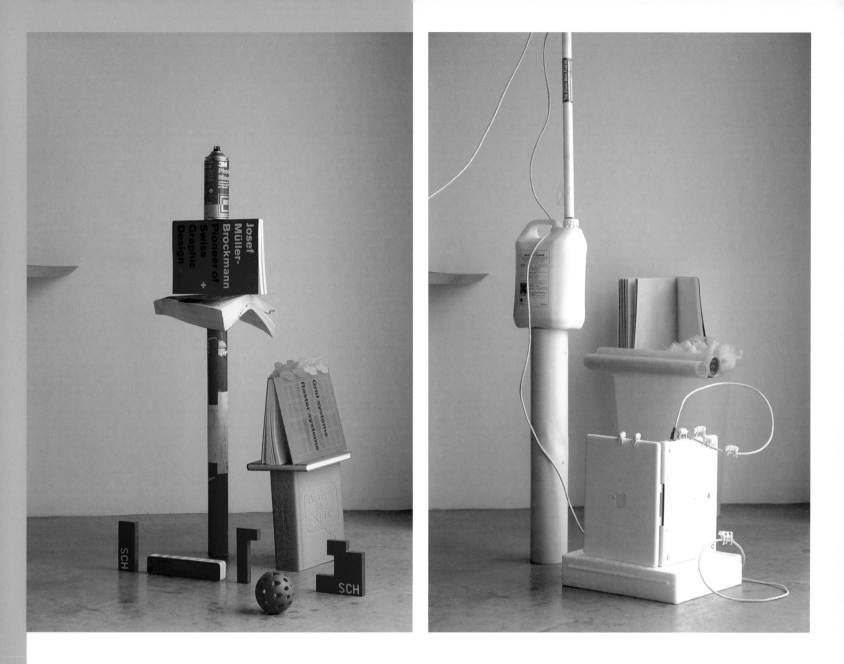

"A color study of our studio"
Self-initiated project with Christian Davies
London, UK, 2004

"We had a trainee (Christian Davies) for several weeks and wanted to develop a project together. The initial starting point was to create a portrait of our studio. This led to a classification, by colour, of various pieces of our work, books, furniture and other objects. These were eventually composed into sculptures and photographed. We found out that a group of unrelated objects can look beautiful together."

BLESS

Bless is a tale of two cities: Desiree Heiss is located in Paris, while Ines Kaag lives and works in Berlin. Soon after they had met at a contest for young fashion designers, they began to collaborate. Meanwhile, they have been developing their own product lines. *"Since clothes and accessories are in fact 3-D objects"*, Ines Kaag explains, *"we are used to dealing with space. For example, we never sketch. We always work with the real materials and try our shapes by real-* izing a certain object. For our furniture pieces, of course, we had to make small models in advance, to check the proportions, especially to find the centre point to keep it balanced. When we finally tested the real thing, we soon learned an*

important lesson in regard to hanging objects: *Always make sure there is a strong ceiling."* Ines Kaag can imagine a lot of spaces implicating quite difficult tasks for the designer, testing her ability to solve problems. *"Above all, these* are very crowded or very empty spaces", she says. *"But the bigger the challenge, the more exciting the results. This is how we developed our mobile displays: We had major problems with a very busy space at an exhibition. The question of how* to present a wide range of clothes next to furniture and accessories seemed nearly unanswerable at first. But eventually we found our solution."

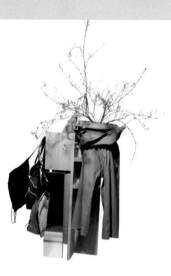

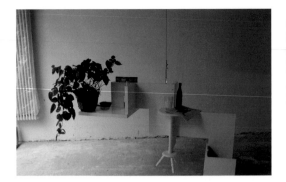

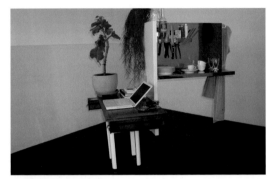

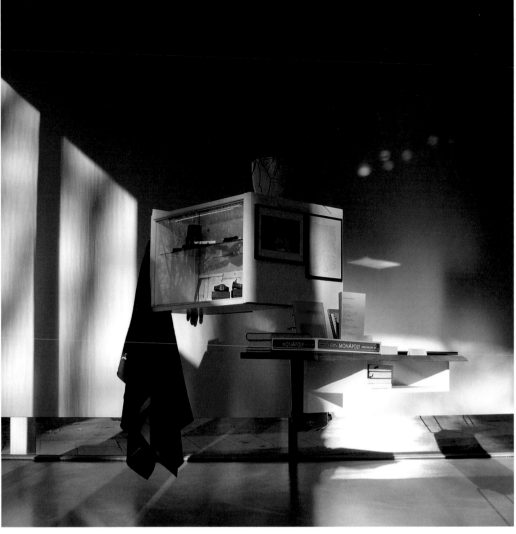

"BLESS No. 22 Perpetual home motion machines"
Shop display / Cash desk
Realized in Berlin and Paris, 2004/2005
First presented at the designmai fair Berlin 2004

"It all began when we thought about how to present our clothes and accessories collection. The question was: How can you put garments on display and keep them tidy at the same time? We were looking for a solution suitable to both public and private use. The result was a new type of wardrobe; a hanging, room-encompassing, perpetually twisting piece of furniture in perfect balance.

We first presented it in our shop at the Berlin designmai fair in 2004; later on it was purchased by our distributor in Japan, by Spanish and Japanese shops and the Leipzig gallery of contemporary art. Each piece is different, but mostly we use oak and lacquered plywood, sometimes materials like plexiglass or objects we find."

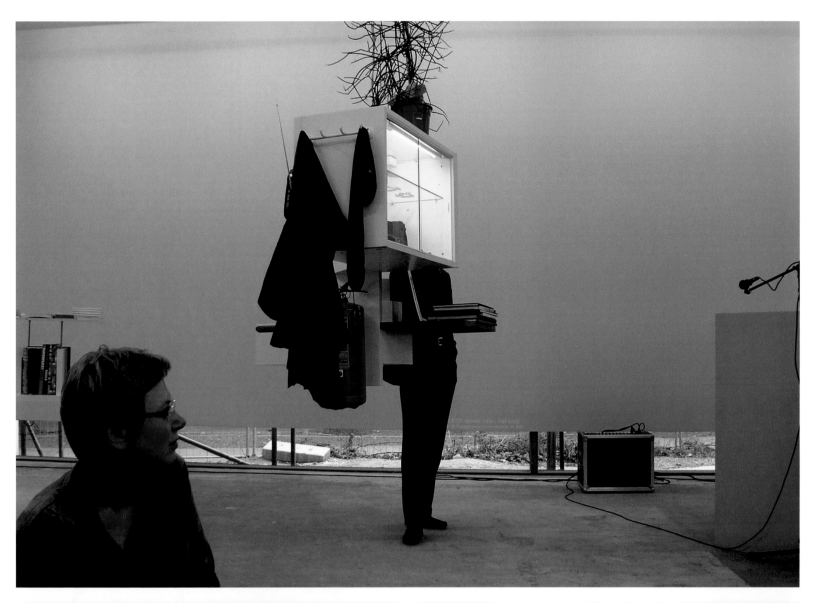

PFADFINDEREI

Viewed from a distance, a great many of Pfad-finderei's graphics are of an eminently abstract kind. Upon closer examination, though, it becomes visible that they have been made in a most concrete manner: adhesive tapes and vinyl foil appear, print clippings meet with video cassettes or metal containers.

Some of their members act as VJs in several Berlin clubs, one of their favourite fields of research is how video and music interact, and they would like to intensify their experiments with that cross-media approach.

The made-up word ‚Pfadfinderei' translates as ‚boyscoutery'. In fact, the studio's credo affirms the belief in good deeds: *"We bring to life an imaginary world ruled by graphics, pictures and music where no child suffers, everyone supports everyone else and there are always enough graphics to eat and look at for all human beings of every colour"*.

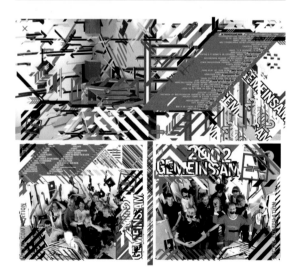

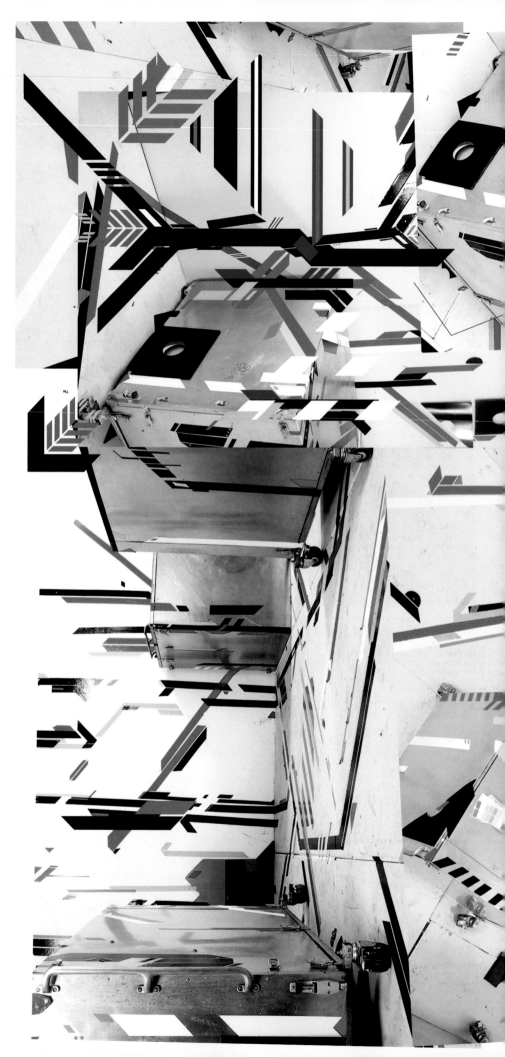

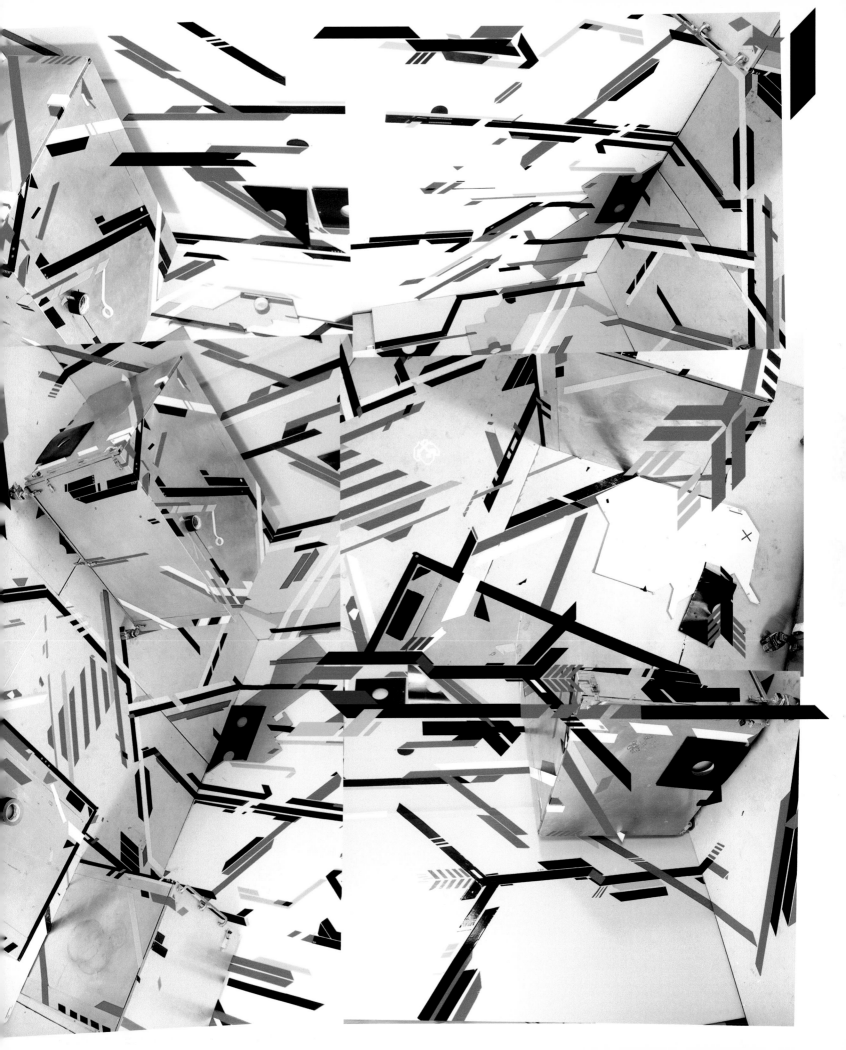

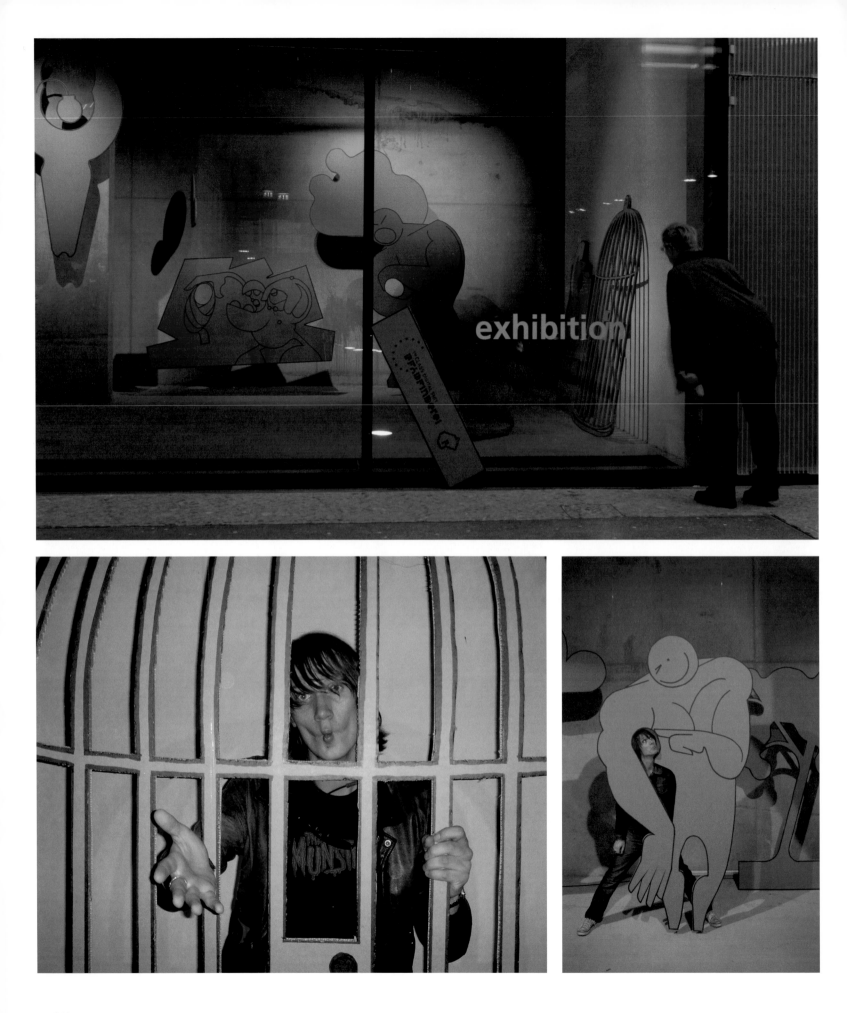

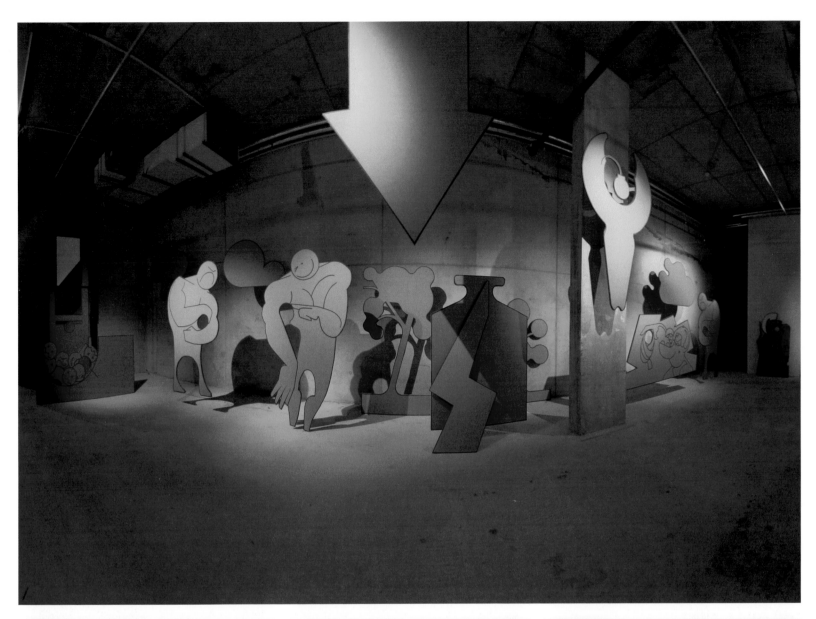

DIY

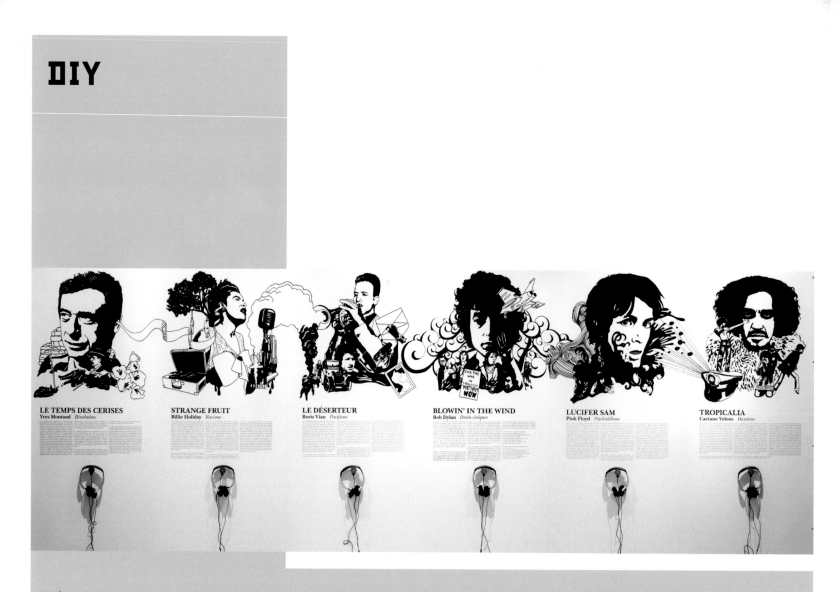

LE TEMPS DES CERISES
Yves Montand *Révolution*

STRANGE FRUIT
Billie Holiday *Racisme*

LE DÉSERTEUR
Boris Vian *Pacifisme*

BLOWIN' IN THE WIND
Bob Dylan *Droits civiques*

LUCIFER SAM
Pink Floyd *Psychédélisme*

TROPICALIA
Caetano Veloso *Dictature*

When Laurence Jaccottet, Philippe Cuendet and Ivan Liechti founded their graphic design studio in 2001, they named it after the abbreviation of their motto "Do it yourself", //DIY. Their main objective, they say, is *"to create a multidisciplinary platform focused on graphic design"*. They want to communicate through various media such as photography, music, film or fashion. Conveniently, they can always apply the actual shapes of their distinct formal vocabulary to their own two brands, a fashion and a record label both running under the name +41 (the international phone code for Switzerland). They have already completed three fashion collections, combining some retro chic with a street wear look, and distributed them to selected shops around the world. *"Each new collection will offer a larger choice of models. Our aim is a complete range of clothes from jeans to T-shirts including dresses, skirts and accessories. We also had the opportunity to create exclusive work on 17-serigraphed leather jackets and a limited T-shirt edition for Nike."*

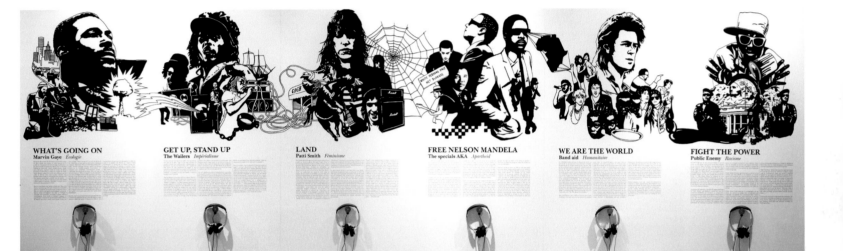

WHAT'S GOING ON
Marvin Gaye *Écologie*

GET UP, STAND UP
The Wailers *Impérialisme*

LAND
Patti Smith *Féminisme*

FREE NELSON MANDELA
The specials AKA *Apartheid*

WE ARE THE WORLD
Band aid *Humanitaire*

FIGHT THE POWER
Public Enemy *Racisme*

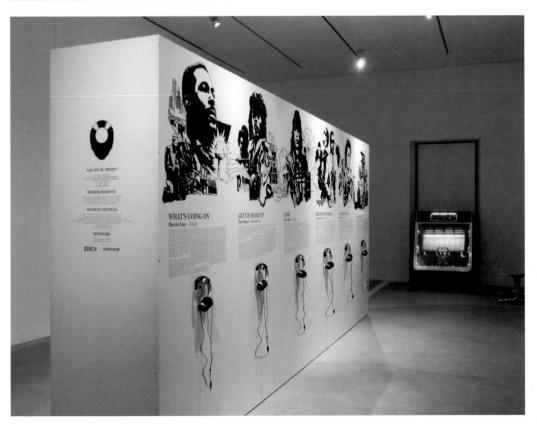

"Musique&Conscience"
Screenprinted wall, 2005

"This installation was realised for an exhibition about consciousness. The concept was to present 12 emblematic engaged songs. The wall is made of wood, 5 metres long, 2.2 metres high with 10 metres of screenprinted drawings and texts (all the drawings are interconnected), and head-phones to listen to the songs."

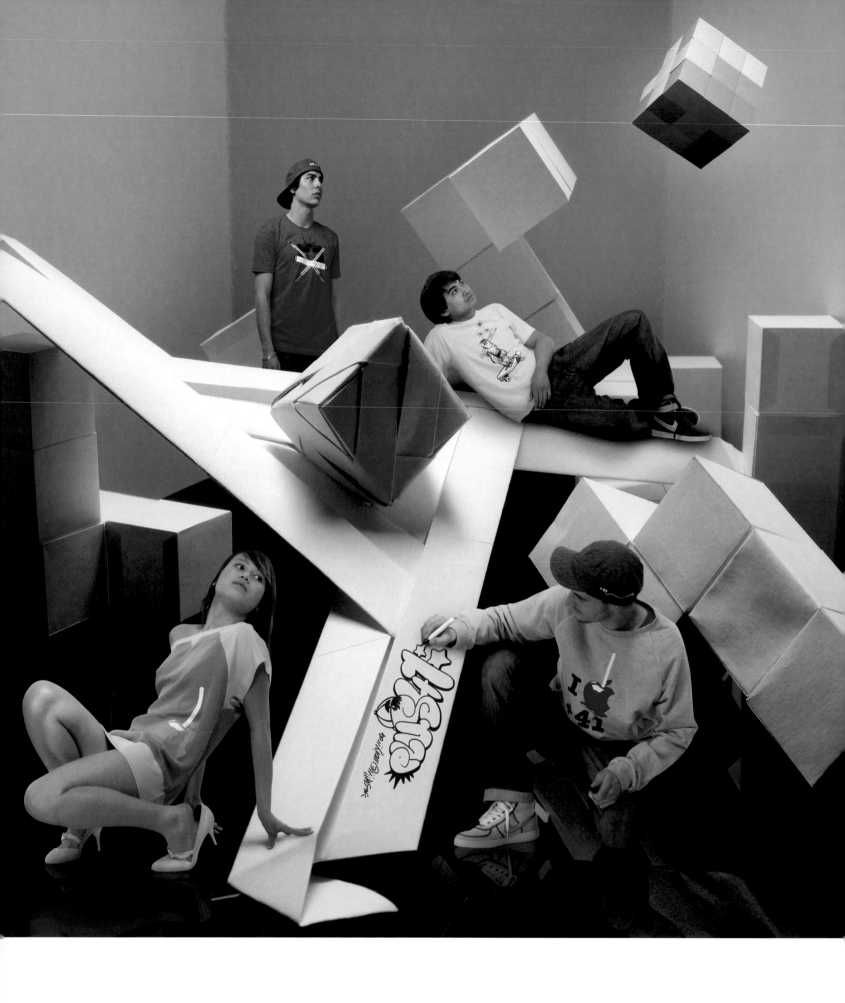

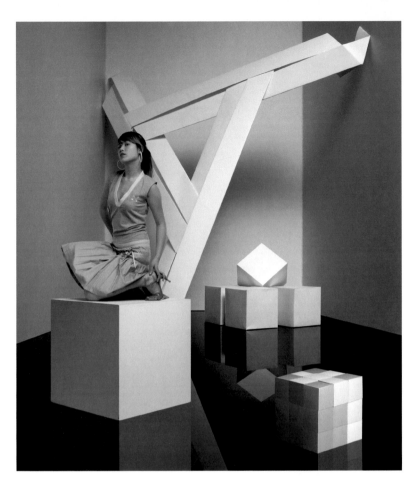

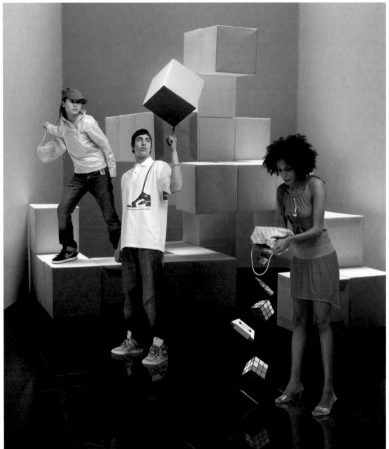

"+41"
Promotion, 2004

"These pictures are to promote our last clothing collection."

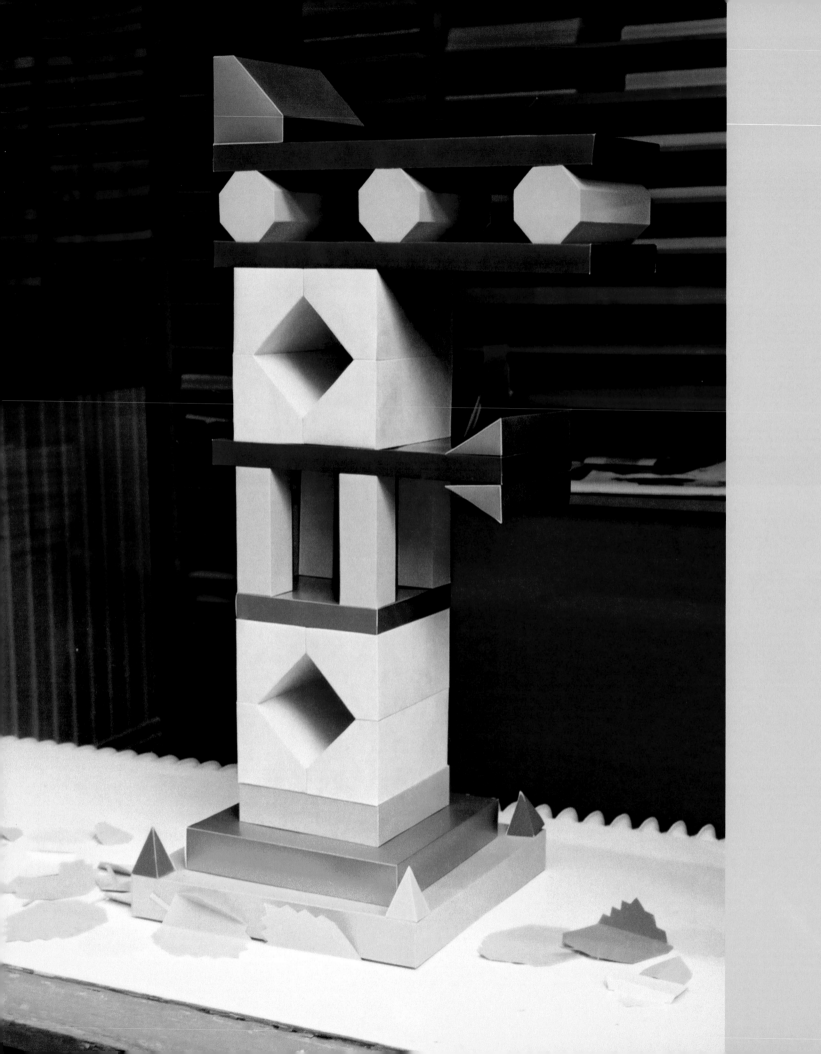

ANDREAS AND FREDRIKA

Feeling at home with graphic design as well as with conceptional art, Stockholm-based Andreas & Fredrika (short for Andreas Bozajic and Fredrika Jacobsson) have no difficulty with switching over from two to three dimensions.

"In both fields of work, you are dealing with various ingredients that in the end make up an entirety. For us, one of them is the material we are actually working with. Another one is our experience - not only with art and graphics: It is important to take a great interest in the whole cultural life of your environment. That includes observations of everyday life. Looking closely at things often shows that you can always create something interesting - out of everything."

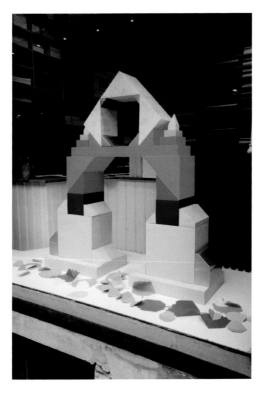

"Andreas och Fredrika for Svenskt Papper"
Shop display, Svenskt papper
Gothenburg, Sweden, 2002

"The Swedish paper manufacturer Svenskt Papper wanted us to build up a window installation to promote its colourful product line. Our solution was to handfold paper boxes and to pile them up to one metre high letters. We chose the letters A and F, in that way promoting ourselves, too."

047

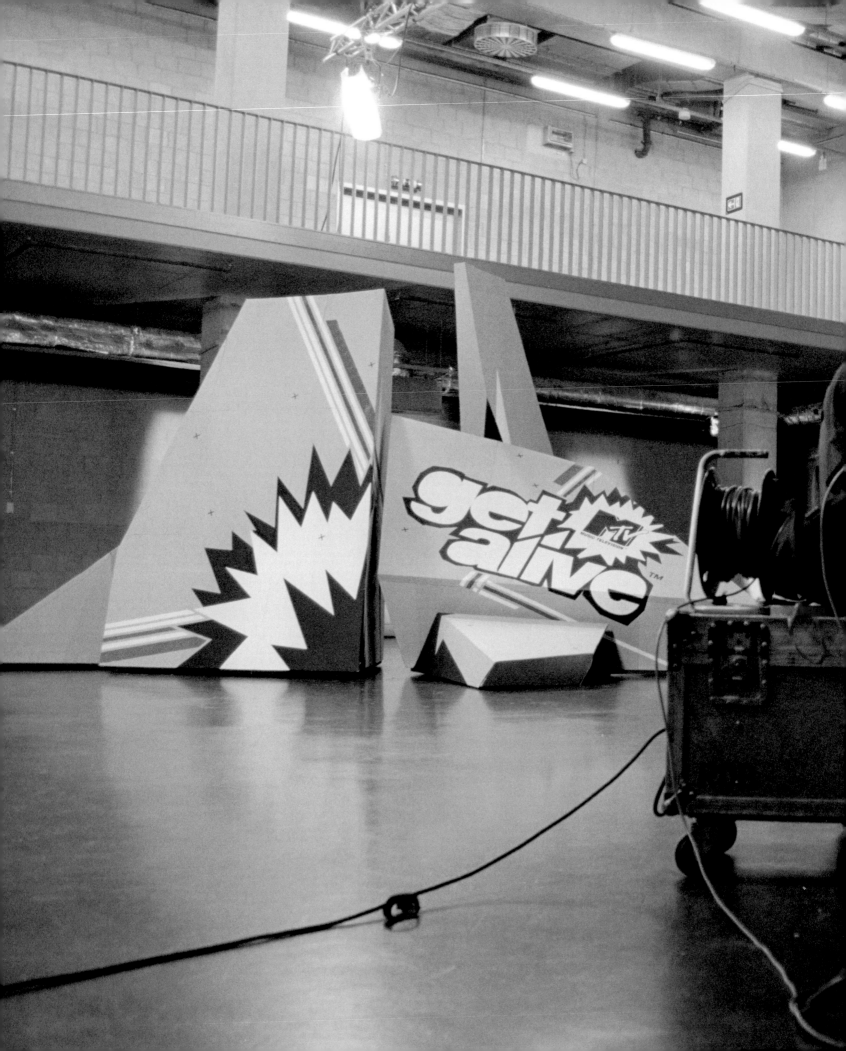

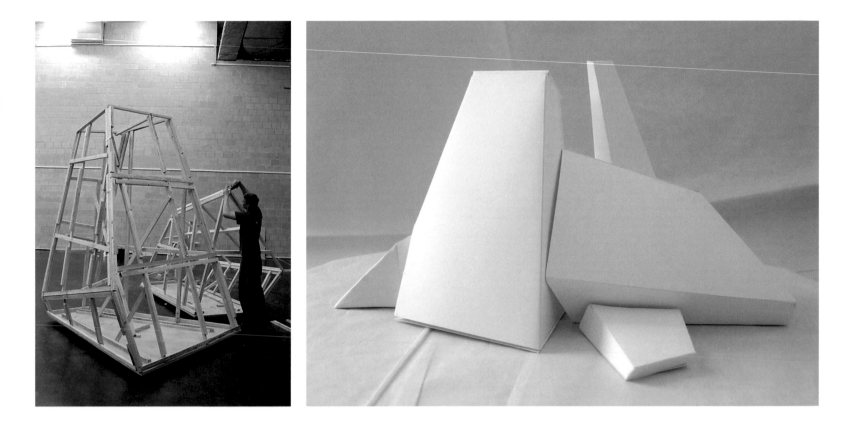

VIAGRAFIK

Viagrafik are five artists and graphic designers located in Wiesbaden, Germany. Though plenty of their work holds a certain street look and reminds viewers of the graffiti context, all of them have already gained experience in big agencies and graphic offices. *"It is most often a symbiosis of imperfection and perfection we are striving for. For us, there is no need for an expensive object.*

We find beauty in a destroyed, rotten wall and like to design it using its own texture and some spray paint and acrylics. Or take a plain white wall. Things like that can be as inspiring as hell."

Rather than focussing too much on the result, they think about the production process itself from the very start. *"You often get the best out of a simple idea. For example, we like to*

recycle materials, to incorporate old cardboard or found objects in our works." Handling things this way also means going out a lot. *"We all love nature, but also abandoned areas in the city. Sometimes it's so inviting to put a little utopian thought into the way we see our surroundings, to confuse and to show a difference."*

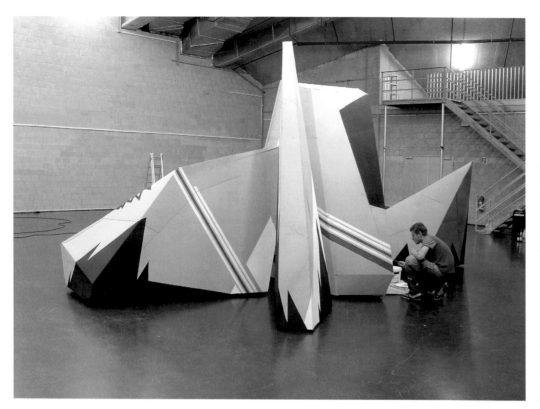

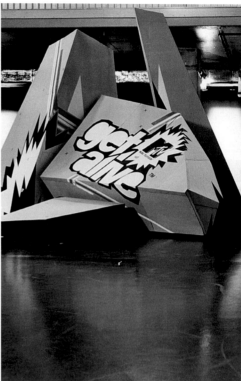

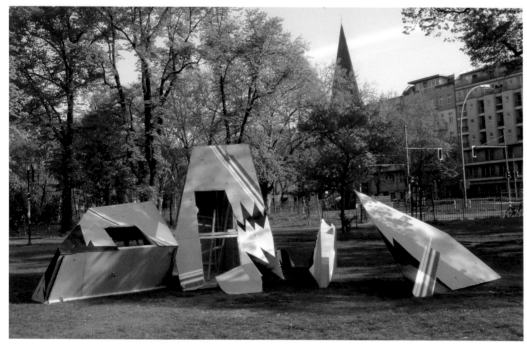

"get alive"
Show, MTV Germany, Berlin, Germany, 2005

"Some people from MTV saw the object ‚slanted'
we did for the Offenbach museums' night and
wanted us to do something similar for their show
called ‚get alive'. We were commissioned to do
the logo for the show and the object. We used lath
wood and cardboard to build up the object, and
afterward painted it."

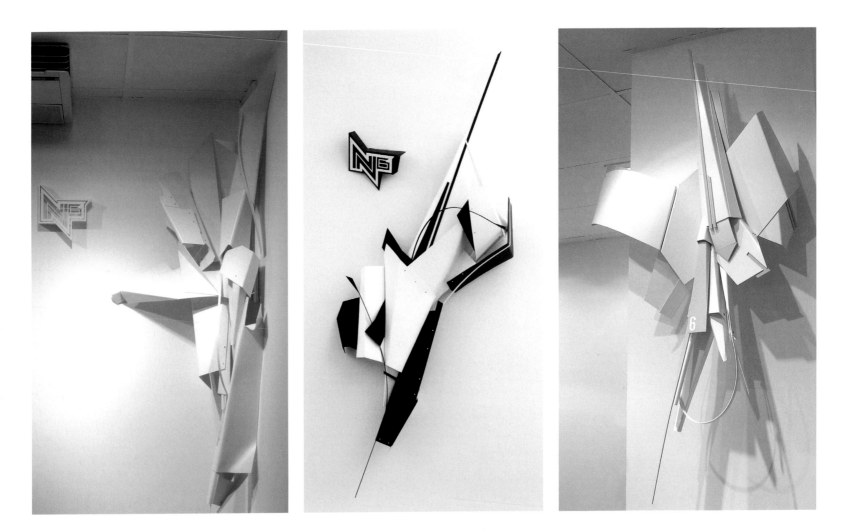

"Adam & Eve / Collapse"
N6, viagrafik, Wiesbaden, Germany, 2004/2005

"We love the excitement of deconstructivism and the process of puzzling. Our intention was to turn industrial plastic, a flat and amorphous material, into three dimensional reliefs. All objects consist of many parts that are interwoven with each other. The graphical elements correspond to their surroundings but at the same time disturb the linear conditions of any room. They offer a sort of break in the wall, threatening to burst apart explosively."

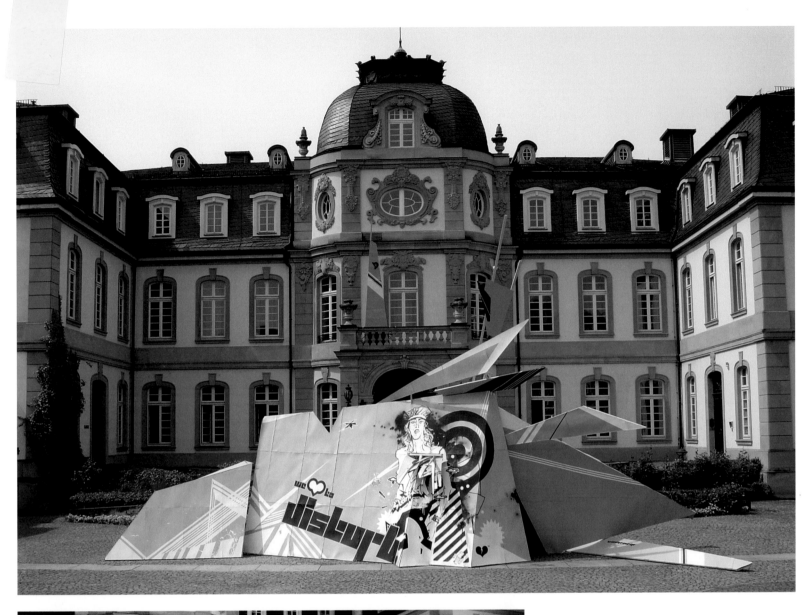

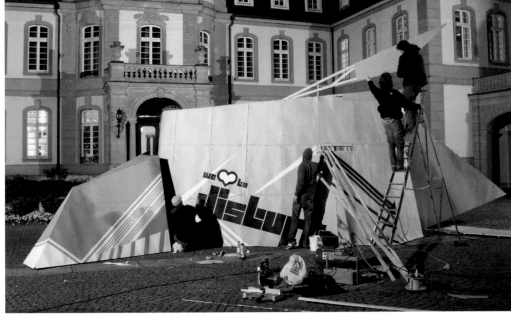

"slanted™ we love to disturb"

Klingspormuseum
Offenbach / Main, Germany, 2004

"Klingspormuseum curator Stefan Soltek invited us to participate in the ‚museums' night' to do a live performance in the courtyard and accompany their main exhibition featuring pentagram design. We were given total freedom to do what we wanted. So we came up with the theme ‚slanted á we love to disturb'. For the museums' night we built a construction made of wood and cardboard that we painted on. The construction corresponds with the historical scenery of the former city hall of Offenbach. By looking at the audience's reaction, we found that our aim to disturb the location's usual dignified atmosphere and create moods of restlessness, seemed to be achieved."

BEAT13

Lucy Mclauchlan and Matt Watkins are Beat13, a Birmingham-based studio for graphic and set design. Lucy describes her profession with the words *"All I ever wanted to do was draw"*. She claims that since she was a child, she has always carried around at least one felt pen, and she still likes to draw spontaneously on nearly any kind of object crossing her way. She has absorbed a lot of motifs from Birmingham's graffiti walls and been inspired by Manga comics; being especially attached to the surreal comic art of Taiyo Matsumoto.

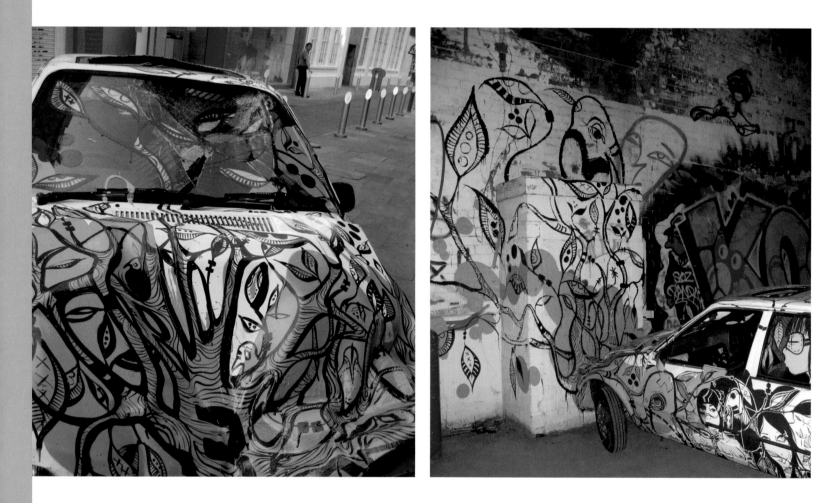

"Supersonic scrap car challenge"
Slater Bros Ltd. scrap yard, Birmingham, UK
Client: Capsule, 2005

"Capsule music promoters had previously seen in random areas of Birmingham that Lucy had a tendency to scribble on dumped vehicles, so it was suggested that one be used for the Supersonic music festival. The car was smashed into the Beat13 Gallery window and painted on the glass. After the event it was pushed round to a brick wall which was then painted too. The leaves and branches were painted to continue the image of the car and let them grow over and up the wall. We used waterproof gloss paint and orange acrylic based household paint. Slater Bros were very helpful when they let their scrap yard be transformed into a painting studio for the day."

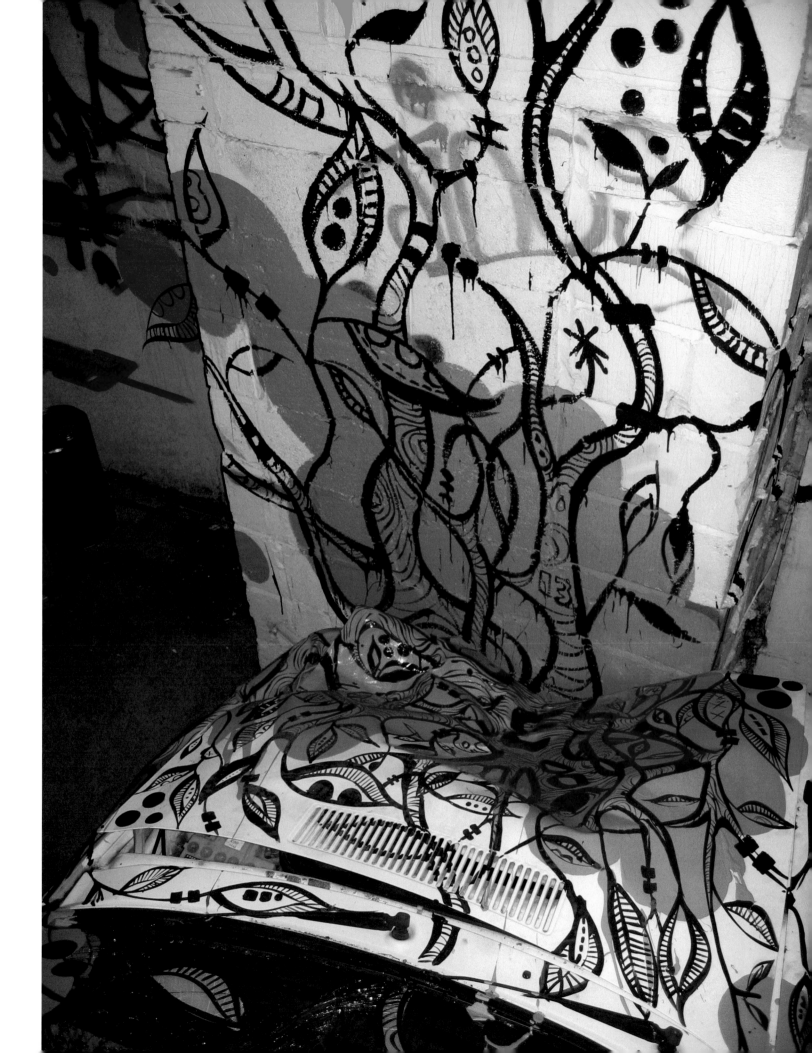

"Wolvo Mural"
Wolverhampton Art Gallery
Wolverhampton, 2005

"The gallery commissioned a mural to fill a long stretch of wall (19 by 3 metres) while a new major section of the gallery was being built to house their acclaimed Pop Art collection. It was also to help attract a younger audience and add something fresh and contemporary to their existing collection.

With the design I wanted to reflect the new building. Besides, spring was in the air. Therefore, I used the wood to add warmth to the space and create the organic basis for the faces depicted within the sumptuous undergrowth, creating a seen of new growth.

This became more of a personal challenge for me because I had previously suffered a wrist injury from painting large scale detailed murals, so I had to change my way of working and not draw too many small very detailed areas and keep it to purely painting rather than using pens."

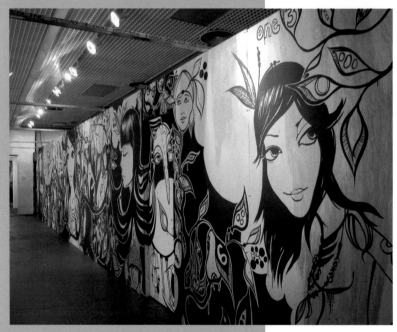

"Supersonic window display"
Client: Capsule
Birmingham, UK, 2004

"The brief was to decorate the window in the Custard Factory, Birmingham's arts and media quarter, with Beat13 images. As not all of us were around, Matt Watkins cleverly collaged photocopies of various pieces of people's artwork. We used just paper, scissors and glue and came to know how effective photocopying can be."

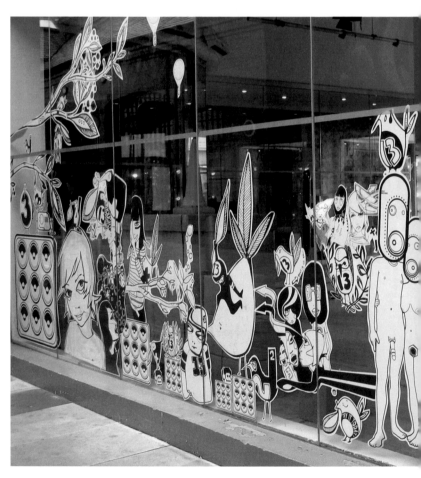

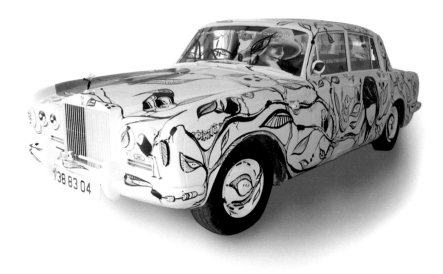
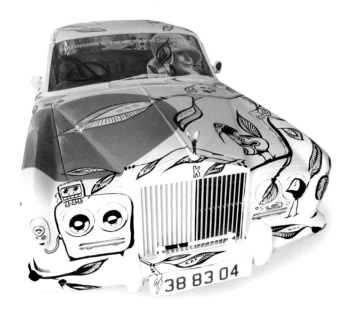

"Rolls Royce"
Client: Kangol
Brick Lane, London, UK, 2004

"No real brief. We were just asked to come along and spend the weekend working on the vehicle. We painted with black acrylic and orange emulsion, and also drew over it using Posca pens. Now I know how satisfying it is to shut a door on a Rolls Royce! And learned how many people think that it is ‚blasphemous' to paint on a Rolls Royce."

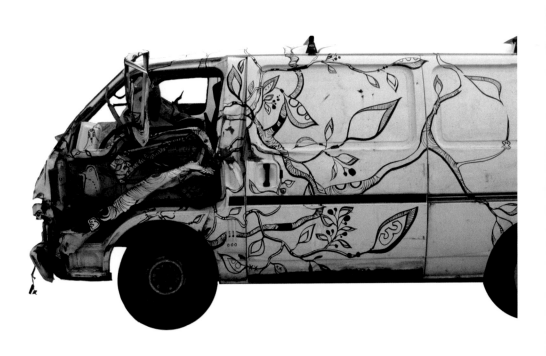

PUBLIC

Long before semioticians began to decode public space as a collection of symbol systems, people have been consciously writing themselves into these spaces to leave their mark or message. Graffiti and street art are two more recent attempts at subverting or superimposing on the symbol systems we call cities.

Streaks of social critique and a drive toward artistic innovation could be seen even in the classic forms of graffiti, along with the hedonistic key theme of "getting famous". This conceptual impulse has increased along with the more prominent street art movement, also known as post-graffiti, in the last few years.

Many street artists have the desire to engage with public space in a way that elicits a reaction, provoking or irritating. The theoreticians among them cite theories that can be collected under the heading "communications guerrilla". Their smallest common denominator could be Roland Barthes' suspicion that the defacing of existing codes is much more subversive than their destruction.

In this way artists who apply themselves to a remodelling of public space are similar to hackers: They embed their own messages into the official code of the city. They rarely do this with the intent to destroy, even if their activities are occasionally grouped in with vandalism. After the New York duo Thundercut "dressed" the figures on some of the city's traffic lights with self-adhesive vinyl, the New York Transit Authority preemptively equipped some of their traffic lights with protective grilles. In contrast, some of the photo-realistic architectural irritations by the Danish graphic designer Pulsk Ravn have been financed by galleries.

Artists who work with public spaces in this way usually have to deal with vastly different expectations regarding their work, compared to what is usual in a gallery or museum environment. For one thing, street art is accessible to people who would normally never take time to look at modern art. For another, someone walking down a street will react very differently to a visual stumbling block than someone going into a gallery. The sculptures of newborn babies made of clear packing tape that the Washington-based artist Mark Jenkins installed into a street scene created the most intriguing effect specifically because of their non-gallery environment.

Many artists like this way of reaching a broad public audience, even though there is seldom any money for street installations of this kind. But galleries and agencies started noticing long ago that the next shooting star of the art world could be discovered on the walls of local communities. The term 'guerrilla' is common jargon in the advertising scene, used to describe a strategy that ensures a part of the public's ever shrinking attention by using highly visible intervention, similar to the strategies of communications activists.

Street artists concerned with a critical reflection of space or a political interaction with passers-by could be faced with the same attention that was given to the graffiti scene when it was intensively wooed by diverse street-wear labels. Even now strategies that originated in street art, like 'Ad-busting', the anti-consumer defacing of hoardings, has been seized on by the ad agencies themselves and elements used in their campaigns. But those who merely want to use the walls of the city as a kind of gallery to show off artistic skills or create a new artistic language can, at least for now, be sure of a tolerant climate.

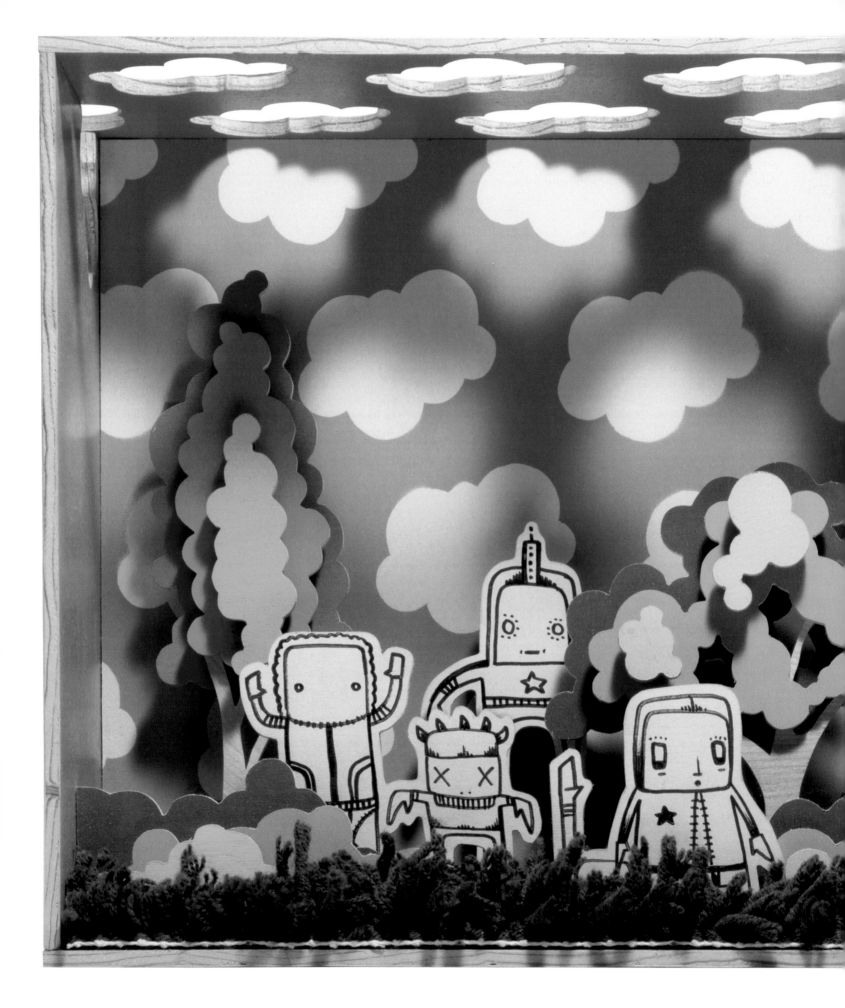

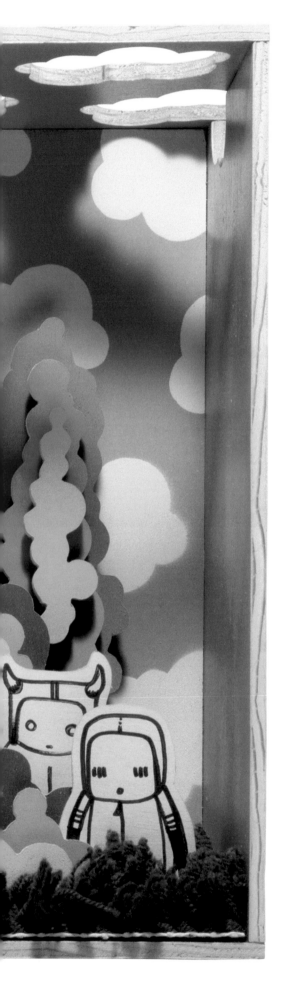

THUNDERCUT

"We love the endless creative possibilities of public spaces", TH1 and TH2 from the Brooklyn artists' duo Thundercut say. *"A lot of our work is definitely based around the architecture and look of the city and actually could not exist without it."*

Before they actually go about altering the urban landscape with their installations, they develop them in their studio. *"We use a variety of techniques to realize our projects"*, says TH2. *"Many times they start as a sketch and are drafted on the computer to figure out the construction measurements. The final piece is then built by hand. We often create 2-D renderings on the computer to help visualize the project in its space. Other projects are realized late at night in our studio as a spontaneous creative process."*

A trip to the hardware store is always inspiring for them. *"Materials are essential for our design process. Currently we find it interesting to see how similar materials can relate to very different spaces and environments. We have been using limited materials throughout our projects to explore the possibilities of what we can do with them."*

Alongside their artistic activities, they both have full-time jobs. *"Having a playful outlet outside of those jobs is crucial to our creativity. We feel that the things we have created through Thundercut really reflect this energy and possess very playful and fun qualities. Some of our projects exist simply to put a smile on someone's face."*

"2:10 on a school day"
Imaginary Friends group show
curated by Katie Taft
The Assembly Annex, Denver, Colorado, USA, 2004

"Being invited to participate in the group show, we chose to explore the idea that children have imaginary friends and are not allowed to bring them to school. So the friends wait in the woods outside the school until the kids to get out of school at 2:15 pm. We chose the diorama format, because it has a very grade school project feel to it, and invokes memories and nostalgic feelings of youthful academia."

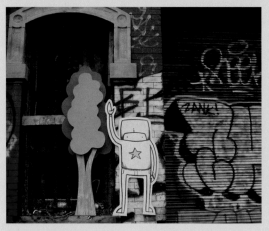

"Friends"
Installation on an abandoned building,
Brooklyn, New York, USA, 2004

"There is an abandoned building across the street from a park in Brooklyn where people often play handball and basketball. We wanted to soften the view. So we created a friendly character and a tree, jigsawed them and fixed them to the front for people to see from the park."

"Team Thunder Sneaker"
Finish Line Stores, Sneaker Pimps, 2004

"Thundercut was asked to decorate or alter a shoe for Sneaker Pimps, a global touring sneaker exhibition. We decided to base our shoe on the idea of the shoe box, being the container in which you bring your shoes home from the shop. So we recreated the actual shoe in wood and left it hollow to accommodate the original shoe inside as a representation of the boxes contents."

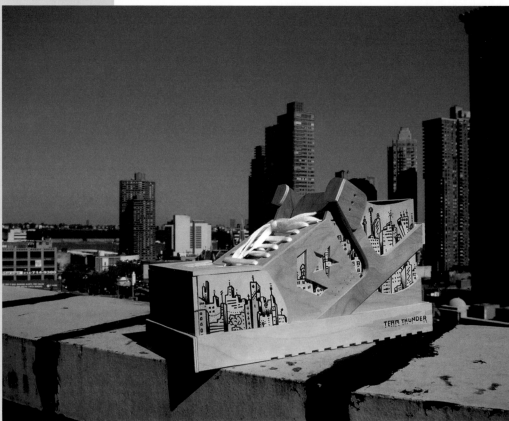

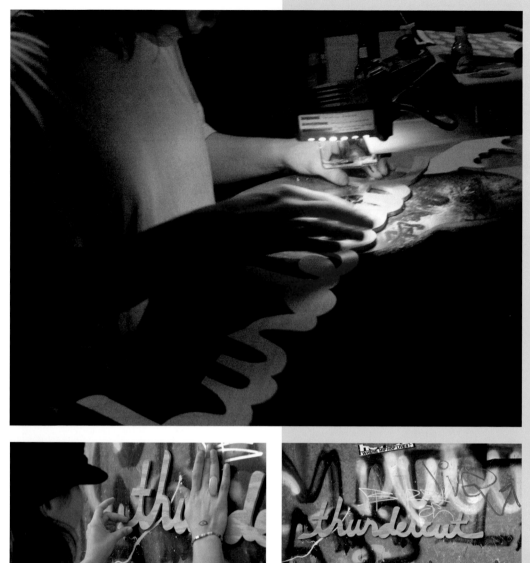

"Seacorn"
Brooklyn, New York, USA, 2003

"Exploring the idea of traditional graffiti, fixing custom cut, wooden shapes onto tag covered walls. We cut them out of scrap wood with a scroll saw."

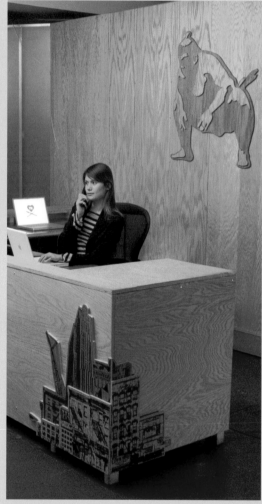

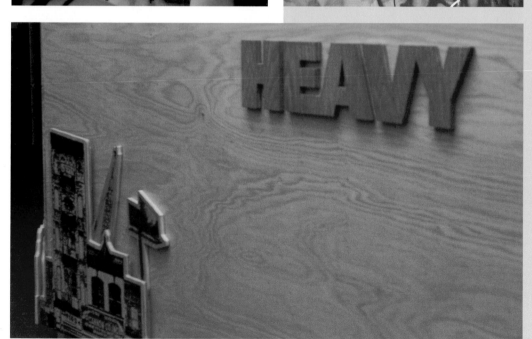

"Heavy Desk"
Heavy office, Manhattan, New York, USA, 2004
Photos by Michael R. Dekker

"Heavy asked us to enhance the reception area of their Manhattan office. With a tight budget and a short deadline, we built a shell around the existing desks, designed graphics for the front face and covered the back wall with wood and the company's identity."

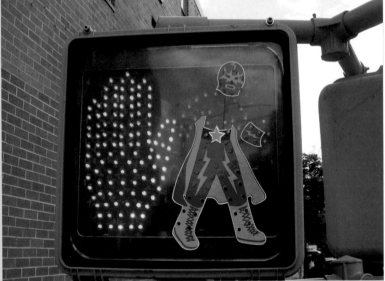
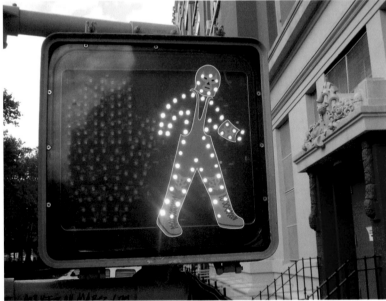

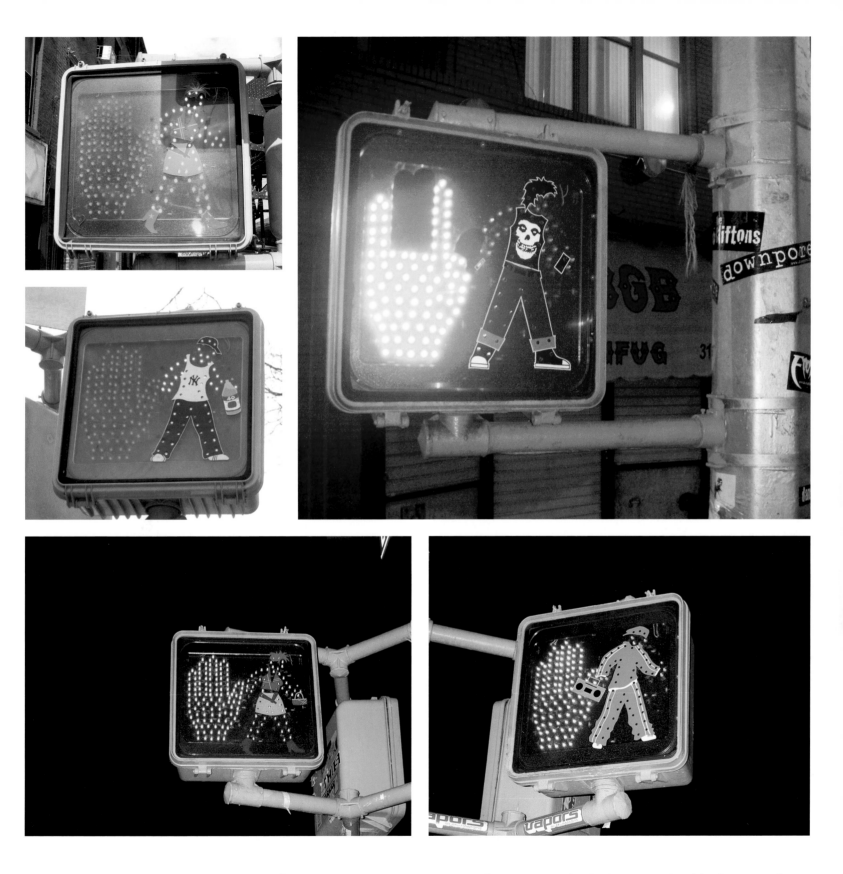

"Dress the Walkers"
Brooklyn, New York, USA, 2003

"The project involved the alteration of New York City crosswalk signs to celebrate the personal diversity of the people in the city. We took the common, highly visible ‚walk' character and designed vinyl outfits to represent gender, personality, and style. The dresses we tailored for them were often inspired by the area in which they walk. In addition to location and style, function remains a high priority to the walkers, so we added holes to the outfits to allow the sign lights to shine through."

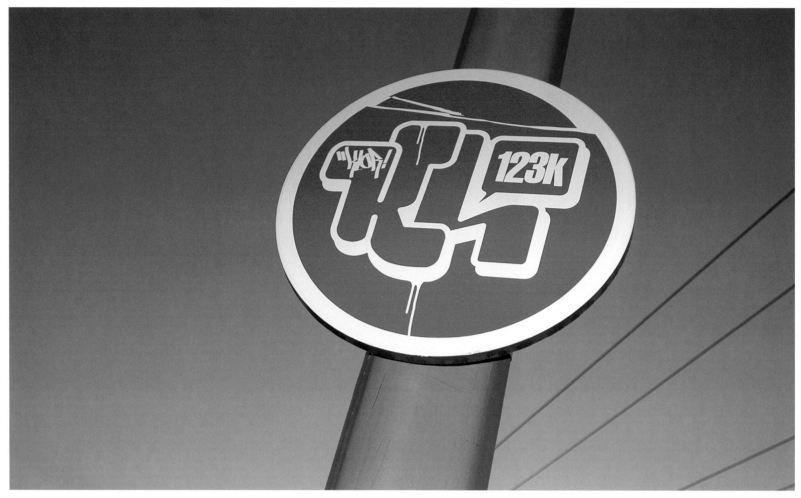

Sign by 123 KLAN (Lille, France)

KANARDO

Kanardo consists of Christelle Chambre and François Verdet, who work together as photographers and graphic designers. They do photo reports and layouts for magazines as well as personal creations and projects to promote graphic design and photography. *"We do commercial projects to earn money, so that we are able to do our more artistic works without any restrictions"*, François Verdet says. Both of them like to work in and for the public space. *"It is here where we can put our ideas in practice in a way that is accessible for virtually anybody - not just the usual art-loving audience."* Consequently, they share a common dream; to build up giant sculptures one day.

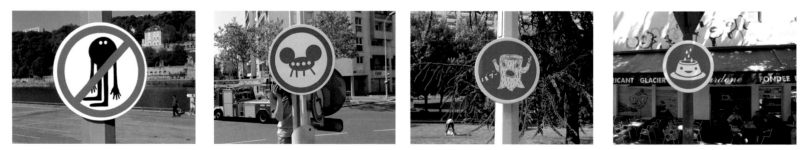

Signs by GENEVIEVE GAUCKLER (PARIS / France), SPACE 3 (EINDHOVEN / NETHERLANDS), AYA KAKEDA (NEW YORK / USA), VICKY WONG (VANCOUVER / Canada)

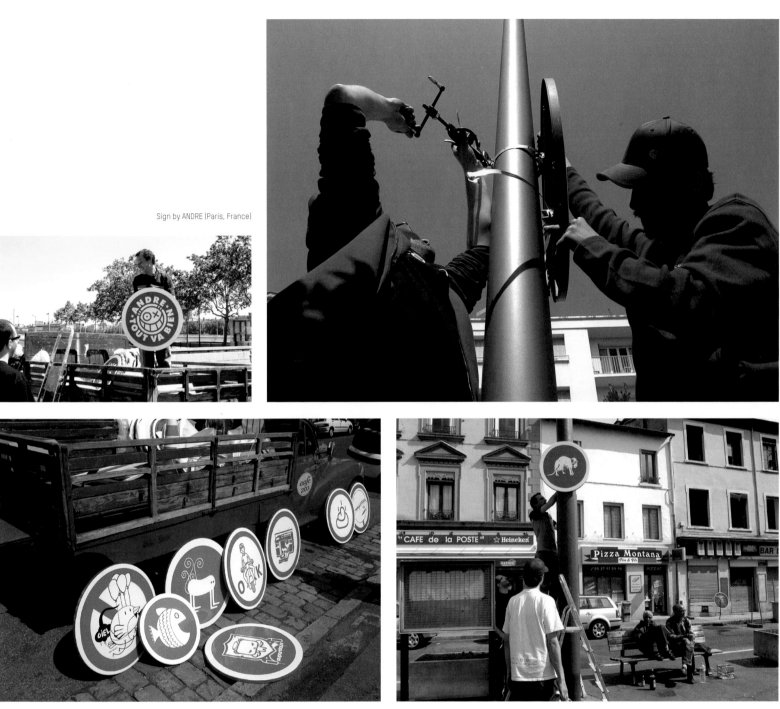

Sign by ANDRE (Paris, France)

Sign by ANDREW RAE (London, UK)

"PANOS, AN OUTDOOR EXHIBITION OF 105 FAKE ROADSIGNS" designed by 45 worldwide artists in the city of Lyon, France, 2004 Client: Unchi Leisure Center Photos by Kanardo

"For this collective outdoor exhibition, we attached 105 street signs to public posts and poles. The signs were made by 45 artists from all over the world and looked just similar enough to real traffic signs to deceive passers-by for a moment. In France it is illegal to create false traffic signs. Indeed, many people found it hard to accept the fact that our signs were not real, despite the fact that they were extremely different to the official ones. It was exciting to create a certain doubt in people's minds, to perturb their everyday life and furthermore give them the opportunity to view the works of international artists.

We made the objects from real traffic signs that had been left in the dustbin. The new adhesives were made with a special printer in which the print head had been replaced with a very fine blade that cut out the adhesive. It is almost magical to see this machine in action as it creates a cut-out starting from an Illustrator file.

We hadn't imagined the big impact this project would have. The signs hung on the poles throughout the summer, and in the meantime 150,000 people have visited our website. 800 of those have sent us emails - most of them congratulating us, but a few were indeed critical."

DOPPEL

Japanese artists and illustrators Yamao and Monmon, known as Doppel, have put forth a peculiar and suggestive style in the last years, absorbing aesthetic approaches as varied as propaganda posters, comics or wooden inlays. Not only their paintings but also their magazine illustrations often slightly resemble big-sized murals, an art form they are also familiar with. Both are used to painting as soon as they enter a room. *"I don't really work on sketching"*, Monmon says. *"What is important for me is to get inspiration by putting myself in the particular environment."* Yamao adds: *"It's basically different to capture an image in 2-D or in 3-D, so I usually develop the image in my head and then start realizing it directly within the respective dimension."* Still, there are obstacles to overcome:

"In 3-D, the compatibility between object material and drawing materials is often the problem", Monmon points out. *"Most of the time, the object I choose to draw on is not really meant for drawing. So for nearly any environment, choosing the proper drawing materials has to be well considered."* Actually, concentrating on architecture as a main outlet requires specific approaches in some ways. *"What I'm exploring right now is how spatial representation can be used as a means of producing optical illusions, like a sense of distance"*, Monmon says. Some issues, however, will probably remain forever. Yamao finds it scary to draw high up when he has to rely on wonky scaffolding. And Monmon finds it annoying that it is impossible to draw with spray when there is a strong wind.

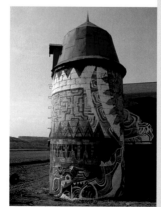

˝EyeRhyme 002˝
Wall painting, Old silo, Hokkaido, Japan, 2004

"It is quite exciting to see that your images can be projected very exactly even on a rough surface. Of course, it is important to set up the spatial proportion for the object, also regarding the surrounding environment. It is really a big job to draw on a huge wall. Three of us worked for three days on this object."

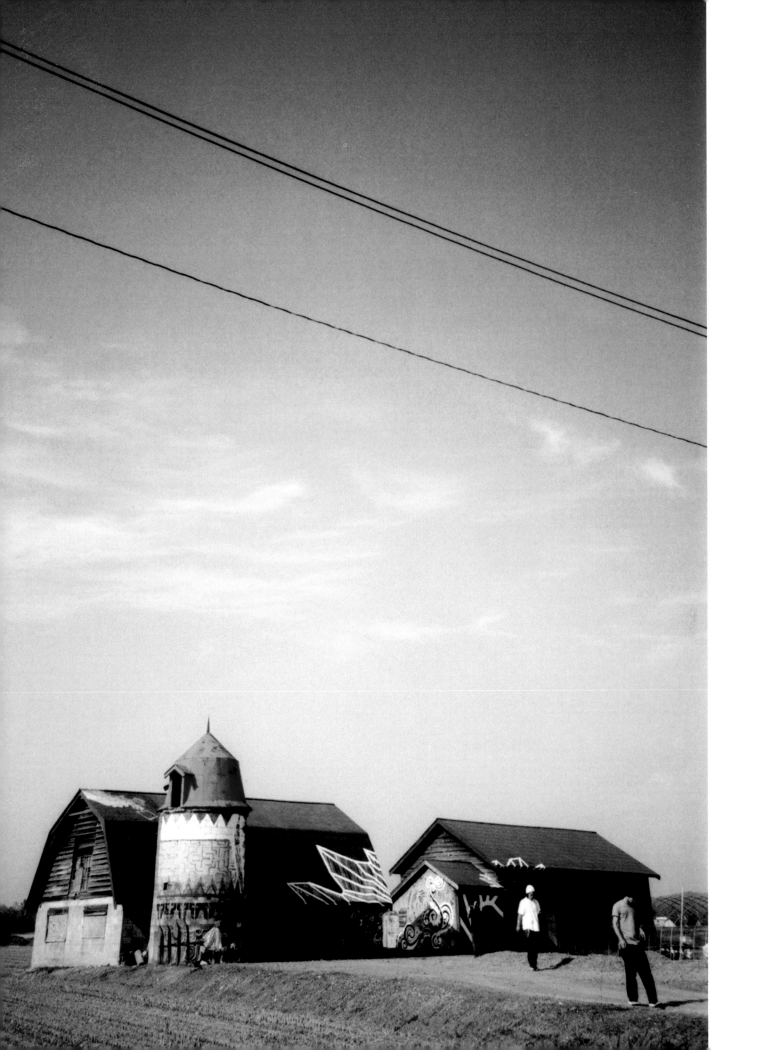

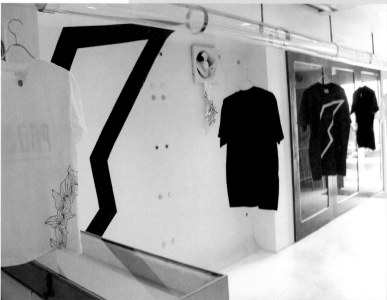

"Pavilion"
Wall painting, Horie, Osaka, Japan, 2005

"We did a collage style wall decoration for this cafe and gallery space by pasting paper prints of our drawings and afterward decorated it with adhesive tape. We learned to explicitly figure out the layout in order to maximize the effect of space."

"Mangosteen"
Wall painting, Mangosteen Cafe
Tokyo, Japan, 2005

"We painted the wall of a cafe which was about to close down. In a group of ten people, it took about a day and a half to finish it. It was pretty tensing to work with so many people. But when you have found your rhythm of painting, it feels like the paint comes right out of your hand."

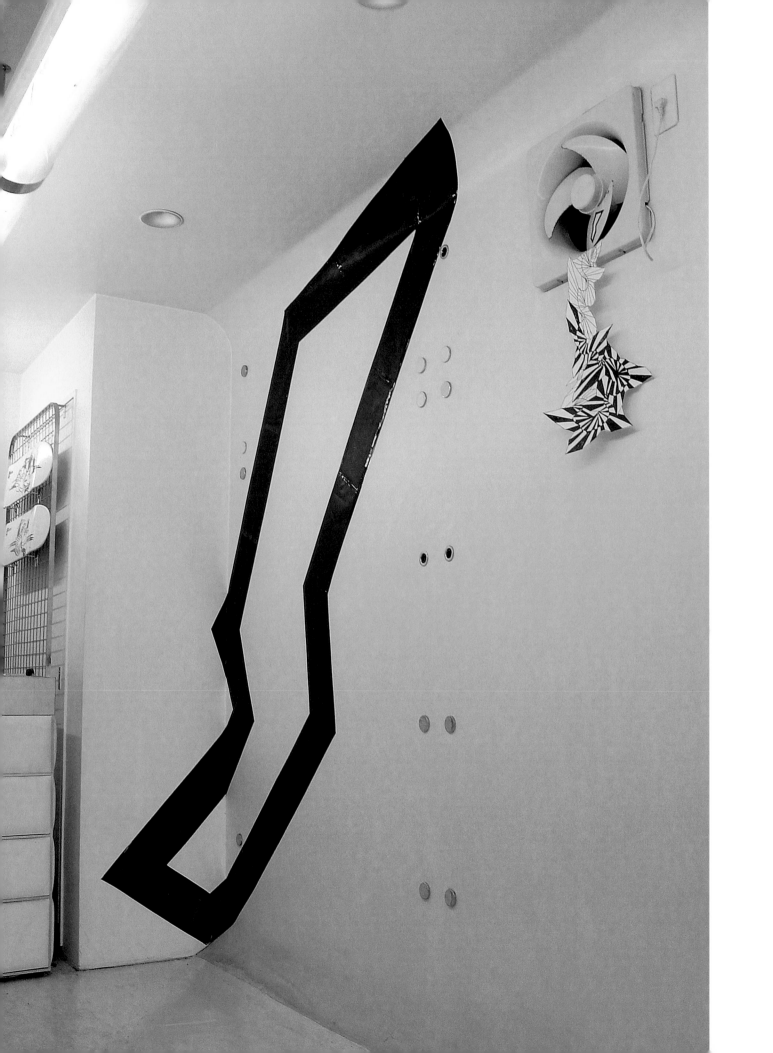

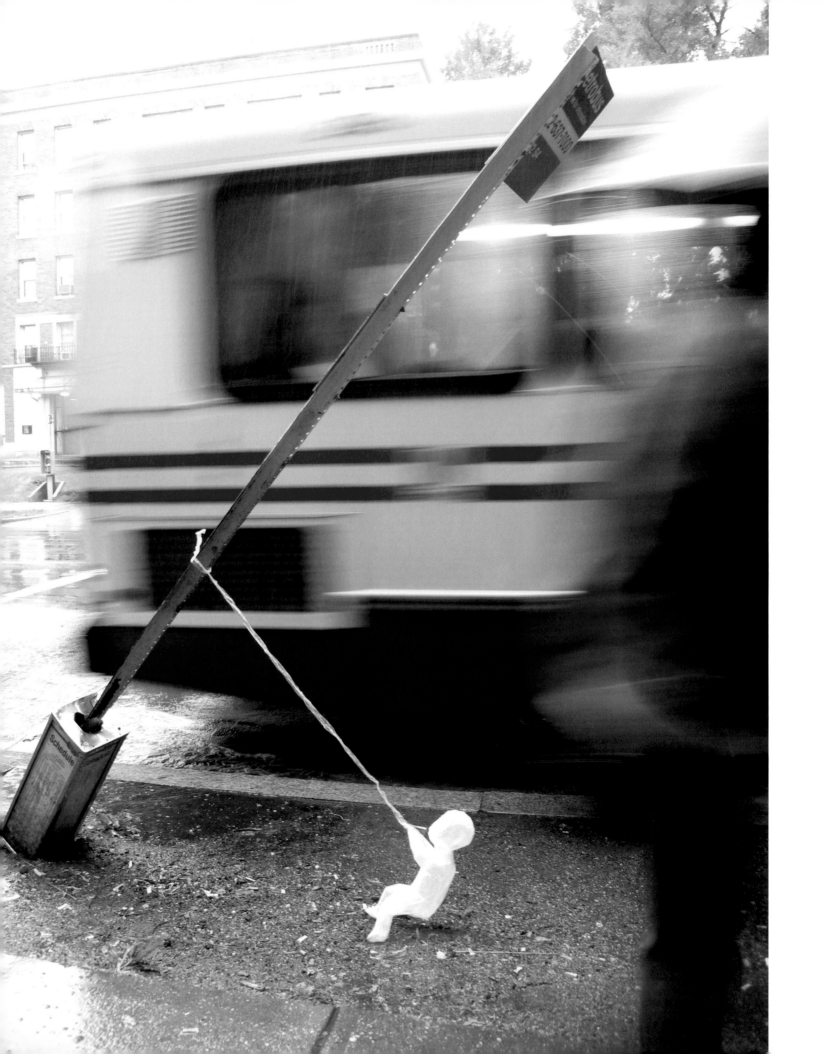

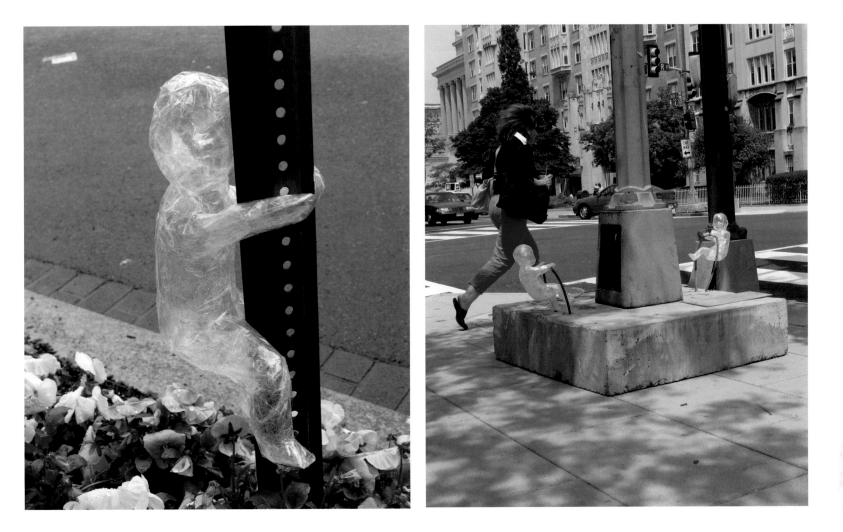

MARK JENKINS

Mark Jenkins has been creating street installations in the Washington DC area for many years now. His sculptural works, among them life-size figures, are made entirely of clear packing tape. *"The material plays a critical role in my installations. This medium is highly reflective and transparent and allows the objects to be seen from a far distance while at close range one can see through them. That creates a paradoxical effect."*

Sometimes, doing this kind of public art can be tricky: *"Certain areas in DC have high security. While the installations are not ‚illegal' people do find them to be suspicious. And of course everyone here is a little afraid that an unattended object might be a bomb and so I've had people approach me with these concerns."* Considering the city as a location for sculptures consistently changes the artist's view of the environment:

"Doing installations, I shed my ordinary perspectives about the city's infrastructure and let it instead become a playground for my works." He especially likes natural settings, such as beaches and forests, but his "dream come true project" would be to have the National Mall in DC between the Capitol and Washington Monument to do an installation.

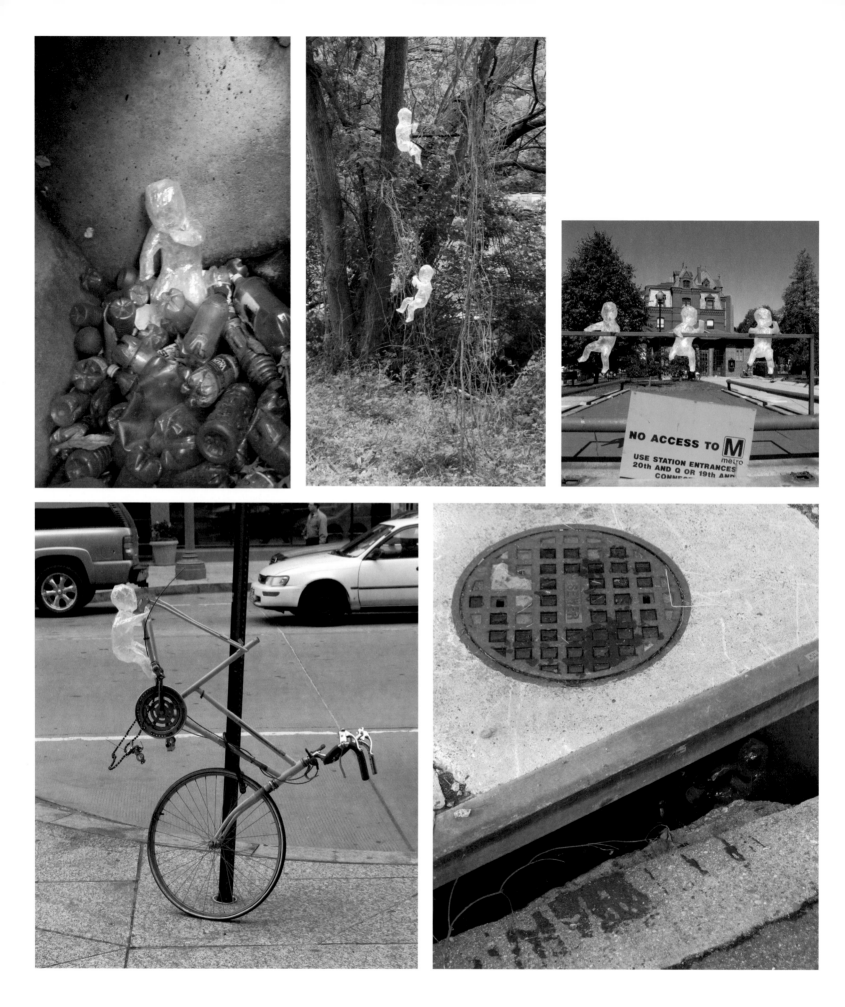

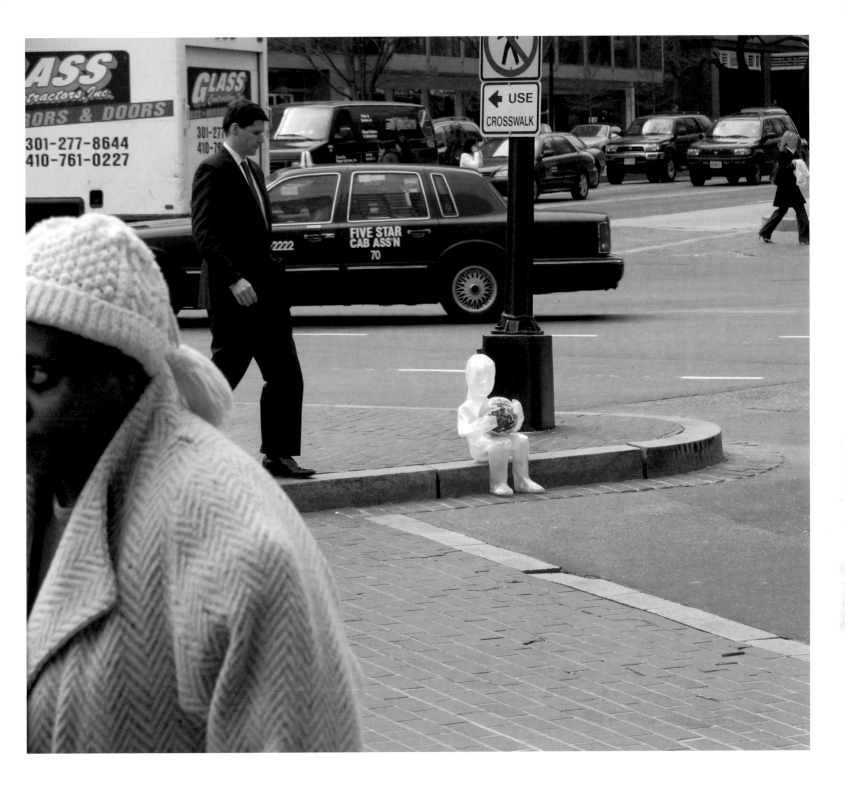

"Storker"
Urban art installation
Washington, D.C., USA, 2005

"The Storker Project is a species propagation movement, seeking to incite passers-by to adopt tape infants. The material is clear packing tape. The technique is cast-based, with post modification in order to pose the figures to interact with the environments in which they are installed.

Doing the installations showed me a lot about the way both urban and natural settings open up and absorb art works in a way that allows them to instantly belong. There is also something revealing about the public's reaction to these sorts of visual outliers."

PULSK RAVN

"Curiosity, play, humour and a twist of reality are very important elements in my work", says graphic designer Pulsk Ravn. With the Copenhagen-based design agency RACA, which she and the architect Johan Carlsson run, she claims a social design concept, *"not necessarily relating to terms like form, function and material, but considering a larger entirety. We believe that in order to create design of importance we have to relate to the social systems that we live in and are dependent on."* As a designer often working in public space, she thinks it is only natural to reflect on and absorb the surroundings of her work. For her, this approach also demands dealing closely with particular urban places she has strong feelings about, for example Christiania, a community neighbourhood in Copenhagen whose residents partially govern themselves.

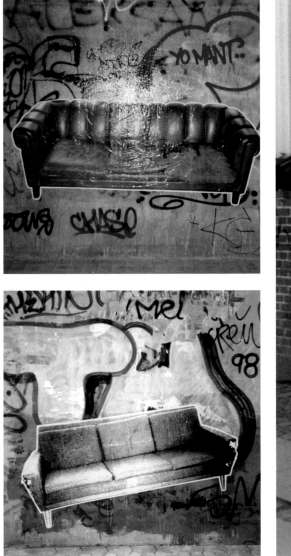

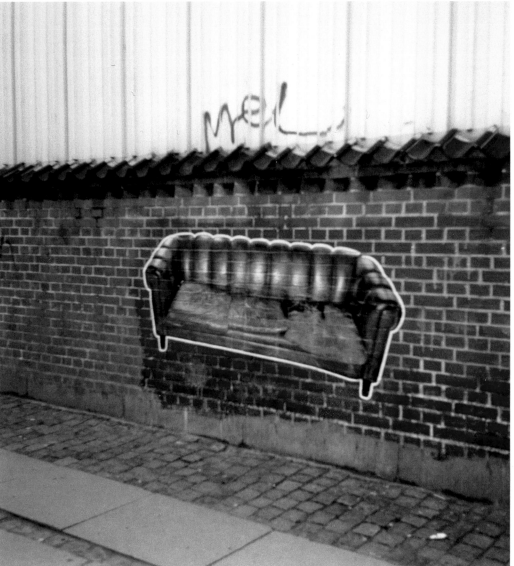

"BLANKT"
Billboard, part of the project www.women2003
Copenhagen, 2003

"One hundred Scandinavian female artists exhibited their photographic works on the usual commercial hoardings, placed in both the city and suburbs. The image I contributed to the exhibition stands as a silent comment to the high level of commercial visual pollution of the public space."

"SOFA"
(in collaboration with Jess Andersen/Badges)
Exhibition "Contemplation room"
Gallery Overgaden, Copenhagen, 2002

"These are black and white posters of sofas, scaled 1:1, silk-screen printed and cut. The exhibitors asked the artists to reflect on the theme of contemplation and urban existence, and in turn to act out the reflexions within the public sphere."

"Photo Suomi"
Site-specific posters for a photo exhibition
1% Gallery, Copenhagen, Denmark, 2000

"The posters emphasize the photographic media's ability to create an illusion of space. The result is a visual communication that not only focuses on the viewer but also on the actual situation to view, and the surroundings in which we are viewing. Instead of dictating a single perception, it invites you to take another view. To achieve this effect, I used big poster prints with an image scale of 80% compared to the real dimensions."

(>> next two pages)

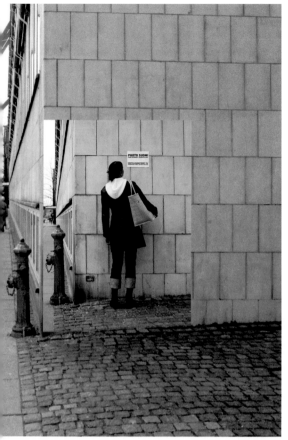
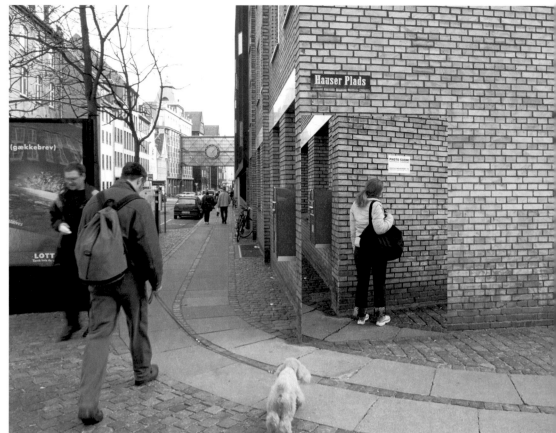
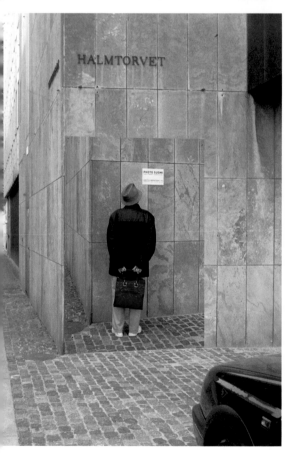
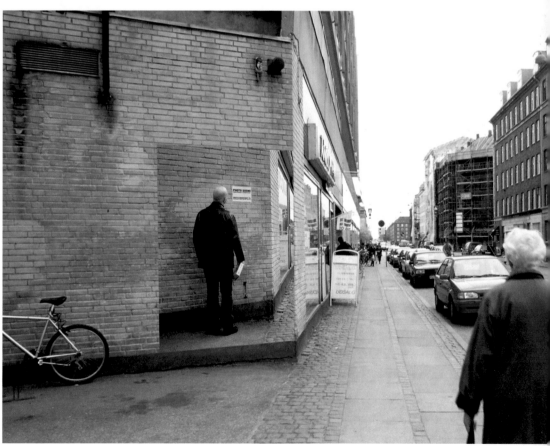

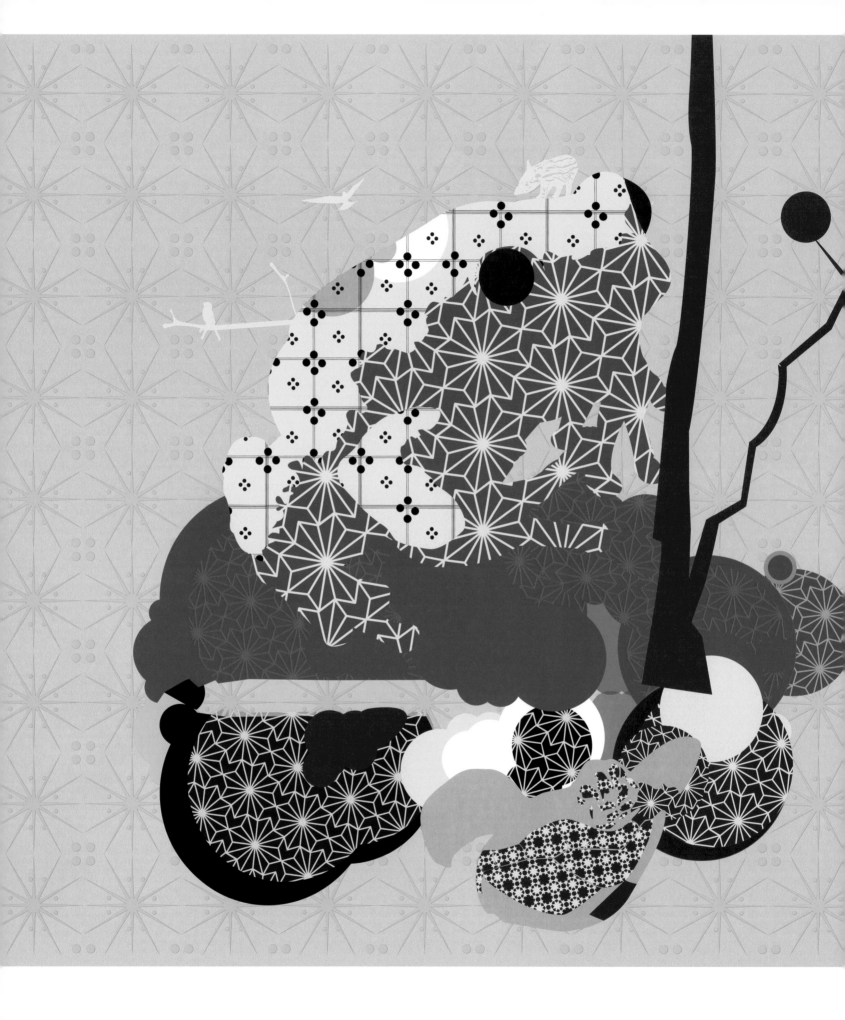

INTERIOR

The idea that there may be a link between illustration, graphic design and interior design is not the first thing that springs to mind when considering design. A few years ago you would not have been able to put this amount of words together on the subject, but nowadays there are countless examples of sophisticated lovingly detailed and highly illustrated rooms. It has a lot to do with the return of the ornament into the world of art and design. The hallmark of classic modernism, devoid of decoration or any sense of time, is now often regarded as a remnant of a puritan rigorism (or, in reverse, is scorned as snobbish), whilst decorative and playful design elements seem to be spilling into all areas of our lives.

But as can be seen here, we are not talking about an unbroken return to classic decor. The decor aims to free the wall from its function as a barrier and to give the beholder a perspective that breaks out beyond formal space. When artists describe their work they often talk about their illustrations as entrance portals to another world. Sophie Toulouse shows us a fictional island-state in which a kind of glamorous anarchy rules. The Venezuelan street artist Masa paints a hotel room so that the guests feel surrounded by the aura of an Amazon rain forest by night and by day. "Travellers spend most of their time in rooms that are very similar to one another," he says. "Airport and hotel rooms look the same all over the world". In order to break this monotony he wants to individualize the rooms through his art.

The desire to challenge the designer monoculture and differentiate rooms is one of the main reasons for getting graphic artists involved in interior design. The function of the room is always decisive: The decor of the walls of a bar can certainly be a bit classier than the public which frequents it; in comparison, the entrance hall of a technical college demands long-term visual guidance for people entering, as the Dutch Designer Fons Schiedon demonstrates perfectly in this chapter. The cultural background of the public plays an important role. The patterns on the cashmere blankets and wallpaper designed by Abigail Lane of the Showroom Dummies are formally, classically designed – the fact that some of her motives turn out to be insects and skeletons should please mainly urban, cynically aware buyers.

The presentation of sales showrooms is increasingly left to artists and graphic artists these days too. The fact that the lifespan of a backdrop for a demanding trendy consumer environment is comparatively short is just part of the deal. The advantage is that the designer can utilise it as a chance to be risqué. Nicola Carter and Luise Vormittag from the British Studio Container were delighted to receive a carte blanche when designing the backdrop for a car presentation; not the easiest of design tasks to say the least. They used production conditions in order to transform the car into a bizarre fairy tale coach, presenting persiflage on the topic of a woman on a car bonnet.

WESAYHI

"Currently, WeSayHi is simply me saying hello", Gary Horton remarks. *"The label allows me to express myself and put an umbrella over my showcase of commercial work and experimental ideas."* He creates communications for clients such as Nike, Nokia and Toyota. But he wants his studio to grow, to become a platform for artists and designers some day.

When he was at art school, he remembers, the hardest thing for him was to settle into one discipline, as he just loved to work on everything. *"But that's why I thought graphic design was a good move - it's a discipline that can be applied to anything."* Motivated in this way, he soon got used to crossing the boundaries of his home discipline, without ever leaving it behind.

"Personally, when presented with an opportunity to work in a space that is already defined, I find the outcome tends to be a reaction to that particular space. I work with what I've got."

But there are some spaces left which he would particularly like to work with.

"I have always been inspired by big spaces. The Tate Modern in London, for example, has unbelievable possibilities! And I have always wanted to do something with an empty aircraft hangar, maybe because I am so small. I would also like to team up with Christo and cover Glasgow in blue cloth. Apart from the East End, of course."

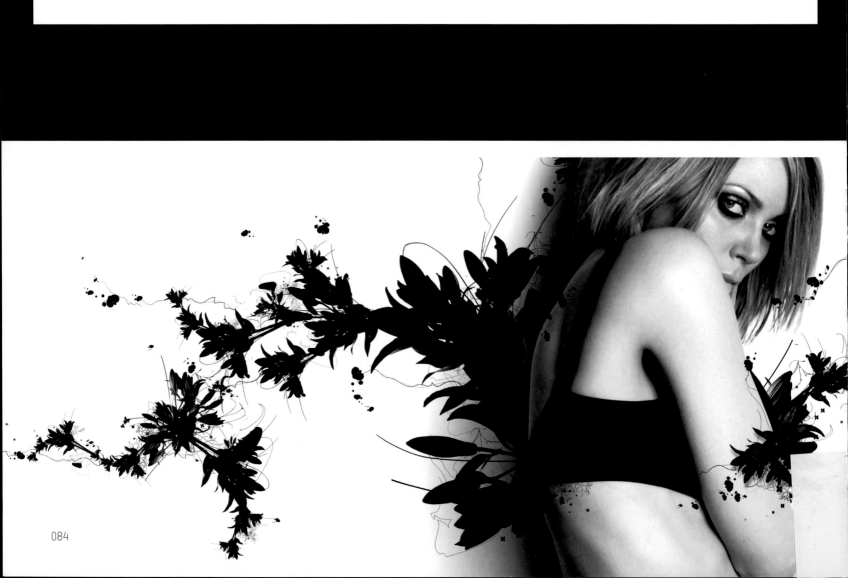

"Belfast Nights"
Inheritance, Inc. Belfast, Northern Ireland

"'Belfast Nights' is an experimental collaboration with Grant Dickson from Nothing Diluted. We were invited to create an installation for a Creative Ad Studio, utilizing a lightbox. They wanted us to bring a new dimension to their space.

We decided to create an image that added a new organic and emotive feel to the very industrial location, but at the same time leaving a lot of space in the image to let the form serve its function."

"Fleurs Noires"
WeSayHi Experimental, Prestwick Airpor, 2005
Photos by Paul Crowther from revolverphoto.com

"Fleurs Noires is a self-motivated project that started as a reaction to the use of ‚black flowers' as a recent graphic trend. We wanted to experiment with this cliché by actually painting real flowers black and photographing them in the studio. We then took these images and created several ‚growing' compositions, introducing a solitary figure that becomes enveloped by the flowers. We wrote the message ‚Black Flowers, they are everywhere' in French to again emphasize the fact that they are physically everywhere. Also, we added a sense of fashion to the typography and communication.

The logical progression was to put the flowers back into an environment. We utilized a corridor of light boxes in a local airport that was being refurbished and thus not in use. This brought the project to life as it needed to be used on a large scale to convey the message.

I learned that sometimes it is best not to wait to be asked to realize an idea."

SOPHIE TOULOUSE

Most of Sophie Toulouse's work is about her virtual community "Nation of Angela" (NOA), a utopian island where community ideals coexist with glamour, and punk meets with Victorian chic. While in a manifesto-like statement about NOA she charges the world outside with being *"a bad dream of a modern society in chains"*, she is far from blaming materialism but rather calls for *"materialistic anarchy"*. Following the situationalists' vision of a "post-spectacle society", she has strong feelings about sweet shops, delis and supermarkets. *"Every time a new place has to be designed,"* she says, *"a new situation arises, too"*. Even though she has become familiar with arranging big spaces and designing big walls, she still remembers doing huge Xerox prints for the first time: *"They had to be printed in up to six pieces that didn't match at all. It was a real nightmare."*

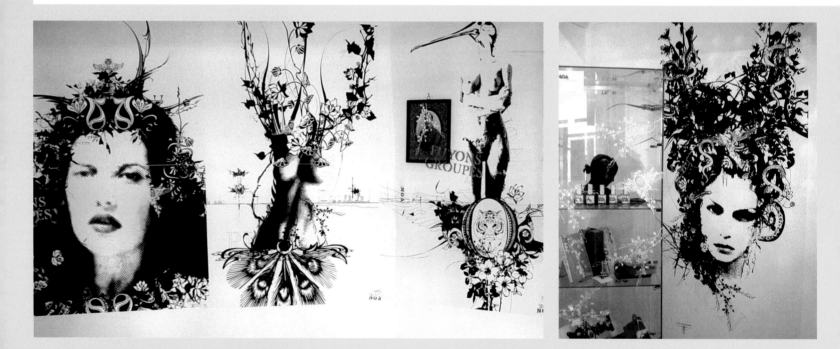

"Nation of Angela - Mass Escapism"
Artazart bookstore, Paris, France, 2004

"For this exhibition of my ‚Nation of Angela‘ works in a Paris bookstore I had to find cheap solutions to fill up plenty of space. I used silk-screen printings, photocopies and a lot of pattern-decorated objects like bottles, bags and even a skateboard."

"Saturday morning"
Josée Bienvenu Gallery, New York, USA, 2005

"Again, I wanted the observer to enter my ‚Nation of Angela‘, with the images mediating relationships between people who take part in my utopian concept."

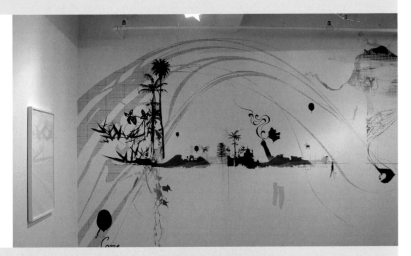

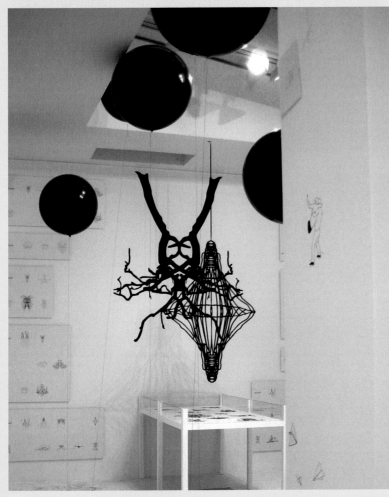

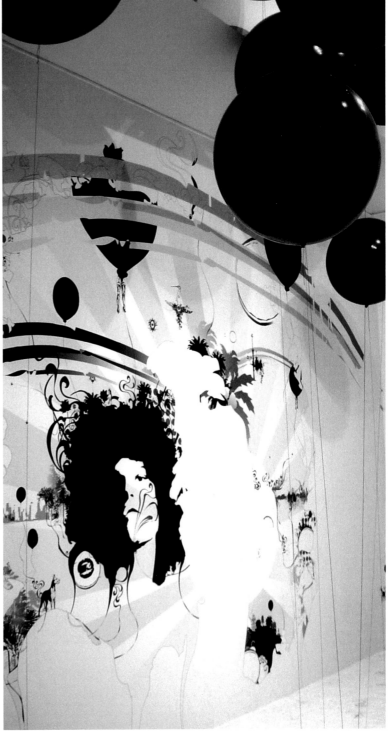

"Draw!"
Wall painting, Galerie du Jour Agnès B
Paris, France, 2005

"I wanted to prepare the wall in a way that would allow the viewer to virtually enter the ‚Nation of Angela‘, my own utopian island state. The patterns were printed on a special kind of paper and glued directly to the wall."

CLARISSA TOSSIN

A' Design is Clarissa Tossin's *"one woman design studio"*, located in São Paolo, Brazil's industrial and trade capital. As a graphic designer who always tries to push her discipline beyond the limits, she likes to be confronted with *"unstable boundaries and hybrid results, everywhere and anywhere"*. As a reference, art and architecture have always surrounded her creation process: *"From a personal perspective I would say that Lúcio Costa and Oscar Niemeyer influenced me a lot with their visionary ideas embodied in the city of Brasilia. Living there for ten years during my adolescence is somehow still echoed in my work."* Like an architect, after sketching in 2-D, she sometimes does some hand-made models of the spaces she is going to design. *"Or I examine them on the basis of 1:1 prints. But that of course depends on the size of the project."* Always in search of unexpected answers, she believes in the advantage of working in a free, explorative way: *"No play, no gain."*

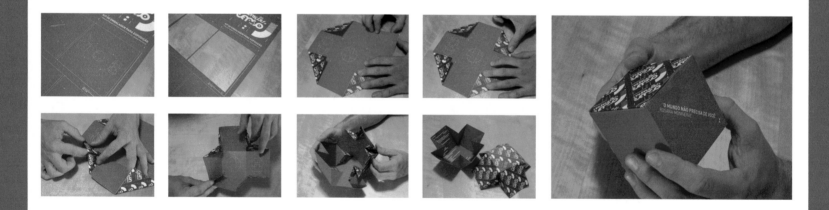

"Directions on the Back"
Galeria Vermelho, São Paulo, Brazil, 2003/2004

"Since 2003 I have been working with the Vermelho art gallery, and ever since we have been trying to develop communication design projects that would function both as communication pieces and autonomous artworks.

'Directions on the back' consists of a packaging proposal for the gallery's exhibition spaces. The artist Rosana Monnerat occupied the ground floor with her sculptures, while Edouard Fraipont's photographs filled the second floor. The design was developed as a double faced poster that functions as a self explanatory assemblage kit, teaching the spectator how to make his or her own packaging.

Using a 1:100 scale, the poster develops into different packaging, each one revealing the name of the artist on the top and all information about the artworks contained. The traditional Japanese origami technique used enables each packaging to be easily unfolded and folded again."

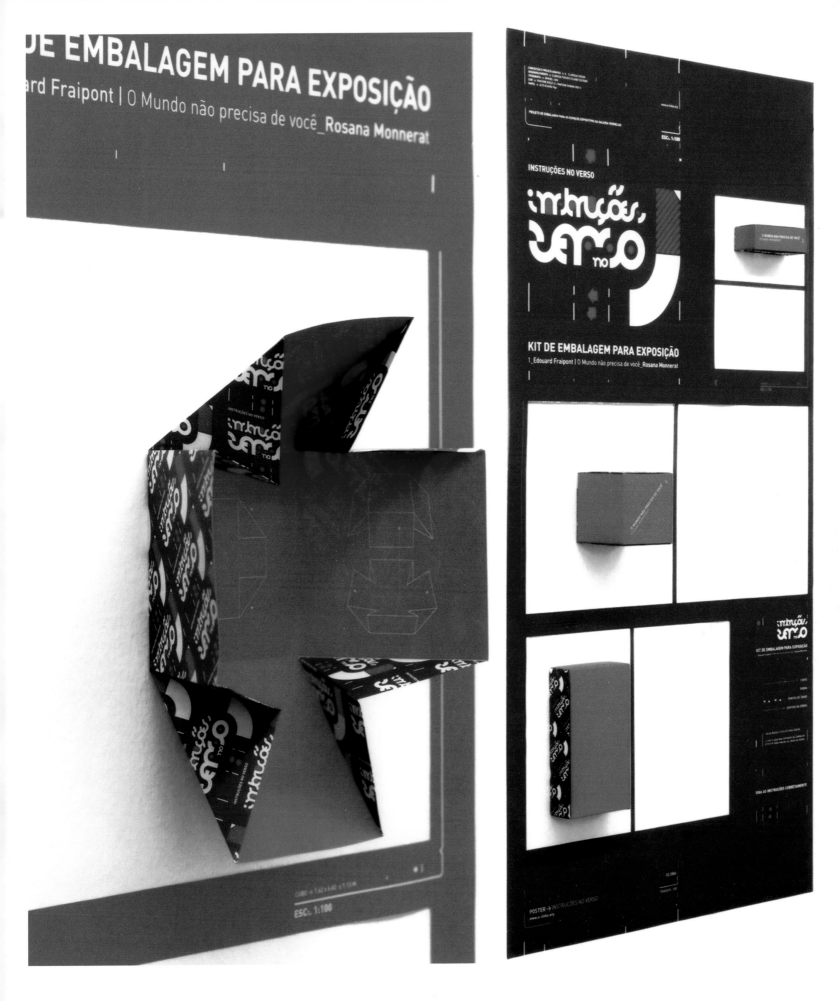

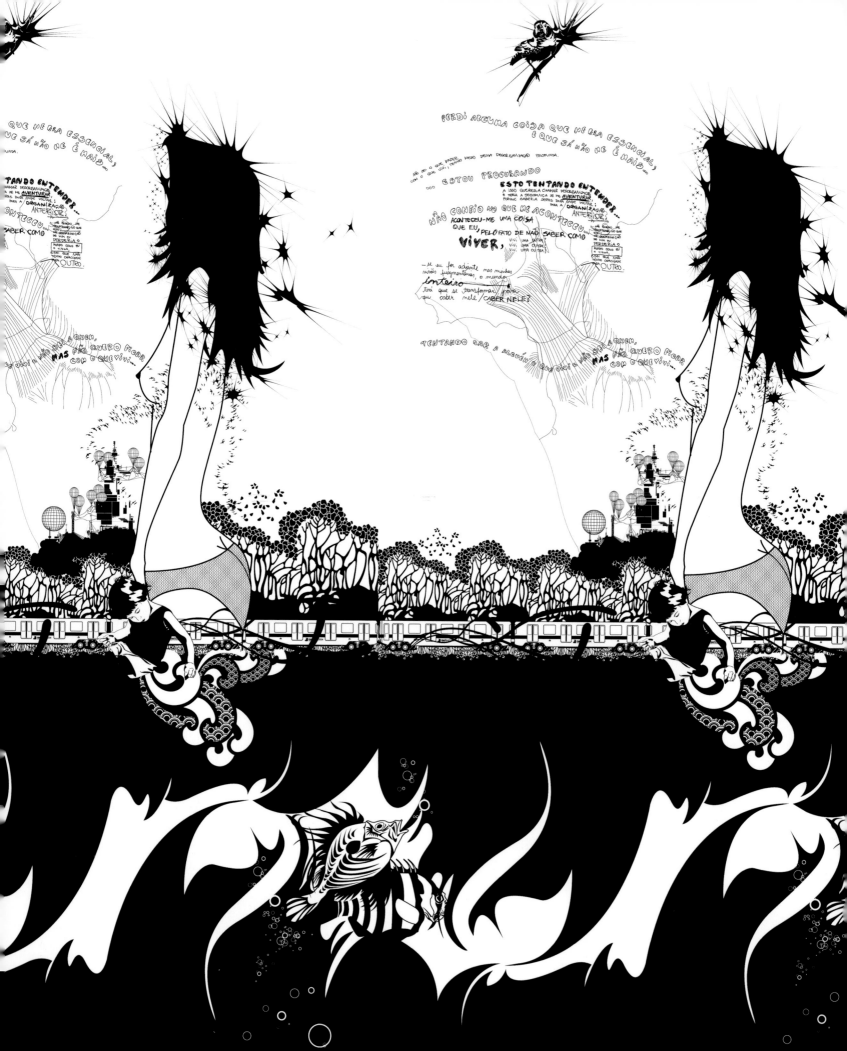

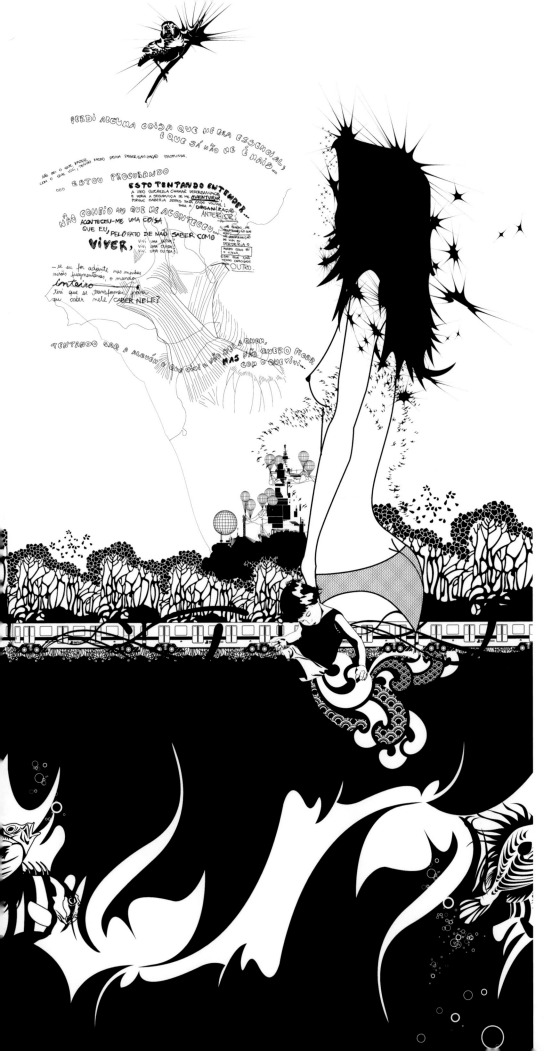

"Urban Wallpaper"
Resfest Brazil, São Paulo, Brazil, 2004

"In Brazil, there is traditional photographic technique called ‚lambe-lambe'. It is mostly done by street photographers who shoot the picture with special self-constructed cameras that even contain a simple darkroom where they develop the photos. The results are simple but expressive portraits, sometimes a little blurred.

Urban wallpaper is a set of three ‚lambe-lambe' posters, applied side by side just as wallpaper would be. Because I incorporated the inherent limitations of this process in the design, it became a very personal piece eventually. I was surprised that a simple black and white image made people stop to read the text. Lambe-lambe rocks!"

"Robot friend"
Paul Smith men's wear shop
Covent Garden, London, UK, 2003

"The cardboard robot started life as a work produced for an exhibition entitled ‚Humans vs the Robots'. After the show I was asked to exhibit it in the window of Paul Smith men's wear shop in Covent Garden, London.

The robot's head turns from side to side, powered by a fan motor. The antenna on his head also moves, being connected to a solar powered motor. I had to find a way to prevent the fan from overheating and setting fire to the cardboard. After having researched the electronics necessary to alter the fan, I found out it would be much easier to connect it on an everyday household timer."

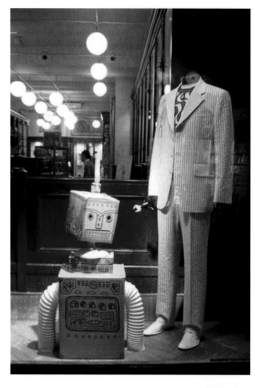

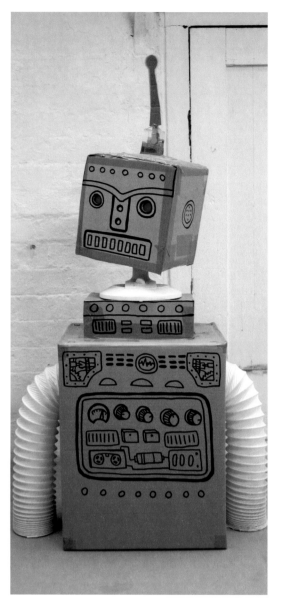

ANDREW RAE

"While doing the handicrafts with paper, cutter and glue, we learned to be highly patient."

In their distinctly naive and absurdist style, Andrew Raes drawings encompass a variety of subjects such as urban and pop culture, odd devices and somehow mythical creatures. *"It is essential to all my work that it comes from a childish, playful place"*, he says, *"whether it is irreverent, stupid, funny or just plain weird. I always try to enjoy the work and keep it playful."* To keep it that way and to give it the characteristic hand-made look, he prefers to use everyday materials like permanent markers or cardboard boxes. Dealing with spaces, he always models *"the real thing in 3-D after a very cursory sketch"*. He works with the illustrators' collective ‚The Peepshow', and their studio in Bethnal Green, London, is one of his favourite spaces: *"But that has more to do with the people in it than the space itself."* However, there are other places that turn up in his dreams and thoughts a lot, particularly when he is imagining locations for drawings. *"One is the car park of the hotel my Aunt and Uncle used to own in the Mull of Kintyre. Another is the old chalk mine near my parents' house in Croydon."* Though he doesn't consider architecture as an important influence on his design process, he is very fond of a particular building: The Elephant Tower in Chatuchak, Bangkok. *"Apparently, the owner believes he was blessed with the ability to earn money by the Elephant God."*

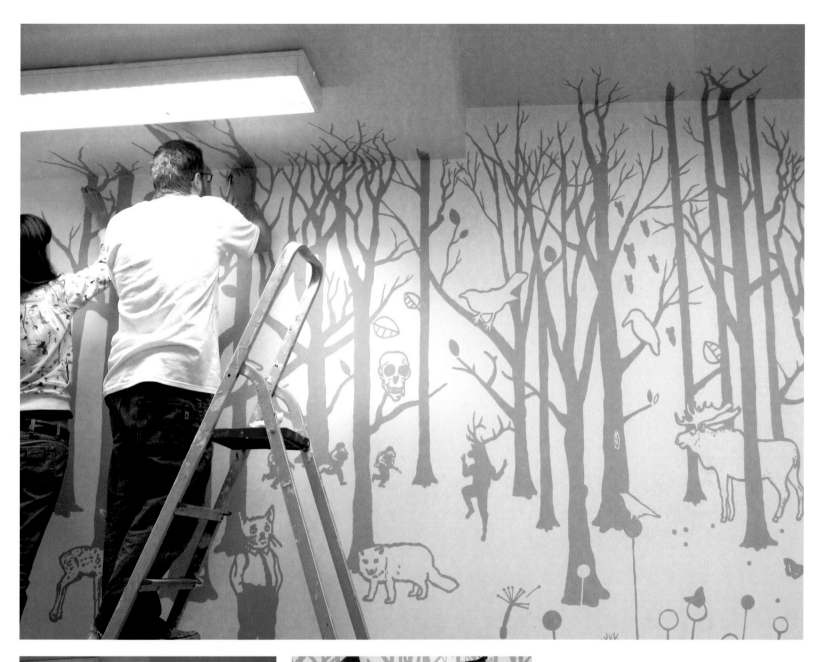

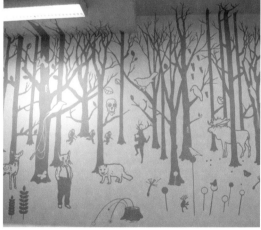

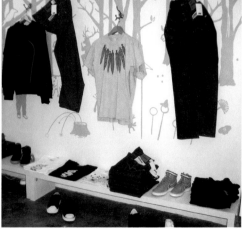

"Beneath"
Mural, Beneath fashion store
Stockholm, Sweden, 2005

"This mural, at the same time being a corporate identity pattern, was made for the Stockholm fashion store Beneath. Working with Chrissie Macdonald, I originally planned it to be a mono-chrome background for the clothing to be hung in front of and around it. We planned it to be black on black, using gloss and matt finishes, but on seeing the space we realised it would be too dark and oppressive that way."

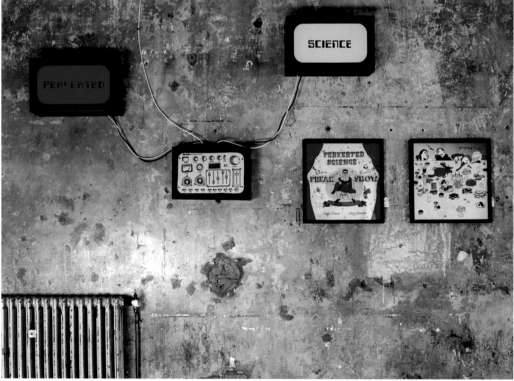

"Perverted Science"
Mural, dreambagsjaguarshoes bar
London, UK, 2003

"For an exhibition marking the fourth anniversary of the ,Perverted Science' club night, I created a mural and lightboxes and hung framed enlarged artwork produced for the flyers over the past four years. The wall design accompanied original works by artists from the Peepshow collective on the theme of perverted science. I made photographic reproductions of the flyers produced from the original computer files and used modified speaker cabinets for the lightboxes. The mural was projected and painted with emulsion paint. I learned that doing an exhibition with others is less daunting."

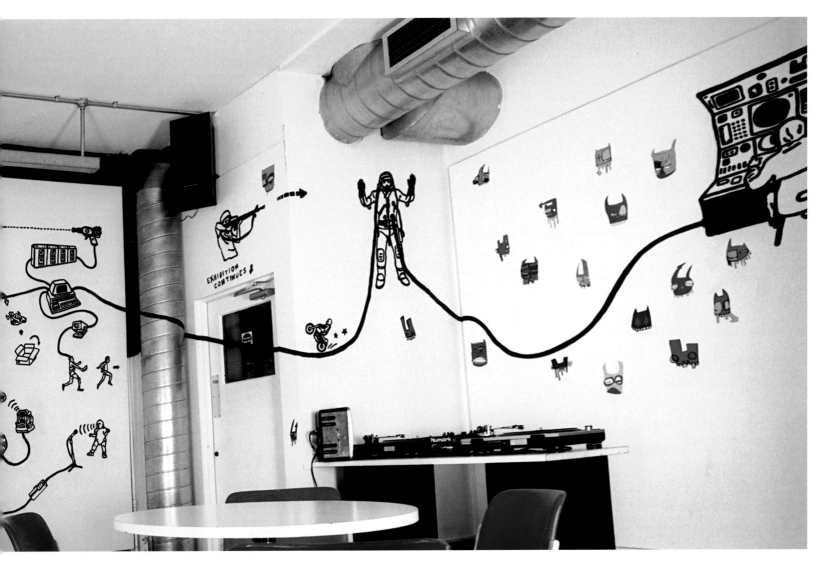

EP

Graphic designers Pipa and Carol call themselves eP, the abbreviation stands for Extended Play. The name is part of the programme: *"Play is everything"*, Pipa says. One can conclude that credo from the images and patterns they weave into another, combining playful ornaments with abstract patterns. While the single elements of their graphics always interact with one another in an apparently dynamic way, they could think of even increasing it: *"We have always had this dream of creating animated wallpaper."*

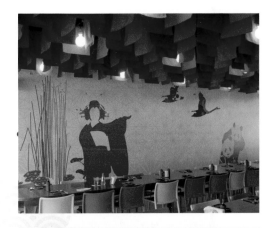

"Shimo"
Shimo Restaurant
architect: Marcelo Rosenbaum
São Paulo, Brazil, 2002/2003

"We were commissioned to create the identity of a Japanese restaurant that had to reflect both contemporary and traditional Japanese culture. We wanted to make it look like it could be in Tokyo nowadays, so we did some research on traditional and contemporary Japanese iconography and created the logo in the form of a stylized character. We first wanted to print the restaurant's menu on the huge three story wall. But, having the logo in mind, we decided to illustrate it with a kind of Manga, taking up pop cultural themes and at the same time resembling traditional Japanese illustration."

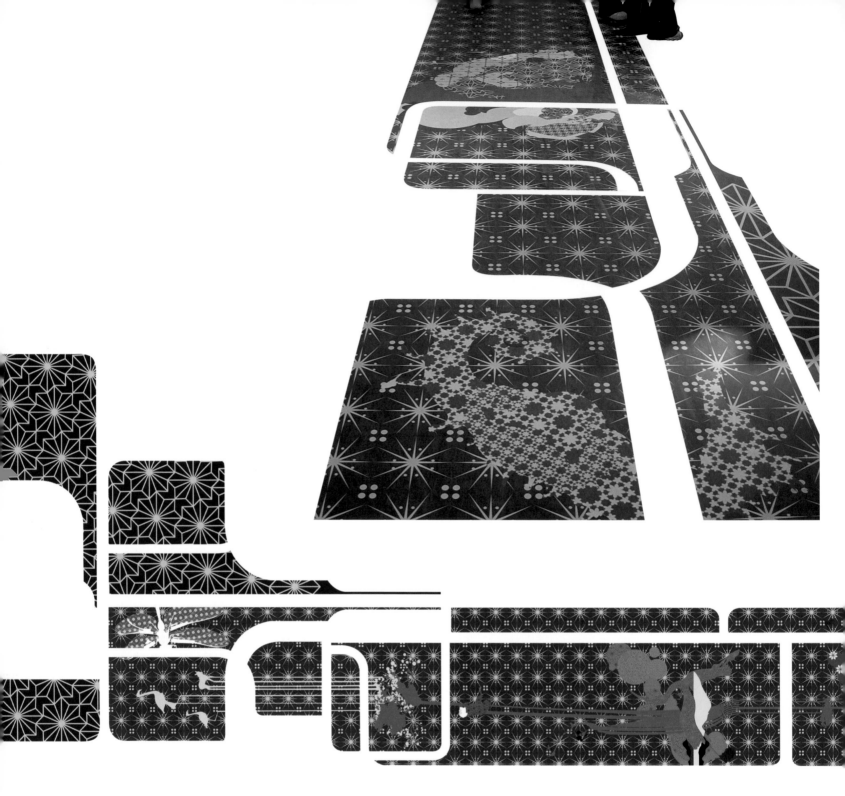

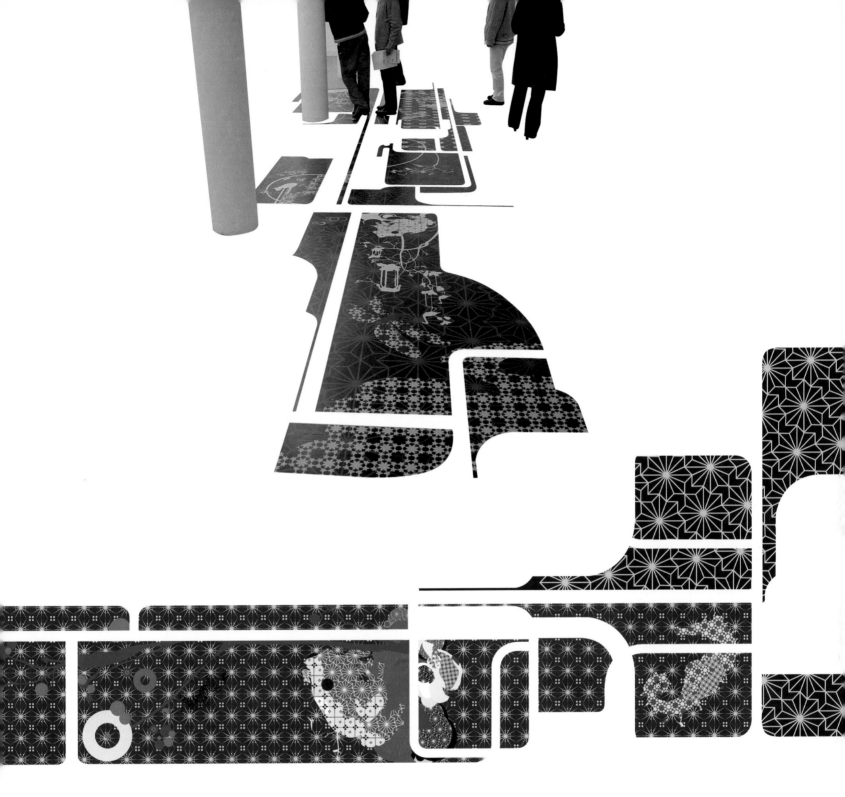

"Cut-up garden"
Selfridges department store, London, UK, 2004

"We had to create ten illustrations for a show about Brazil at Selfridges. Having just finished Shimo, we didn't want to make just hanging posters, but wanted to further develop the idea that you can walk in (or on) design. At this point, we came across the paving designs by Roberto Burle Max, a great artist, architect and botanist from the sixties. We were really inspired by them, so it is mainly a homage to his work."

YURI SHIMOJO

Whenever Yuri Shimojo is painting a mural, she tries to tell a story that is related to the place and at the same time personally inspires her - *"so that the artwork extends beyond simple pretty designs and patterns."* In her murals she strives to combine the freedom she enjoys as a fine artist and the communication skills she has developed as an illustrator. For her driftwood works, she undergoes an even more meditative process of imagination: *"I don't initially think about what I want to create - I just collect what I can, then I live with the collected pieces of driftwood for 24 hours, to spend day and night with their natural form. Then suddenly I have revelations, and the driftwood starts to look like E.T. or a Lamborghini Countach."*

Considering the strong feelings she has about places like shantytowns or children's wards in hospitals, she wants to create work that can *"inject some positive light into environments that tend to be dark and gloomy."* Correspondingly, her dream project would be to design a playground.

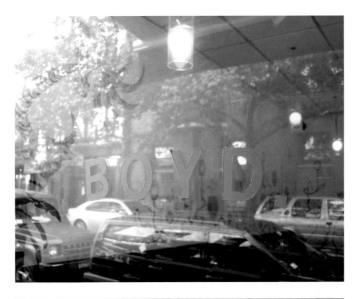

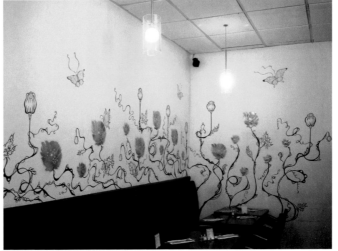

"Boyd"
Mural, Boyd Restaurant
West Village, New York, USA, 2005

"Given that it was a restaurant, I had to carefully choose the perfect colours to comfort the visitors. To make it a very personal space, I composed motifs from episodes of the chef's childhood memories in Thailand. I used water-based house paint and stencils."

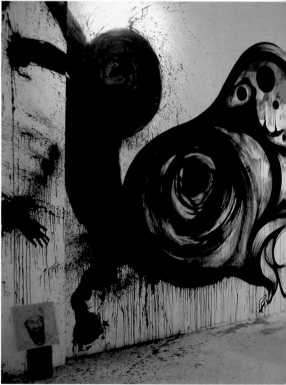

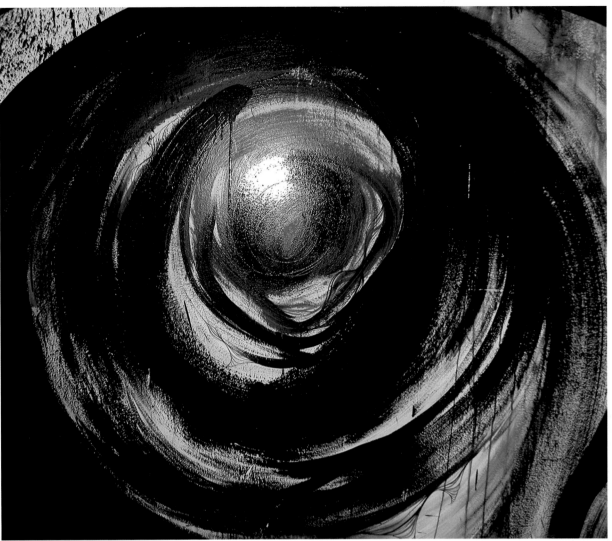

"Better Tomorrow"
Artwork for the group exhibition
"Better Tomorrow Today"
Supreme Trading's Annex Galler y
Williamsburg, Brookly, New York, USA, 2004

"This is part of a sequenced mural. While the paintings as a whole deal with how to achieve a better tomorrow, my section represents emotional confusion that exists in today's society. I worked with charcoal, sumi ink and house paint."

FONS SCHIEDON

"For some projects", Fons Schiedon says, *"material is a leading component. When the application is very specific and the role of the design is extremely focused on a particular ‚function', the material determines the basic direction of the design."* When working with architects or sculptors, he feels that even a relatively simple project can come with a lot of technical demands that also have to be realized on the level of the graphic design that is involved. Luckily, he conceives the realization phase as *"a game of constant searching, building, changing, breaking and reconstructing. It is playing to create - and playing with the elements you have created in order to create something else."*

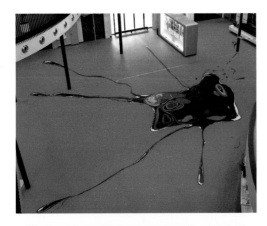

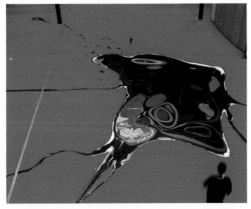

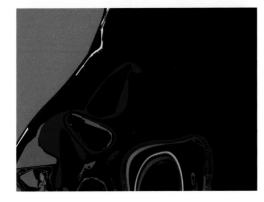

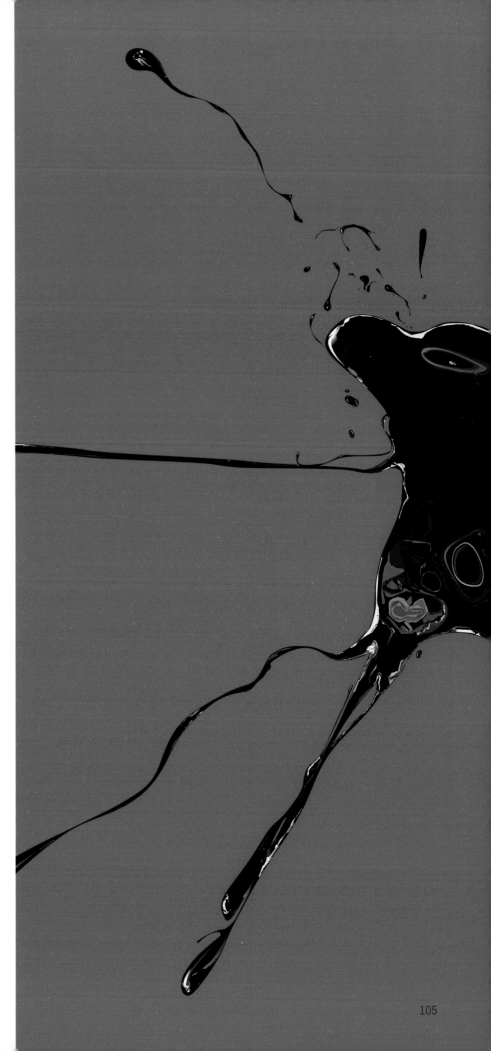

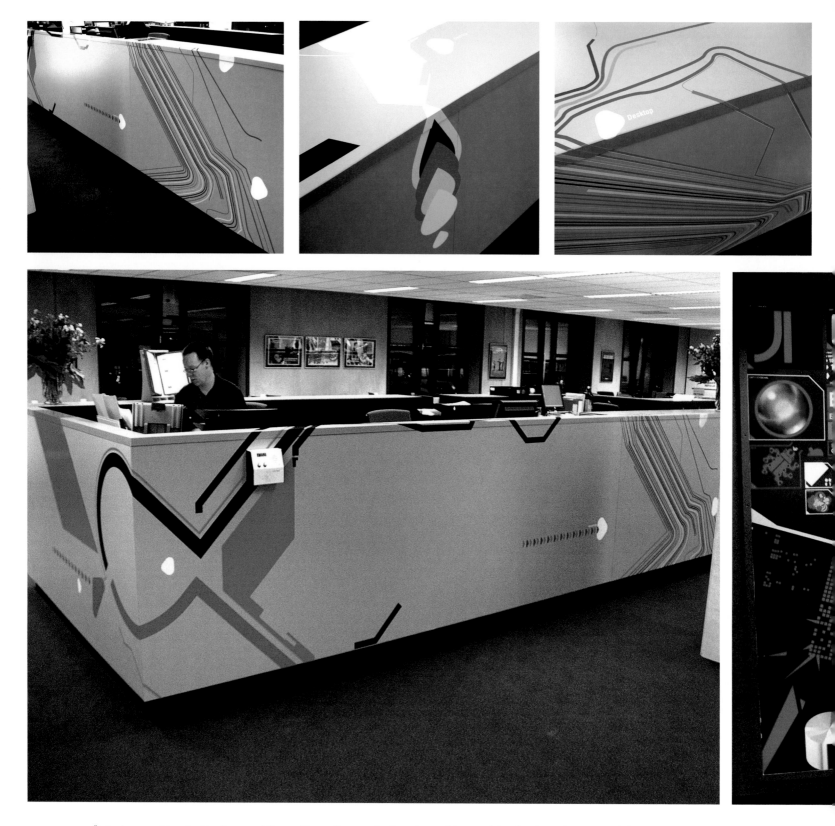

"Interior graphics for the floor and the library of ROC van Amsterdam"
ROC van Amsterdam / Workshop of Wonders
Architecten, Production: Shop Around
Amsterdam, The Netherlands, 2004

"According to the interior architects, this school building for technical studies had to be simple and balanced. At certain major locations though, they wanted powerful expressive images to counteract the minimalism. Additionally, the images had to have some level of abstraction to be able to maintain their effect over the years. For the floor, I chose to create a drawing of an oil stain, oil being a major natural resource and thematically connected to the school's programmes. It created a huge visual impact on the bright red floor, spreading across the space of the main hall. Viewed from a higher floor, it appears organic and fluid. Viewed from close up, it doesn't seem that organic any more. Instead, its coloured shapes appear detailed and technical.

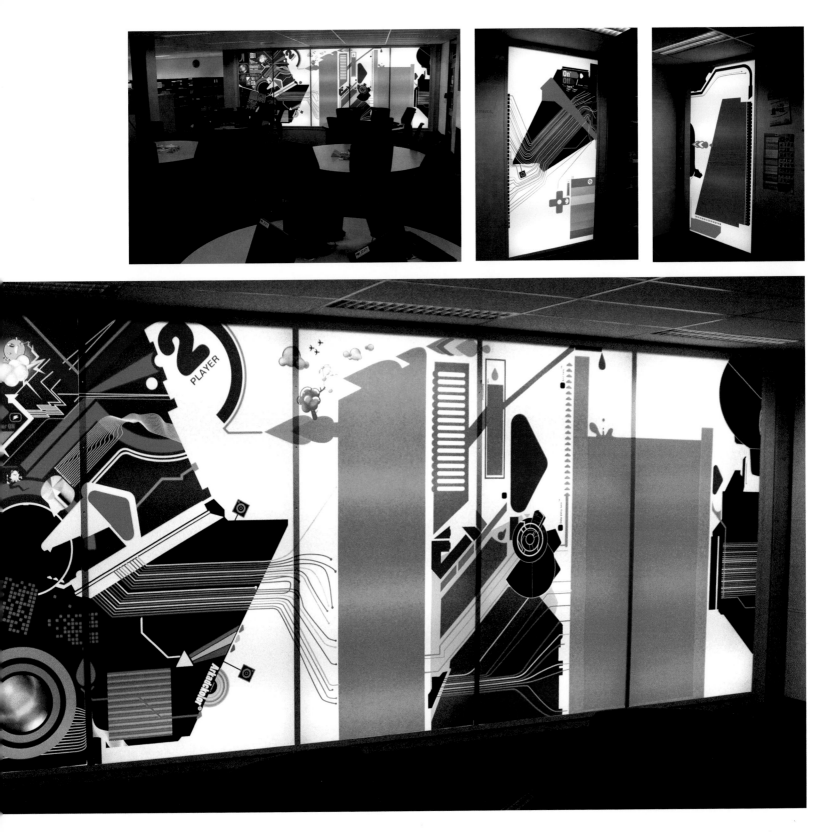

I created the design using Illustrator. For the floor, it was printed on thin fabric using a thermographic press. On the location the design was assembled and glued to a white basic floor. After this, red epoxy was applied to the surrounding surface. Another layer of transparent epoxy was added to cover the whole floor. The impact of scale is massive. Trying to visualize the effect of a design made on a 19-inch monitor, blown up to over 20 metres is something you only learn from actually seeing it happen. It's not just a bigger version of the design ... it is rather its correct size.

The designs for the light-walls and desk in the library respond to the fact that this library is now a network of computers rather than a collection of books. Images from the collective memory about the early days of computers are combined with newer associations of personal technology, altogether creating an arcade-like chain of visuals.

The design was printed on self-adhesive foil and applied to the plastic panels. The graphics on the desk were machine cut into shapes and applied afterwards."

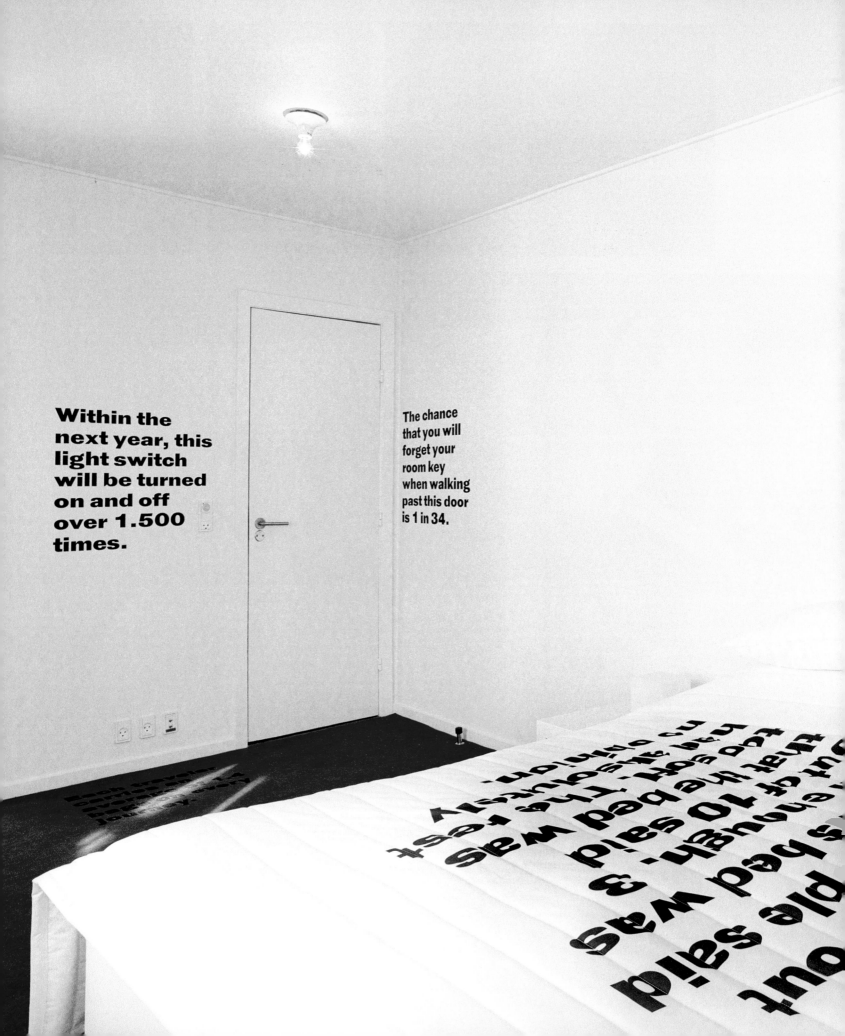

E-TYPES

The Copenhagen-based agency e-Types designs corporate identities and advises companies and organizations on identity and brand strategies. Their members also design and develop typography. One of them, Mathias Jespersen, sees no obstacle in switching from traditional graphic design to 3-D for particular projects. *"It's all about the space that is left unused. By extending to another dimension, you just get more space."* Jespersen doesn't believe that questions concerning the material are more important in 3-D. *"Anyway, material is everything. Our approach to traditional graphic design is always to consider how the content is best presented in form. The format, the kind of paper, ways of folding, embossment or engraving, varnish - all these are values that materialize the media."*

Since communication via typography is his main business, Jespersen has a very special dream project: *"I would like to paint some of the German autobahns in fluorescent paint so that from the moon you will see a big M - for Mathias."*

94% of all hotel guests expect no surprises when entering their room.

One flush of this toilet uses 12 litres of water.

Self-confidence
is in the typeface

...typeface and the quali... appearance is something complex which form... itself out of many details, like form, proportion, ductus, rhythm etc. If everything harmonizes, the total result will be more than the sum of its components. The only reliable basis for the design in a type is a positive feeling for form and style.

My expensive Quartz watch once belonged to JFK

...brown fox jumps over the... and feels as if he were in the heaven of typography

specia te maki

"Room 304: Spades – The Royal Garden"
"Room 414: Diamonds – The Crown Jewels"
Hotel Fox, an art hotel by Volkswagen
Copenhagen, Denmark, 2005
Photos by Simon Ladefoged

"The only brief was to decorate two of the hotel rooms - no rules. We did both with a typographic approach. To get a sharp and detailed result, we chose to work with foil. We could also cover the door, panels and the like with it. We printed on the carpet, too.

Room 304 deals with self-confidence. Every day, we are bombarded with around 10,000 written messages in newspapers, on hoardings and on computer screens. Very few people are aware of the massive quantity of typographies they are exposed to each day and how important the font is in making the message come across in a situation of information overload.

The other room, 414, is all about complexity and reliability. The old rule of thumb still exists: "Never trust statistics with unnamed sources. Strive to create your own understanding of the data, and question causalities. Design is, and always will be, a content-driven business … We're all in the business of making sense.

While working on the projects, we found that German efficiency seems pretty chaotic - but the whole atmosphere at the hotel was very calm."

GENEVIÈVE GAUCKLER

Geneviève Gauckler works as a graphic designer, illustrator and art director in many different domains, such as publishing, web design and video. *"Usually, I start doing graphics straightforward on my computer, without sketching anything"*, she says of her working methods. *"Actually, this is quite new - before I used to sketch, but now I'm old and experienced!"* During her trip into the 3-D world of hotel room interiors, the main difficulty for her was to imagine the space while working on the 2-D artwork. *"It was very* challenging."* Being more of a classic graphic designer, she admits she is not very interested in material. *"I'm not proud of it. Every normal designer should care about material, but I care more about shapes and ideas. Shame on me!"* On the other hand, she does take a great interest in the work of some architects. *"Ludwig Mies van der Rohe, Le Corbusier, Tadao Ando and Jean Nouvel. It is always very inspiring to see how they cope with proportions, materials and the inevitable issue of form and function."*

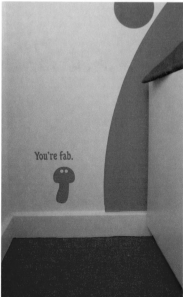

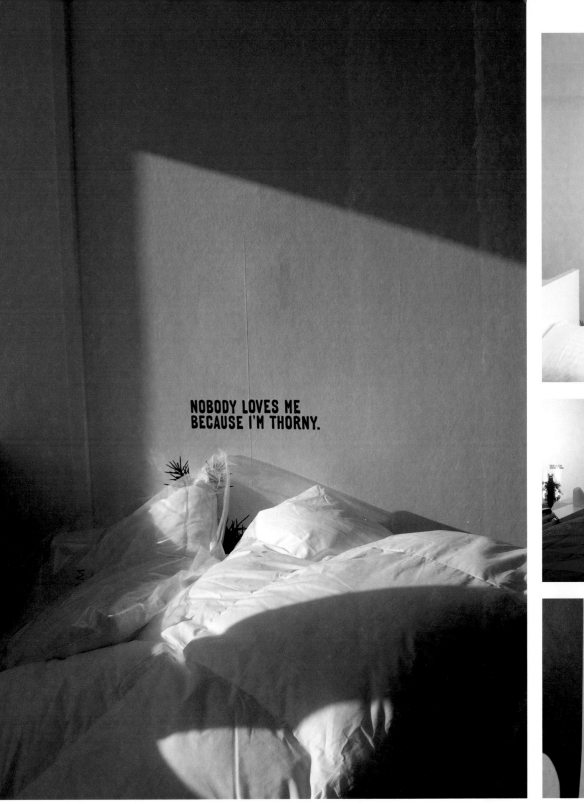

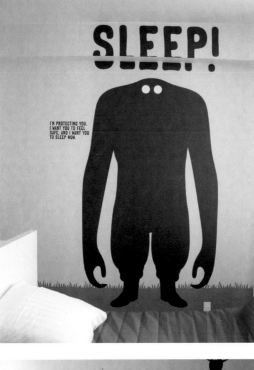

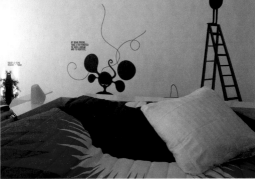

"Room 303: Guardian Angels"
"Room 203: Sweet Sleep"

Hotel Fox, an art hotel by Volkswagen
Copenhagen, Denmark, 2005

"I found myself working on interiors for the first time and loved the freedom to control everything: the walls, the floor, the bedsheets – no logo and no bar code to add. I wanted each room to have its own character, its own atmosphere, as if the characters were welcoming the traveller.

In room 303, the guardian angels take care of you and your dreams. Their rounded and smooth shapes wrap you in feelings of security and softness. Room 203 - ‚Sweet Sleep‘ - feels just like coming home: All your best friends are waiting for you. They‘re sweet, soft and cute, and they want you to be happy. Finally, there is the glorious, Technicolor-Dream-Coat room 106 where rocking horse people eat marshmallow pies.“

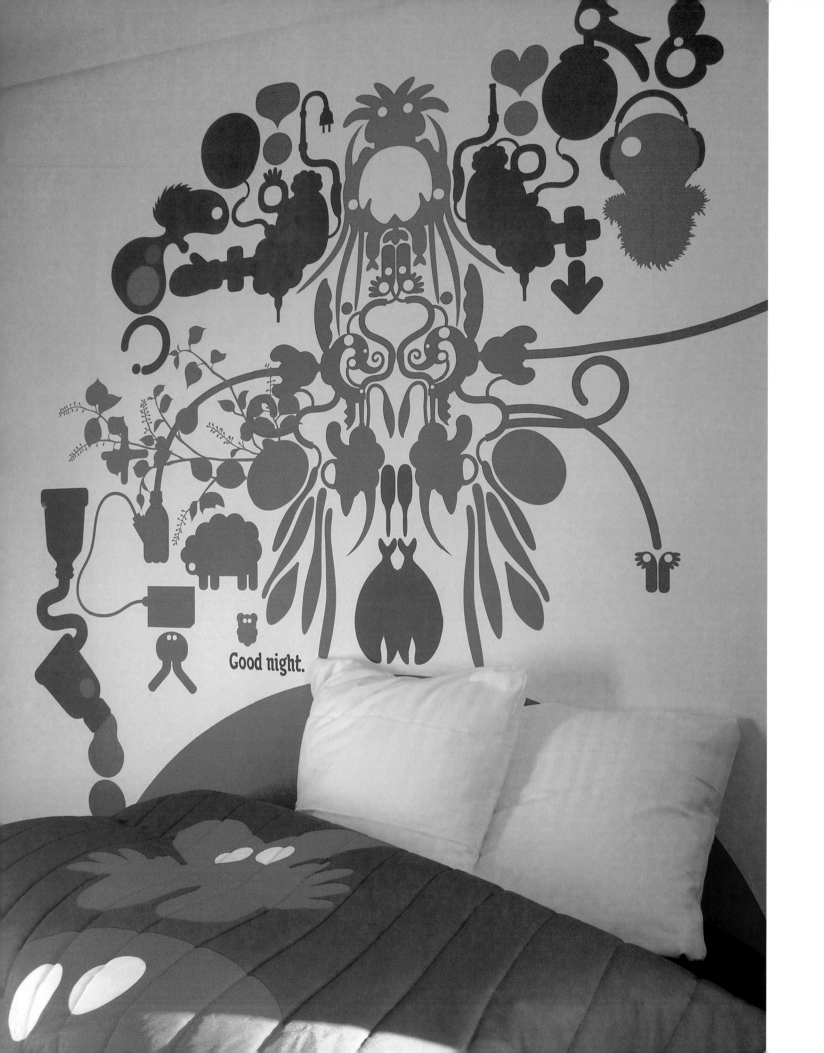

Good night.

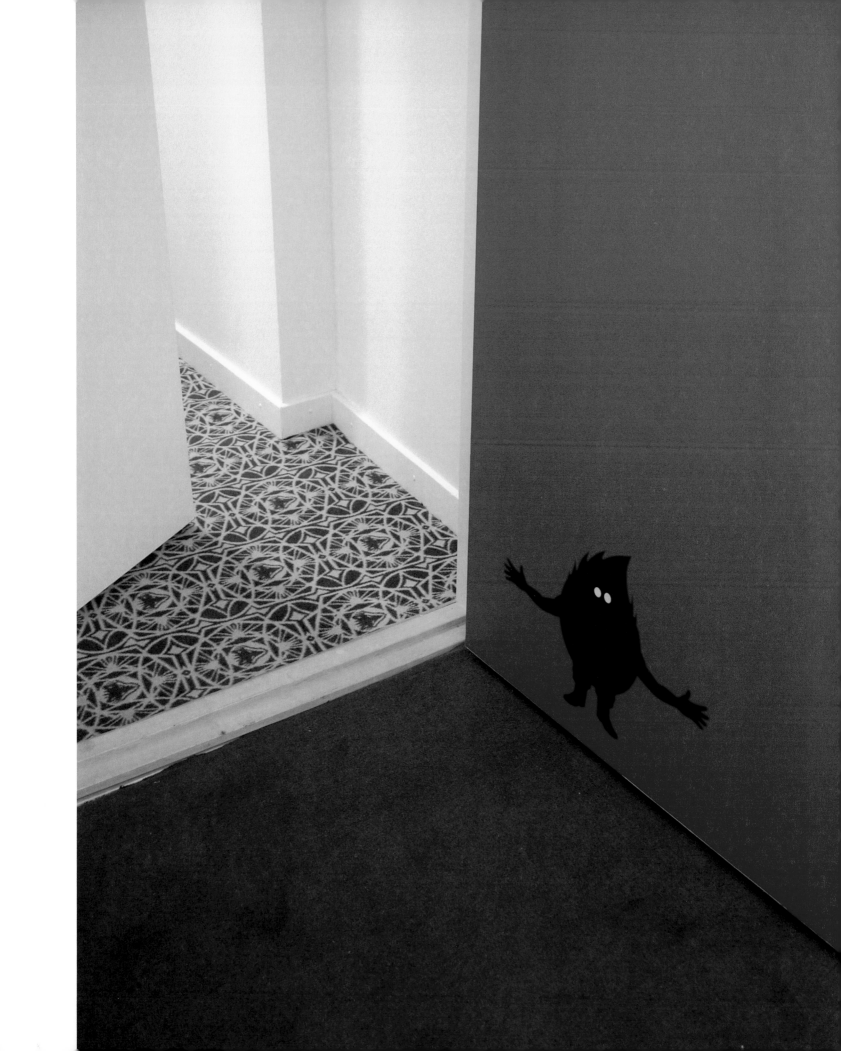

MASA

For Venezuelan street artist Miguel Vasquez aka Masa, it is essential how users will interact with an installation or object. *"I try to pre-visualize in which way they will follow any given path. What motifs are most likely to be looked at when people begin to walk along my pieces? Where will they stand and stop during their current stroll?"* While creating the main concept, he always watches out for any possible material that may communicate and accentuate the idea best. *"I keep linking visual references, like forms and colours, to visual or tactile materials. So the surfaces I am working on keep a tight relation with the idea to be developed at the end. The medium could be anything as far it works best for the idea."*

Since he is used to working fast, he says, and most of the time organizes the content first, he finds himself able to spend as much time as possible to play freely with types, images, compositions and colours. *"'Play' has become one of my essentials, even obsessions, being necessary not only in the design process but also mostly in the result that the audience will experience. My aim is to give my works a ludic and organic look and feel, where the audience can experience second lectures of hidden details as forms, words or characters."*

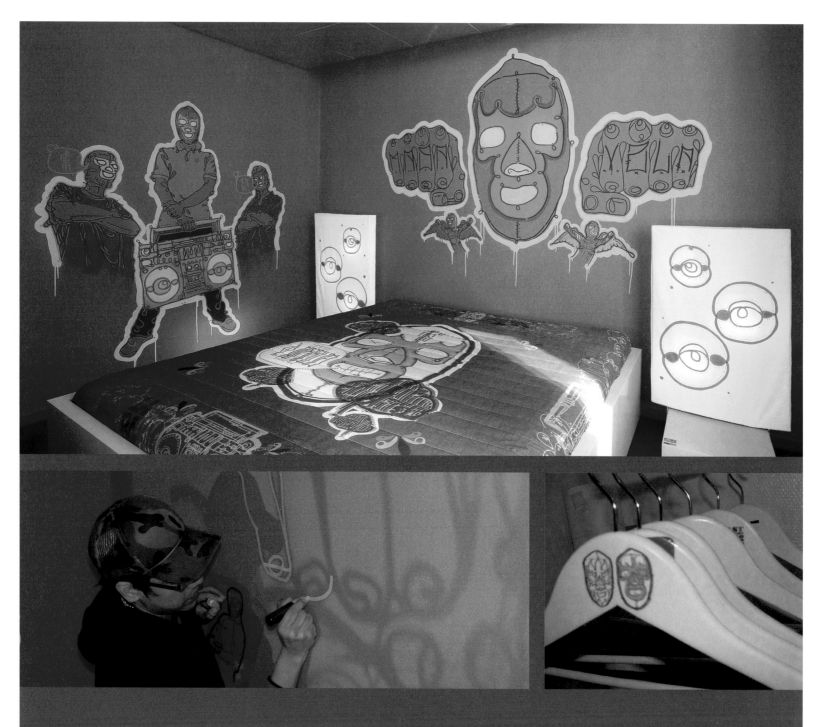

"Room 308"
Hotel Fox, an art hotel by Volkswagen
assited by Jakob Printzlau "PLASTICKID"
Copenhagen, Denmark, 2005
Photos left side:
Top photo by diephotodsigner.de,
bottom by Plastickid & Masa

"My design for this hotel room is about urbanality and individuality. I came up with the idea using one of my sketch books; to approach the whole room as a T-shirt collection, taking up the theme of Mexican Wrestling, known as Lucha Libre, focusing on the ‚enmascarado‘, the masked man, who has become a kind of cultural icon.

First, I took a set of pictures of a friend, posing with a mask in several different positions. Then I drew 22 individual line illustrations with black markers which show wrestlers in different positions. I additionally presented them dressed in daily outfits - as a businessman, a hip-hop kid and so on. I want the guest in some way to become a character, a hero that has to fight the obstacles of travelling, tight schedules and boring meetings.

The images and themes are quite graffiti-related but I decided to avoid the usage of spray paint and stencils. So I went for permanent markers, brushes, rollers, silver and etching inks and silkscreen prints. And I used real wrestlers' masks as garments for the lamps."

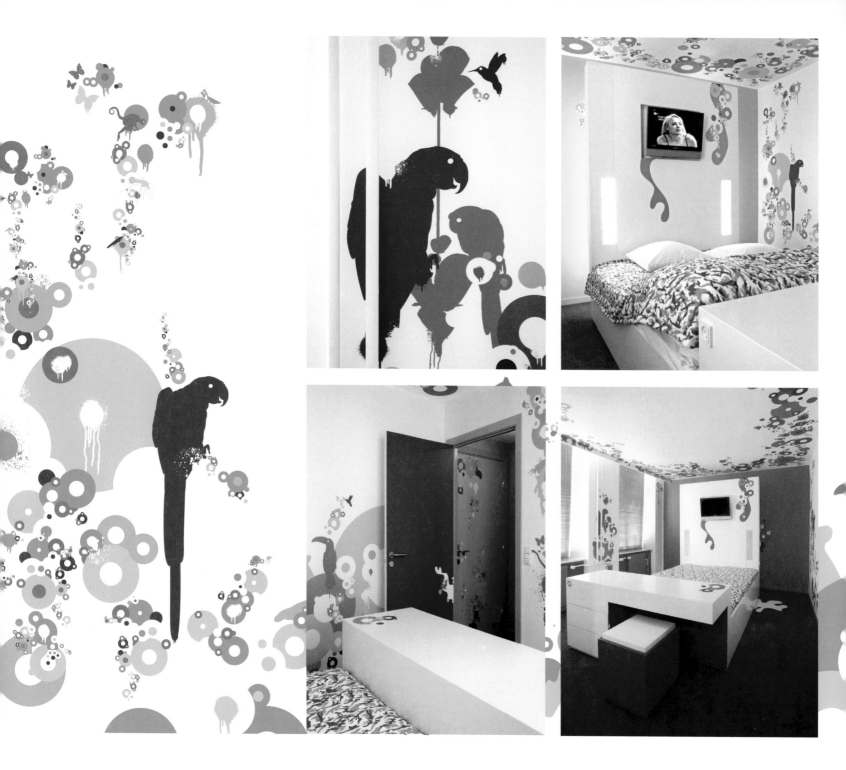

"Room 115"

Hotel Fox, an art hotel sponsored by Volkswagen
Copenhagen, Denmark, 2005
Photos by diephotodesigner.de

"I liked the idea of portraying an outside organic environment in a confined inner space. Instead of just making the room look bigger, I wanted to translate the freedom experience of an Amazon rain forest, a place to rest and be safe.

One important aspect was to create a difference between daytime and night-time within the same room. My solution was to use ‚glow in the dark' vinyl foil for some small details and all the animals' eyes. This way, in the day they are unseen, but at night they become alive and give the room a different feeling.

People spend most of their time travelling in airplanes, waiting at airports and staying in hotel rooms, very neutral and even aseptic places. In contrast to that, I came to think that rooms should provide the guest with a certain individuality and a specific experience."

"artcar installation"
assited by Jakob Printzlau "PLASTICKID"
Volkswagen "Studio Fox"
Copenhagen, Denmark, 2005
Photos by Masa & Plastickid

"To customize this car, I decided to accent the main shape lines of it on the outside and let the graphics happen mainly on the inside. In normal daylight there is not much too see but since I used fluorescent vinyl foil again, the car's forms reveal themselves in the dark.

The theme I chose was ,El Día de los Muertos', the Mexican Day of the Dead, when dead ancestors are celebrated most joyfully throughout Mexico and the Mexican-American community. I removed all the seats and painted the whole car, inside and outside, in matt white and some important parts in fluorescent green. Additionally, I stuck lines and cut-out forms of ,glow in the dark' vinyl foil over the car. From the same foil, I had illustrative cut-outs installed to keep the idea of the driver, his family and all the parts previously removed from the car.

It was kind of an experiment on the run, because I could only visualize the results when there was a total absence of light and full coverage of UV light inside the container which was not always possible. So I had to play with forms freely over the surface of the car."

CONTAINER

London-based design duo Container consists of Nicola Carter and Luise Vormittag, who both started as solo illustrators. For them, material always plays a large role in the design process, whether it is fabric, paper or more unusual things such as flock. *"We like our objects and illustrations to have as much of a hand-made quality to them as possible"*, Nicola Carter explains, *"so we are always on the lookout for lovely paper, fabric and decorative elements."* Having said that, she adds that they do not always go for the safe option by choosing tasteful materials for every project. *"Sometimes it is fun to have a selection of tasteless and otherwise ugly materials and use small elements of them to make up an object."*

Through their drawings, they like to build little narratives. Thus, when they design a room or decorate an object, it will literally be readable afterwards. *"Leading the viewer through a little ‚container world' fantasy is great fun for us. We are lucky that clients will let us use this playful aspect in different settings."*

Though they tend to sketch in 2-D, an important part of their work is to study the qualities and difficulties each particular space brings about. *"There have been restrictions and limitations with each different setting we have worked in, such as low lighting in a club or the need for durability of the material used in a cafe. Until now, each project we have worked on has had a problem to overcome. We have had to learn on our feet which materials are suitable for different projects. But we have been lucky enough to work with some skilled people who have helped us out of some sticky situations."*

As they have already realized one ‚dream come true' project - their illustrations covering the walls of hotel rooms - they are now are looking for another one. *"Maybe a hotel or space in New York, or on a beautiful island - with time for sunbathing!"*

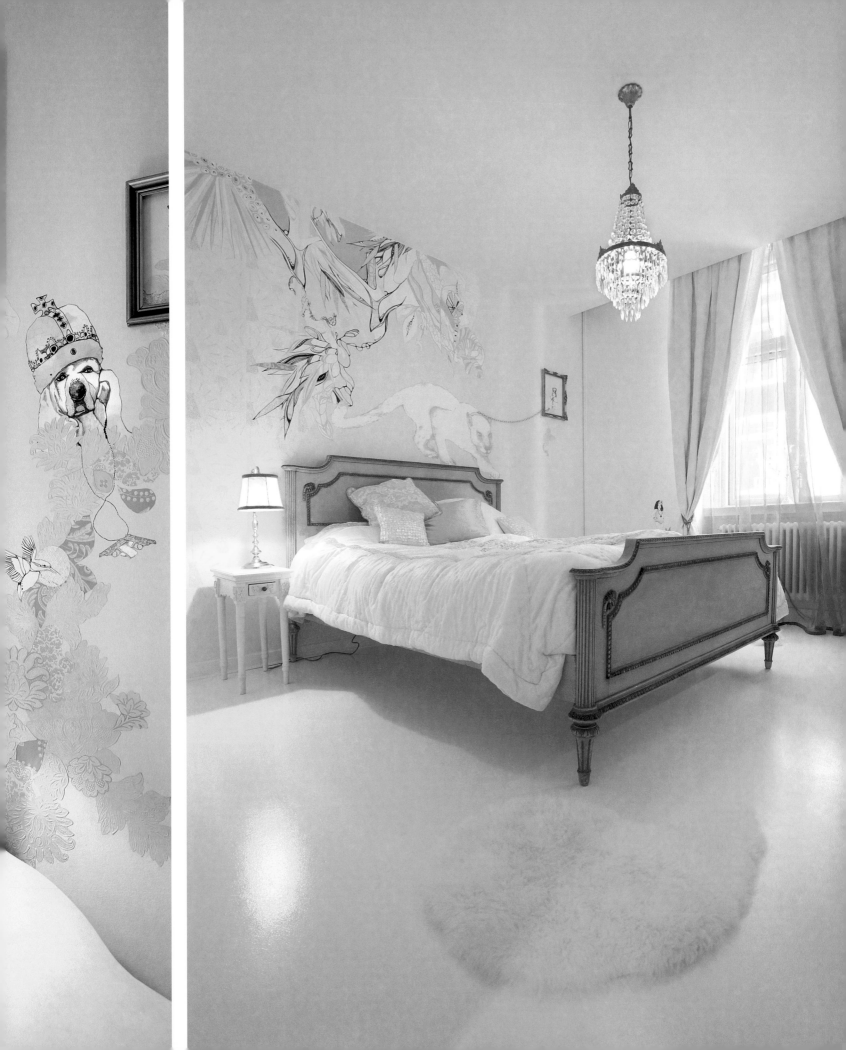

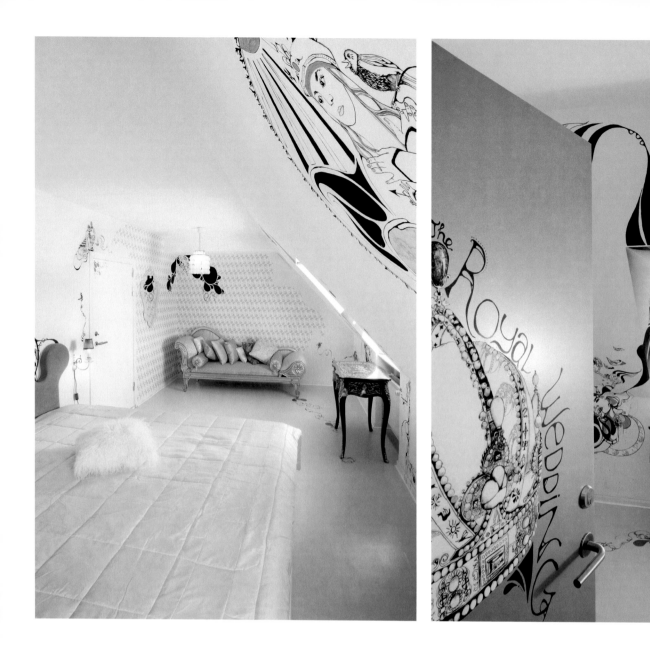

"Room 208: Diamonds - The Crown Jewels"
"Room 502: Hearts - The Royal Wedding"
Hotel Fox, an art hotel by Volkswagen
Copenhagen, Denmark, 2005
Photos by diephotodesigner.de

"To design four rooms for the hotel, we came up with a royal theme to emphasize the feeling of being special which one has when staying in a hotel. We decided to base variations of this theme on the colours of playing cards: hearts, diamonds, clubs and spades. To this end, we used a very broad range of techniques and materials. We fixed pieces of wallpaper and prints of our illustrations onto the walls. We did the same with a collected range of objects - picture frames, doilies, vinyl stick-

ers. We also cut carpet to cover the floor and chose appropriate fabrics and furniture. We thought about light solutions. We bought ridiculous tassels. And we rented a flocking machine that looked like a home built device.

By doing all this, we acquired some new skills. While cutting carpet is not as hard as you might think (especially if you get the kind of people to help that actually do the cutting for you while you just hold the lamp), flocking a surface is really hard. Do not try this at home."

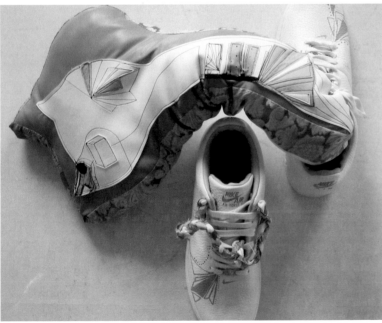

"Invasion of the Kitty Snatcher"
Nakayoku project,
celebrating 30 years of the "Hello Kitty"
character, sponsored by its manufacturer
Sanrio, Hong Kong Arts Centre, 2005

"Customizing a pair of Nike trainers on the Hello Kitty theme of 'Hide and seek with Hello Kitty and friends', we thought of a little horror narrative. We imagined the Hello Kitty character actually being swallowed by the shoes and then spat out again - she is, however, still caught up in the texture of the shoe, hence the cat-shaped growth emerging from one of the trainers.

We attached sewed and stuffed fabrics to the shoe and added some small details to the other shoe - the platted shoe laces. We drew on the shoes with permanent markers."

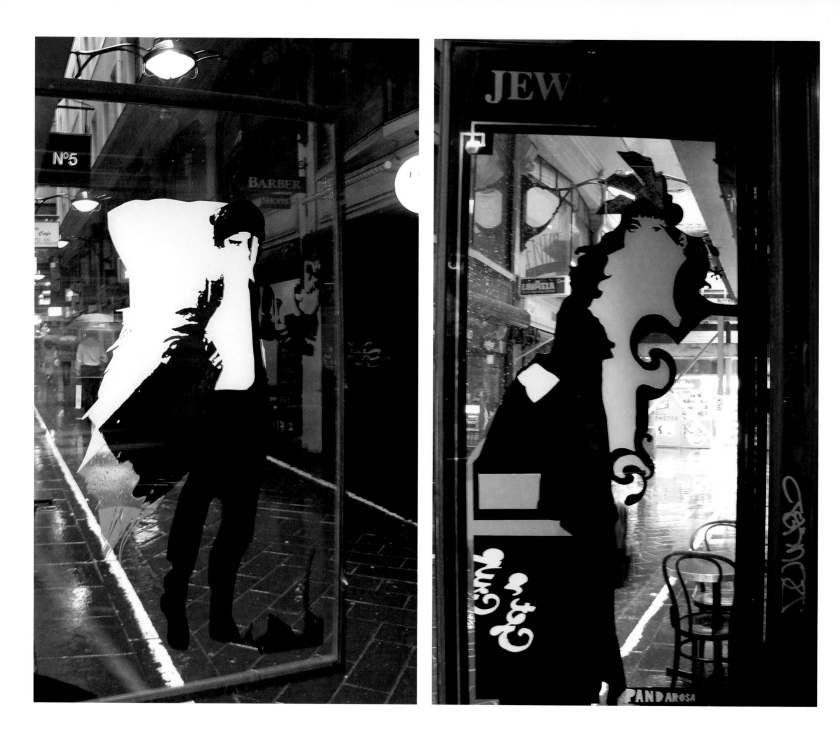

PANDAROSA

Pandarosa (Ariel Aguilera & Andrea Benyi) operate as a design studio specializing in creating graphics for a range of artistic industry clients. More recently, they have expanded their activities to exhibition, installation and interior based projects. "*We are applying our artistic approach to both our experimental art practice and professional clientele*", Ariel Aguilera explicates. "*Through this we aim to break the preconceived idea that design and art cannot coexist.*"

The architects and sculptors they like give them lots of inspiration: "*For example, we find it quite amazing how Antoni Gaudí or Alexander Calder could give life to their non living creations. Definitely, throughout our recent visit to Budapest all we did was admire the architecture around us.*"

Still, thinking in bigger dimensions seems to get along well with a definitely graphic mindset. Ariel Aguilera has the strongest feelings about the sky, because "*it constantly morphs.*" And

when he used to live opposite the docklands, he was fascinated by the huge ships coming in and the different shapes they would create with the shipping containers while unloading. "*Since then, I have had this idea to create really huge sculptures out of those containers. Each one would be individually painted and organized, and together they would create various ‚pixel based‘ images.*"

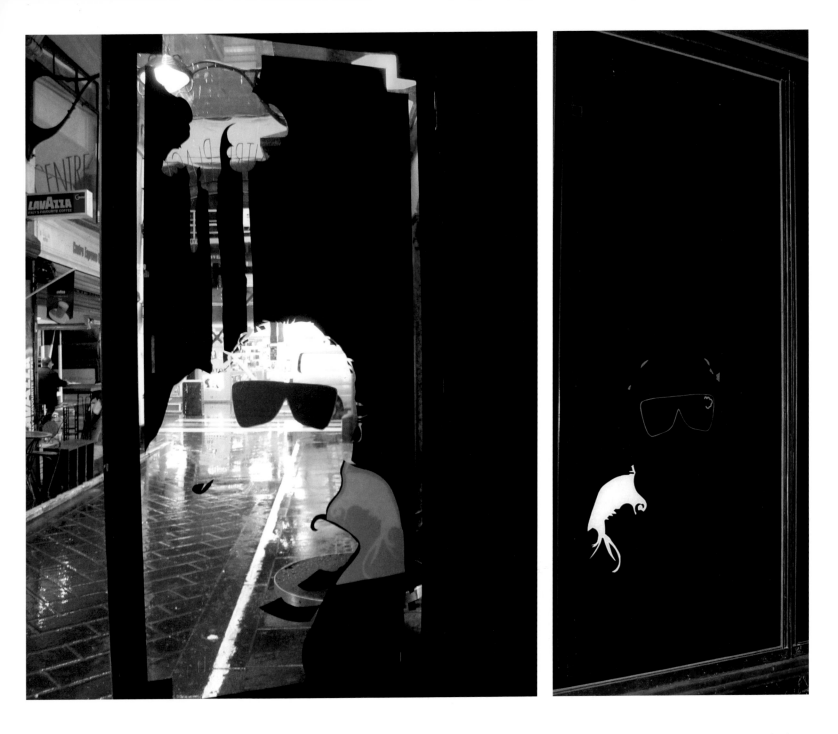

"Versus, as in VS"

Collaborative exhibition by Pandarosa & Organic
Melbourne, Australia, 2004

"Being inspired by the works of Klimt, Schiele and Toulouse-Lautrec, we decided to create a series of portraits within a large, but very thin jewellery case space. We cut vinyl foil and various paper stocks and applied them to the inside of the glass. We discovered that abstraction makes for a very interesting and recognizable portrait, and the ‚back‘ or ‚hidden‘ section of a design solution can be as good if not better than the front."

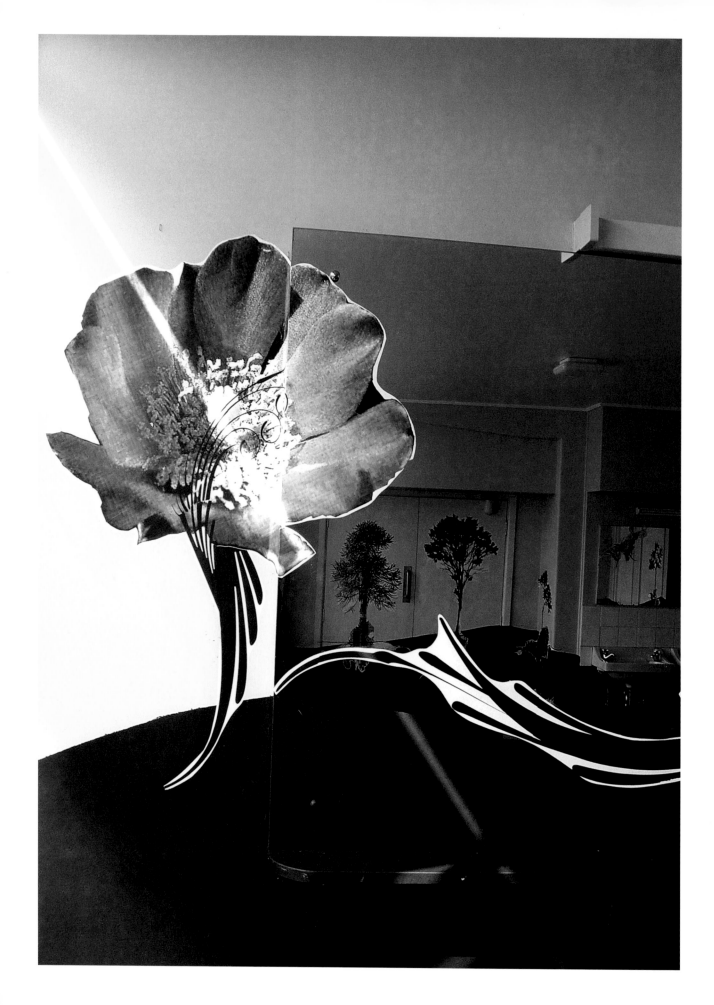

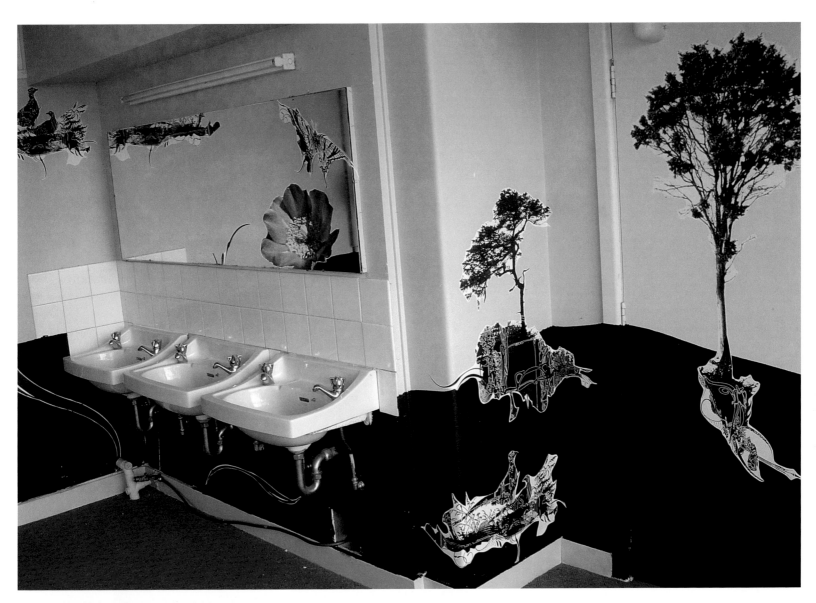

"Back room for John Butler trio"
Design by Organic for Pandarosa
Big Day Out music festival
Melbourne, Australia, 2005

"We wanted to create an environment for musicians to relax in, while waiting to go onstage. The setting was supposed to convey a chilled atmosphere for the artists to interact with. We painted the walls and pasted large cut photocopies onto it. We discovered that reflections create more visual coverage and a larger environment space."

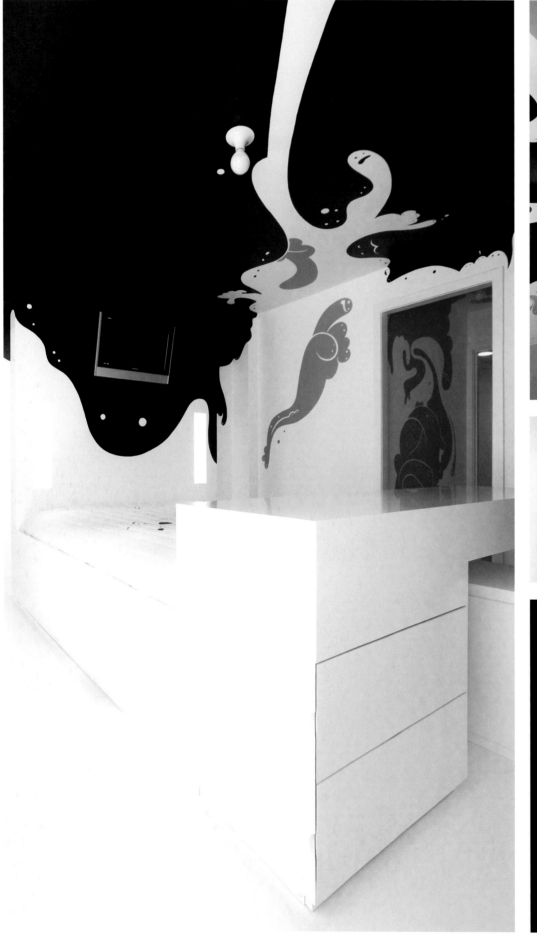
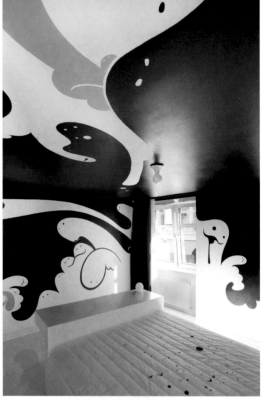

© VW

RINZEN

If Rilla Alexander could follow through with her most-wanted project, it would be nothing less than bringing an entire world into being, *"a large scale alternate reality you can believe in, and become lost in."* On a smaller scale, this seems to be what the members of the Australian Rinzen art collective she belongs to are trying to accomplish. *"We always aim for creating a holistic environment. Hence the architecture* *of the particular space we are doing a project in is of great importance to us."* The same goes for the materials the Rinzen members work with. As their own symbolic language is one of distinct individuality, choosing the appropriate material becomes a crucial factor. *"We have a particular interest in traditional, handmade or hand-painted outcomes for our large scale work, enjoying the personality it imparts."* For any project, 2-D sketches are the starting point. *"This applies to the illustrative worlds brought to life simply by virtue of their size or their positioning, as well as to the puppets and sculptural elements we create."*

When asked if there is any given space she is moved by, Rilla Alexander refers to Rinzen's mission again: *"We want to make that space."*

129

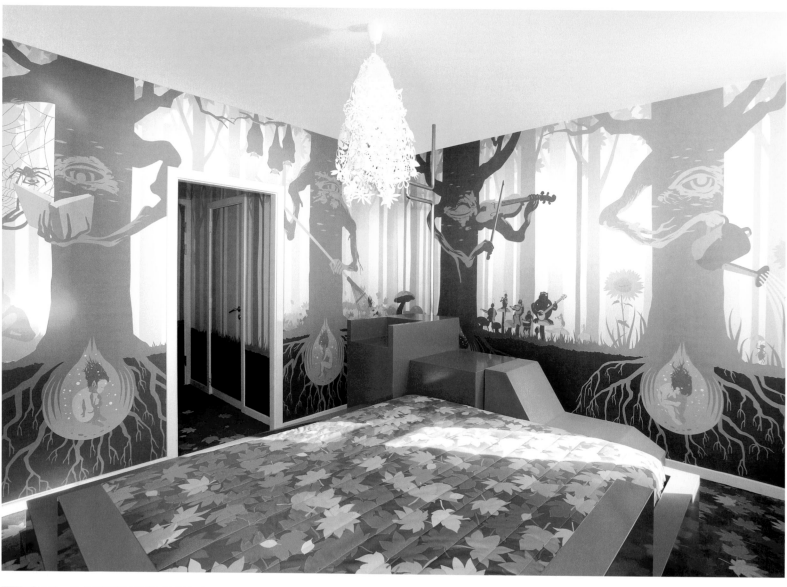

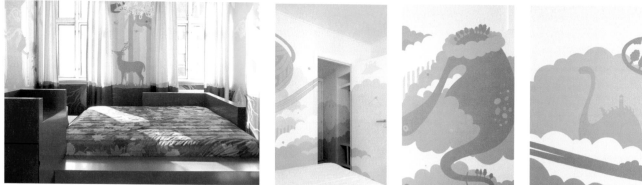

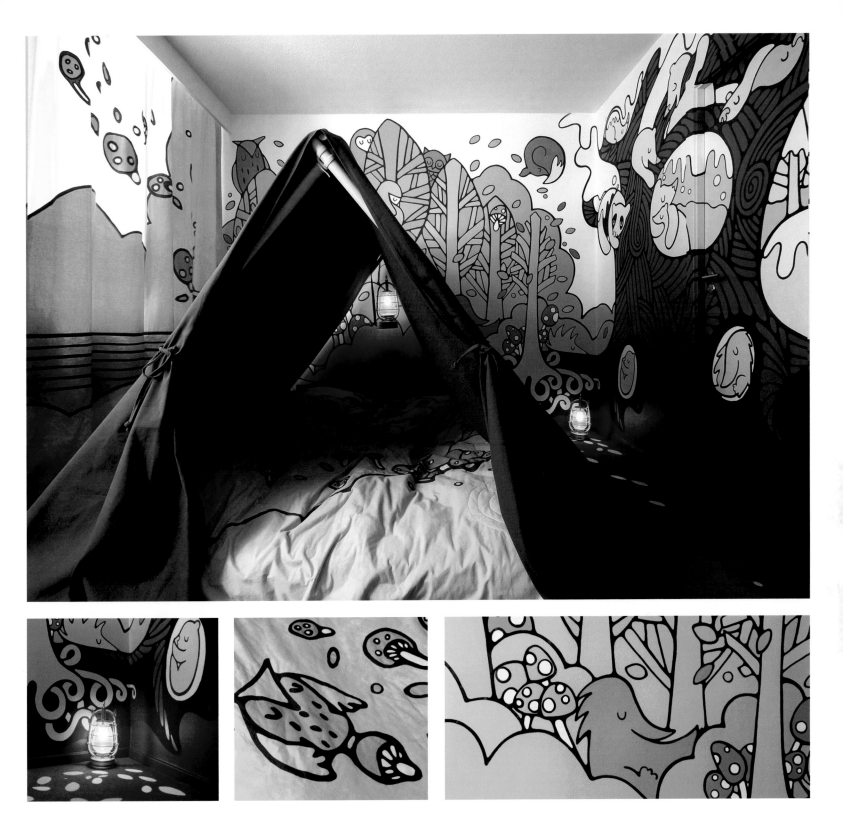

"Room 107: Good Spirits"
"Room 307: The Dryads"
"Room 211: The Traveller"
"Room 121: Sleep Seasons"
Hotel Fox, an art hotel by Volkswagen
Copenhagen,Denmark, 2005
Photos by diephotodesigner.de

"When designing the rooms, we were happy not to meet with any of the ,hotel restrictions' we had expected, so we could really customize them. Our idea was to create four different immersive worlds, thus offering guests very different experiences; ranging from cool and cleansing to warm and coffee coloured. For example, materials in room 107 were all white or black, providing a solid backdrop for the graphic. In contrast, we used laborious hand-made techniques in room 121 to emphasise its cosy, friendly nature. For example, the bedspread and curtains have all been hand-dyed, appliquéd and quilted.

After all, we actually got the impression that anything is possible if you make it happen."

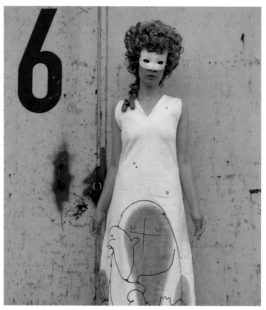

"Seeker Dress"
Dress by Lisa Alisa, Photo by Antje Müller

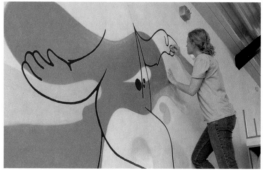

"Are you my home?"
Helium Cowboy Artspace Gallery
Hamburg, Germany, 2005
Installation views by Jan Kopetzky
Process photo by Joerg Heikhaus

"With this exhibition, we featured the sasquatch, a legendary creature of the North-American wilderness. Our sasquatch character 'Seeker', as a spray and acrylic paint mural, walks up the stairs beckoning viewers to the second floor of the show. He also appears in the shape of a three-dimensional soft sculpture (made out of stuffed wool material with embroidery and beads), surrounded by a floating forest and flanked by smiling trees, whose roots are entangled in an embrace.

When observing the visitors, we noticed that people are really fond of big, friendly creatures."

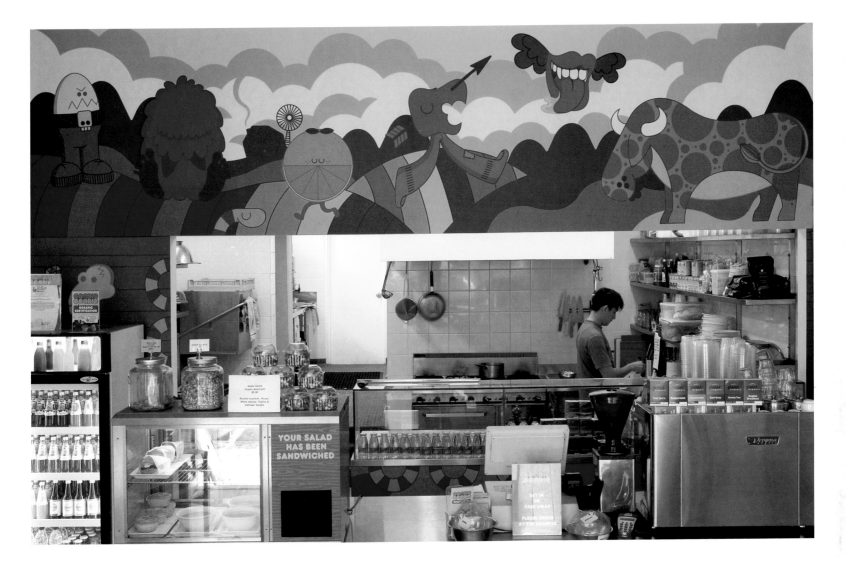

"Goodie Goodie"
Goodie Goodie Store, Sydney, Australia, 2005

"We were supposed to design characters and a mural for the store, with a playful attitude toward the all-organic food on offer. The aim was to emphasise the idea of being a ‚goodie goodie' by eating only what is good for you. We created a fantastical farm populated by all manner of creatures - some are obviously good, whilst others are somewhat dubious or just plain strange. Each of the characters is magnetic allowing them to move about or come and go as they please. New members to the Goodie Goodie family are likely to turn up at any given time.

The mural was output digitally onto vinyl and applied to a metal base. Using the same method, we also produced the characters, except they were applied to a magnetic base."

WOOD WOOD

T. Karl-Oskar Olsen is part of WoodWood in Copenhagen, Denmark, which besides having two clothes shops also has established its own fashion brand and does creative projects for different companies. *"Normally, I start with drawing"*, Olsen describes his design process. *"Drawing has always been my favourite tool. Afterward I switch to cardboard. You can't believe how a drawing deceives the eye! Cardboard is the truth, it shows you how much space you are actually using."*

When talking about his relation to architecture and sculptural art, Olsen speaks his mind:

"They are not important at all for my work. I would never take those two elements into consideration when I design. I have to stay focused on what I am good at, and it is neither one of them. Architecture is boring and art is too complicated." He gets a lot of his inspirations by watching the Cartoon Network with his daughter, especially the series ‚Powerpuff Girls'. *"What I would really love to do is to make the stage design for them if they ever played in the Royal Opera in Copenhagen. But somehow I don't think that will ever happen."*

"WoodWood stand at Bread & Butter"
Berlin, Germany, 2004

"We created the design for the show on our spring/summer collection, drawing with markers on cardboard. It cost 150 euros, still it was a 1000 times cooler than Miss Sixties' with its probably 200,000 euro budget."

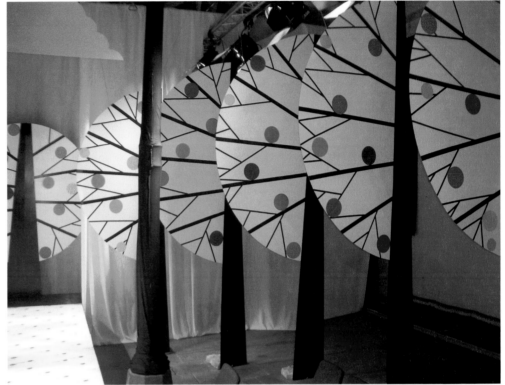

"Fashion Show stage design for the Copenhagen Fashion Week"
Client: Unique Models
Copenhagen, Denmark, 2005

"We customized lots of highly durable wood for that fashion show. I really loved to see people act in my designs and also enjoyed the elements of sound and audience."

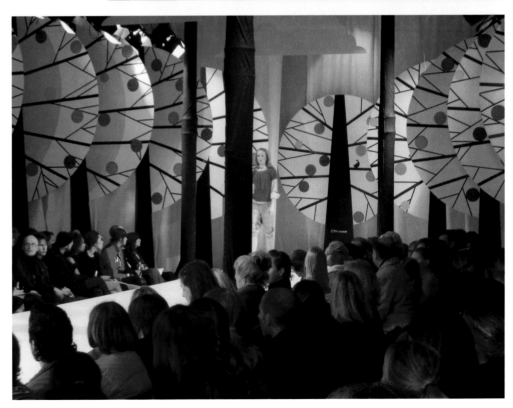

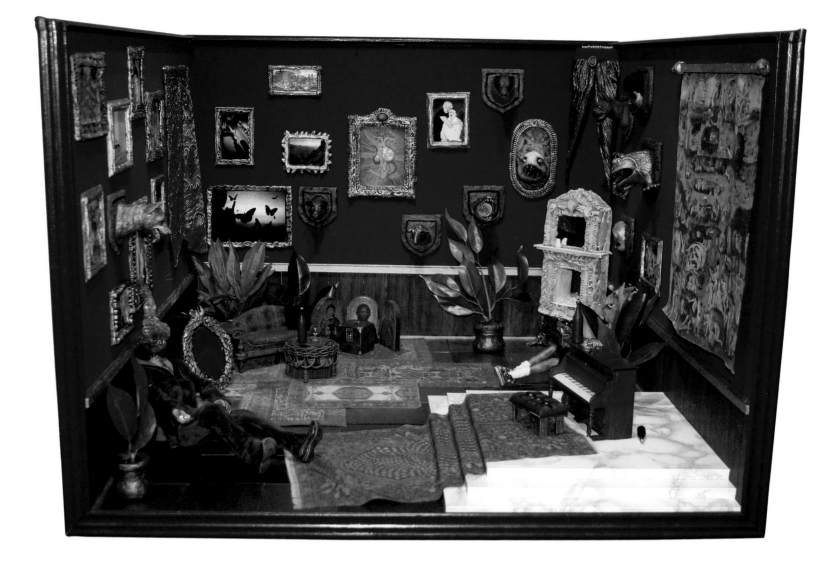

VÅR

‚Vår‘ is a Swedish word meaning both ‚our‘ and ‚spring‘. It is also the name of the graphic artist team consisting of Karl Grandin, based in Amsterdam, and Bjorn Karvestedt, based in Stockholm. Their work has been exhibited in galleries and can be found in books and magazines, on T-shirts, album covers and furniture. When working together, Karl Grandin says, play is more or less crucial: *"A lot of our diorama type pieces are based on playing. As we build the environments and characters, we are creating imaginary worlds."* While some of their works are planned in detail for months, others are *"free-styled"*, made up as they go along. *"Planned or not, we do build a lot of stuff. We try to work in a variety of fields, mixing different materials as well as mixing design* with printing, architecture, sculpture, etc. That makes it a lot more stimulating."

Having just finished a huge mosaic piece in their favourite bar in Stockholm, they have experienced the joy of working with big dimensions. *"It's really nice to be able to shape a space where you spend a lot of time, a place that has a continuous influence on yourself and your friends."*

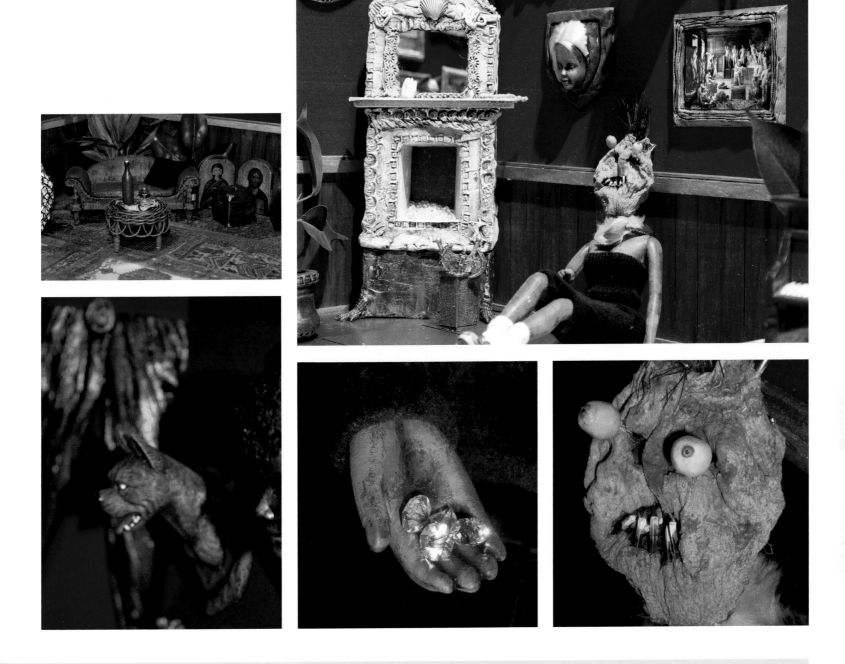

"Svensk Form"
by Björn Atldax, Vår and Karin Lindh
Svensk Form at Skeppsholmen
Stockholm, Sweden
Client: Svensk Form, 2004

"The theme of the exhibition ‚Nu' (‚now') was to show what is happening in contemporary Swedish design in different fields, and my part was one of about ten pieces. We collaborated with Karin Lindh and tried to merge our different reference worlds to create a small universe, consisting of the ideas we got during the one week we locked ourselves in her studio. We wanted (like many before

us) to explore the boundaries between art and design and to learn more about each other's creative personalities. The pictures on the walls of the diorama show earlier works by both of us and try to show where we come from as artists.

We used vegetables, old dolls, clay, wood, different types of paints and lots of other things, basically those you can find at home in old drawers."

137

"Konversation"
by Karl Grandin & Björn Atldax, Vår
Kartell furniture store, Stockholm, Sweden, 2003

"The Italian furniture company Kartell invited us to create a single piece for an exhibition in their store in Stockholm. We wanted to rework something out of their catalogue, and decided to customize a table and couch.

We used spray paint and pens, some Vogue publications, a couch and a table both designed by Piero Lissoni."

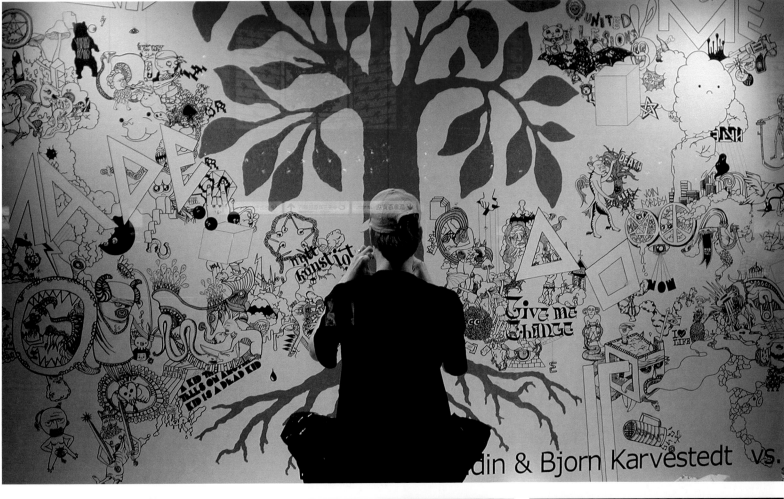

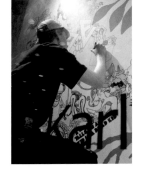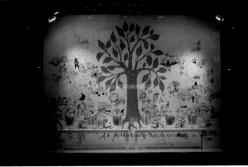

"Graffiti Meets Windows"
by Karl Grandin & Björn Atldax, Vår
Hankyu Department Store, Osaka, Japan
Client: Stoique, 2004

"Graffiti Meets Windows was an exhibition in Osaka in the summer of 2004, curated and organized by the Tokyo firms Stoique and Hankyu. We did a wall painting in a shop window and designed a sticker for a perfume bottle by Jean-Paul Gaultier. We used paint, Posca pens, rollers and brushes on wood."

SHOWROOM DUMMIES

"Generally, all our designs are image led", says Abigail Lane, head of the London-based design company Showroom Dummies. In her own way of working, she often uses source material from old books, magazines and photographs that she has taken, and manipulates them with the computer. "I may have a particular end in mind to start with, but as it progresses the image may reveal itself to be better adapted to something else. For example, an image of a tornado at the end of a road was in my mind to become one of our wall murals. But then it became the back of one of our screens because it was obvious when I folded the paper roughly that the concertina effect of the panels were going to be better suited to give the image depth and a sense of its dramatic connotations."

Although her design mostly appears to be centred around images of various kinds, the material they are applied to sometimes proves as equally important. "The images of stuffed animals were always intended to be behind the shiny veneer of glass or acrylic to keep their museum quality. Therefore, the screen design grew up around them. Sometimes the images will then go on to work in another material life. I can very well imagine the Fly Sky design working on the fine bone china of a tea set as well as the rough cotton print of our fabric." She never sees patterns or motifs as completely flat. "I always try to imagine them in the circumstances they will actually be in, that is, in a space with other things. It is often the interaction between these things that gives the images their life and dynamics by introducing some kind of story line. It can even be as simple as seeing my dog sleeping diagonally across the dog-chequered design of our blankets."

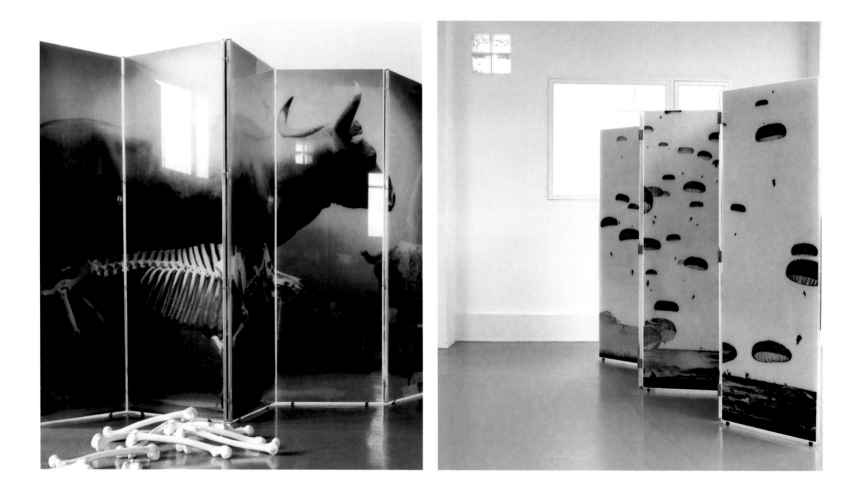

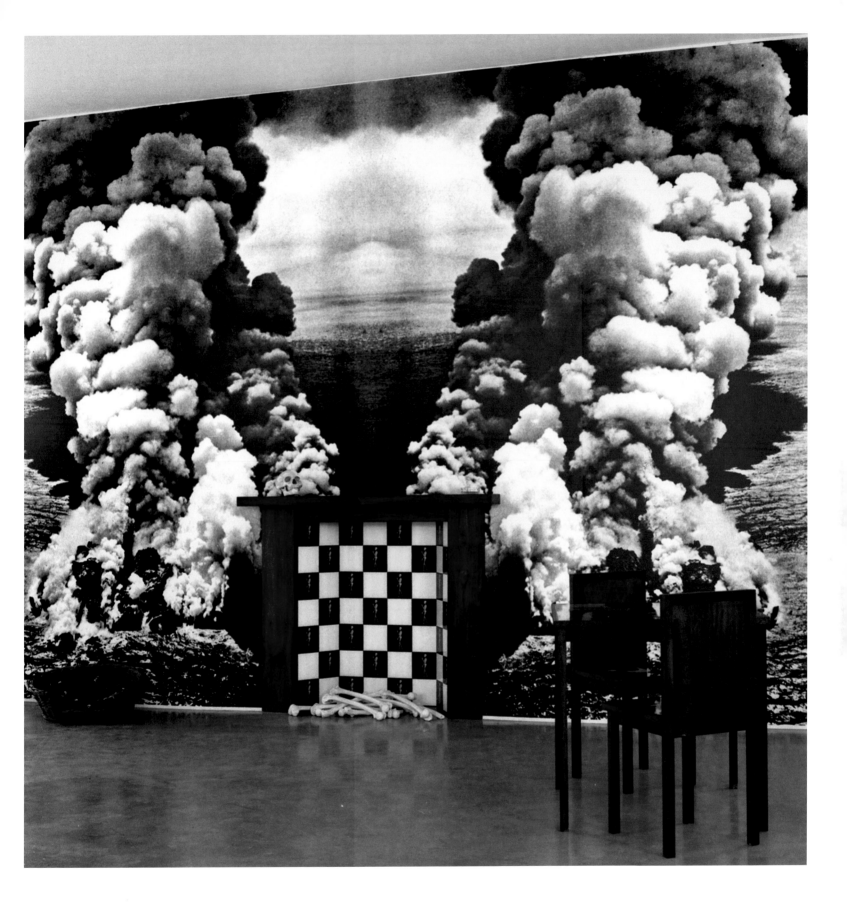

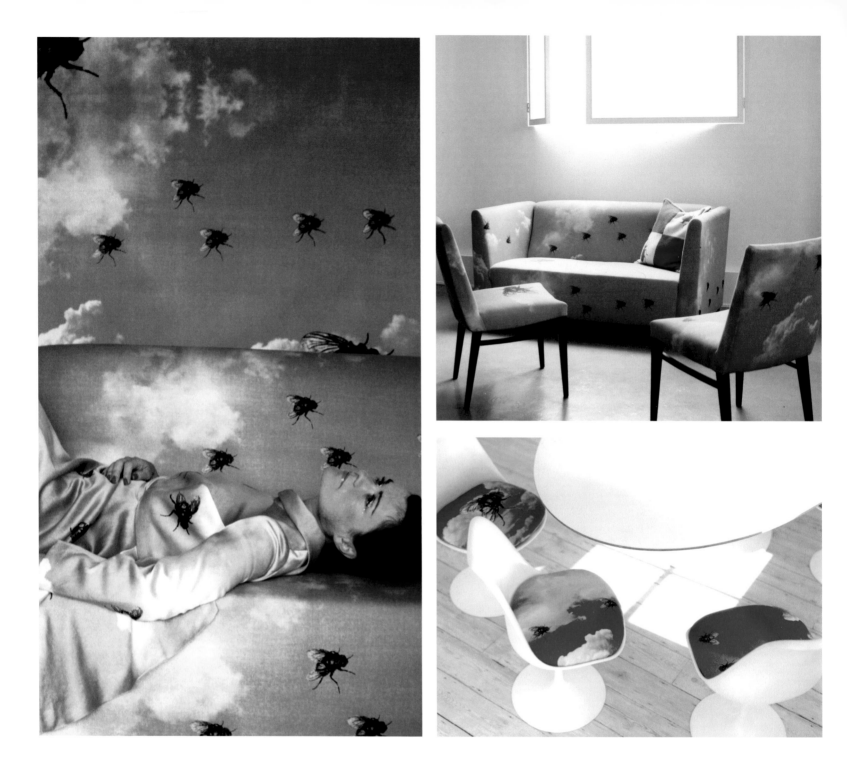

"Interior Motives (natural histories and natural disasters)"
Showroom Dummies head office
London, UK, 2003

"The purpose of this exhibition was to showcase our first prototypes in a coherent environment. Walls were papered with skeletal bodies frolicking with their own spare parts, and a bed covered in cashmere blankets, lay beneath an electric storm in black and white. Apart from thus creating a thematic setting for our furniture and accessories, you can actually purchase everything we exhibit in our rooms. For example, the mural showing a volcanic eruption is ink-jet printed on self-adhesive material with a hard-wearing protective seal to suit any requirements. The interests that I am passionate about inspire me. As they are long-term, the Showroom Dummy style is unlikely to fluctuate with fashions. My love is for the circus, natural history, museums and of course magic. One of my dream projects is to work on all the designs for a gambling club – everything from the coasters to the uniforms, the toilet doors to the carpets, even the money chips and tokens."

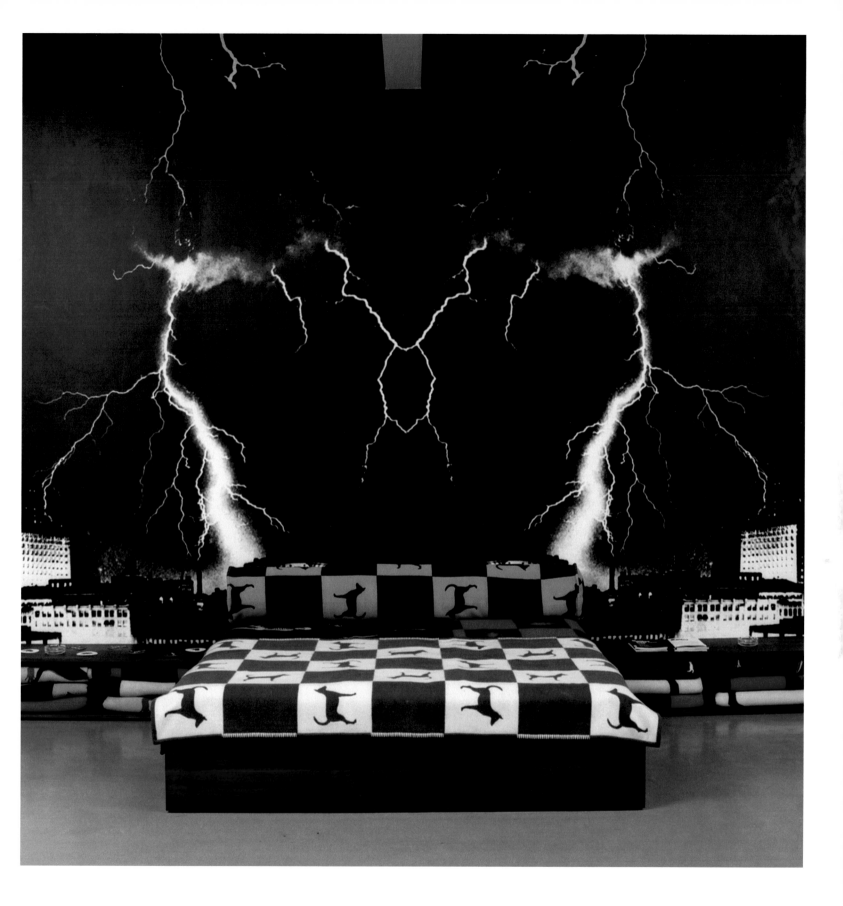

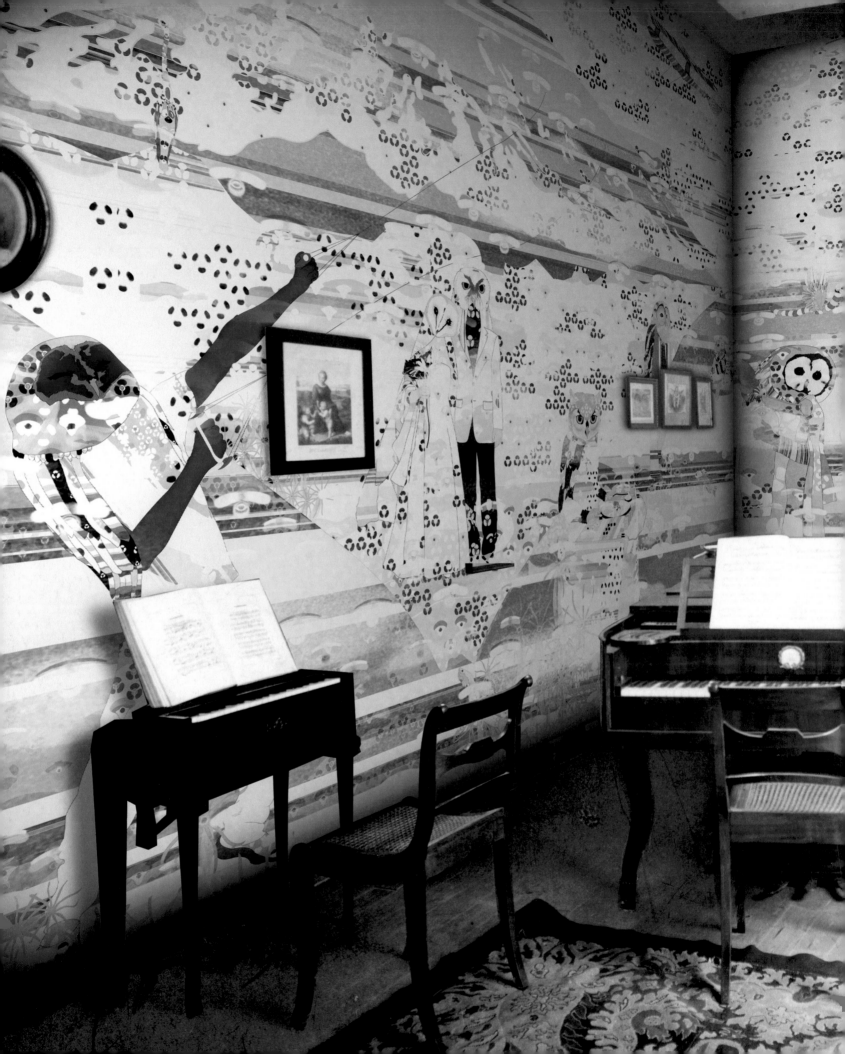

MAXALOT

Max Akkerman and Lotje Sodderland, who together form Maxalot, see themselves as promoters of exhibitions and creative projects, bringing together *"graphic design, iconography, street art and all the hybrids in between"*. Besides running a boutique and website, they showcase graphic design as a contemporary art form in their gallery in Barcelona. The concept is *"to invite trend-setters in the commercial industry to do some graphics free from the constraints of their client-work"*. One of these projects was to show solitary printed wallpapers, used as fictitious backgrounds to historic every-day life photos. Though this is not classic client-work, they both hope that some of the patterns will make it to mass production.

Among the featured artists were WeWork-ForThem, the creative duo of Michael Cina and Michael Young, reflecting early modernist theory with modern day technology, famous "flash guru" Joshua Davis, constantly trying to visualize the laws of chaos, and the art director Pier Fichefeux, who mixed techniques of pattern design with a classical illustration style.

"Exposif"
Wallpaper collection, Maxalot Gallery
Barcelona, 2005
P 142, Fuji One. Wallpaper design by Pier Fichefeux. Post production by Max Akkerman. Historical image courtesy of Corbis.com
P 143, Our Work. Wallpaper design by WeWork-ForThem. Post production by Max Akkerman. Historical image courtesy of Corbis.com

"Exposif exhibition"
at <>Tag, The Hague , 2005
Photos by Eelco Borremans

"The idea was to create giant works of art and make them available to the public as wallpapers. All the research into the most effective way to make this happen was a long road through the possibilities of large-format printing. We learned that digital printing today has the capacity to create colour-true, durable and frankly stunning images. We also learned that there is a growing demand amongst the public to customize space, and that minimalism is a thing of the past.

The brief to the collaborating artists was simple: create wallpaper, either landscape or patterned, with a minimum scalable size of 600 to 300 centimetres. The designs were printed high-res using a large format printer on canvas, adhesive vinyl and matte paper."

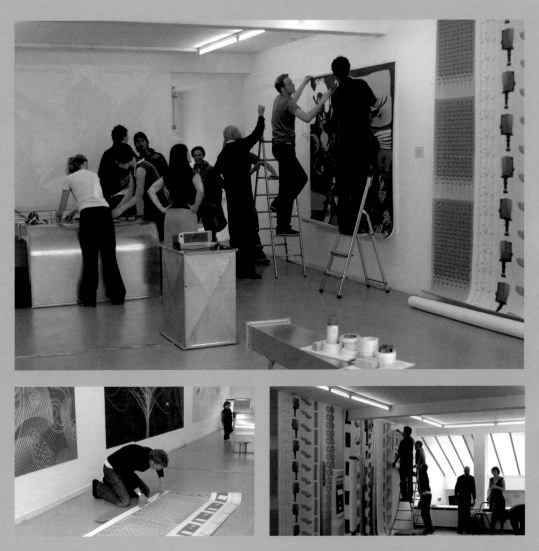

YOKOLAND

Most of the time, Aslak Gurholt Rønsen and Espen Friberg, who together form Yokoland, are doing graphic design. But when they first created their own exhibition in Oslo, where they are based, they did not hesitate to do something completely different. *"We could really do whatever we wanted. Now we had the possibilities of working with space, time, sound, light, different materials and objects in various sizes."* Being in no way instructed to suit any purpose looked like a unique opportunity to integrate a lot of things into the design process they seem to miss in their everyday work. *"We like real stuff more than virtual. There is considerably more depth in a forest than there is in a computer screen."* But fortunately, they say, plenty of their work tends to be in 3-D.

Attaching to the real world does, however, not lead them to overly stick to the chosen material. *"On a scale from one to ten, material would count as a 5.5."* Play is far more important for them: *"On the same scale, it would be a 9.5."*

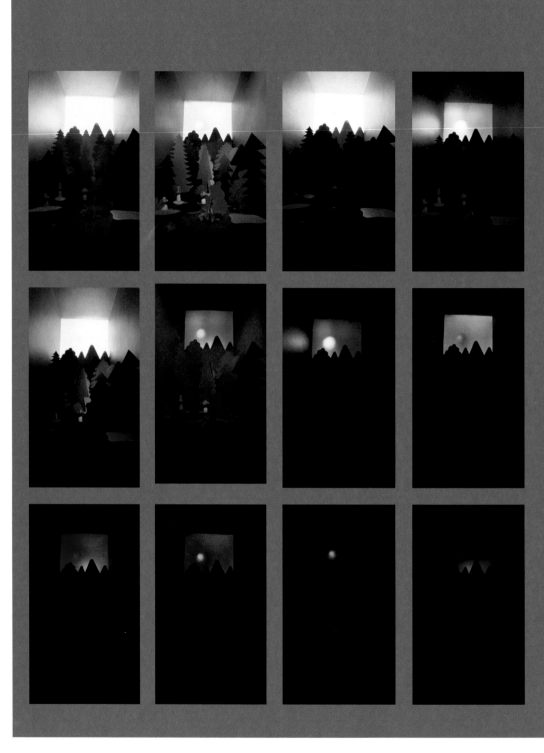

"Forrest room"
"Fra det ene til det andre"
("From one thing to another")
Exhibition, Badet Prosjektrom, Oslo, Norway, 2005

"With this room, viewers should be able to experience a whole day in the forest within ten minutes. So the light changed gradually from morning to night and back again. One could also hear forest sounds, like birds, insects and other animals.

This time, our technique was far more traditional: 1. plant the seeds, 2. water properly (twice a day if it's really sunny), 3. watch them grow, 4. give the plants lots of care and attention, including singing and talking (they are lonely, too), 5. if it gets too big, cut it all down."

"Black room"
"Fra det ene til det andre"
("From one thing to another")
Exhibition, Badet Prosjektrom, Oslo, Norway, 2005

"We made these two installations for our own exhibition, so we could really do whatever we wanted. In the ,Black room' we created a small universe. Fittingly, a musician called ,Center of the Universe' did the sound for this environment, one hour of music that was looped throughout the exhibition. For this room, we decided to devote ourselves to wild imagination plus a bit of intuition, painting the freestyle way in black and white. Doing that, we learned that 7-watt bulbs give a lot more light than you would expect."

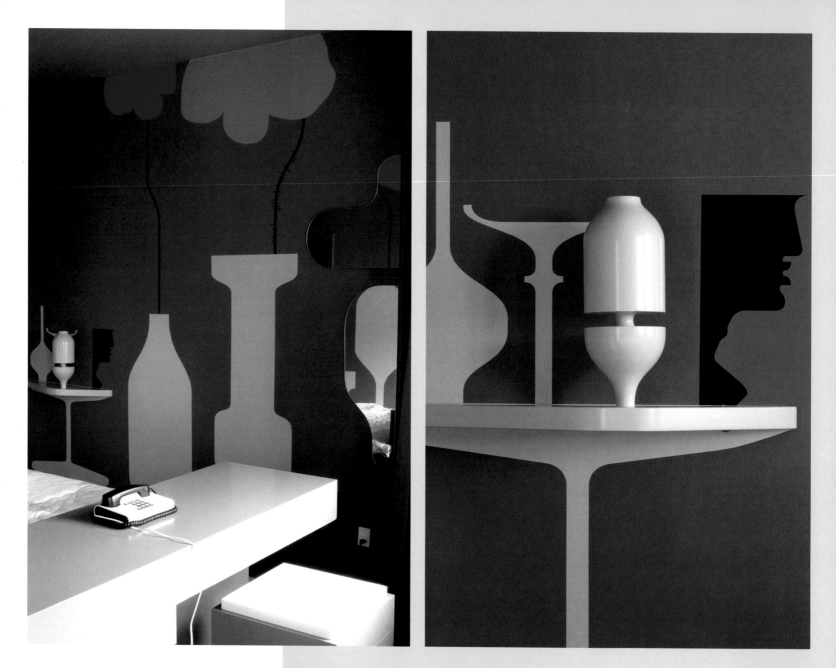

ANTOINE + MANUEL

Parisian designers Antoine et Manuel are famous for their illustrations and graphic design. *"But I think our work is related to sculpture and architecture as well"*, Manuel Warosz says. *"In fact, I see no major difference between the two working fields."* The actual project may be a book cover or the furnishing for a room, but the initial approach is basically the same. *"Quite often, we begin the design process by inventing an entire system of forms, with its own special vocabulary and rules. In this phase of conceptualizing, we focus on shape and on the story we want to tell. For the moment, the choice of material doesn't matter that much."*

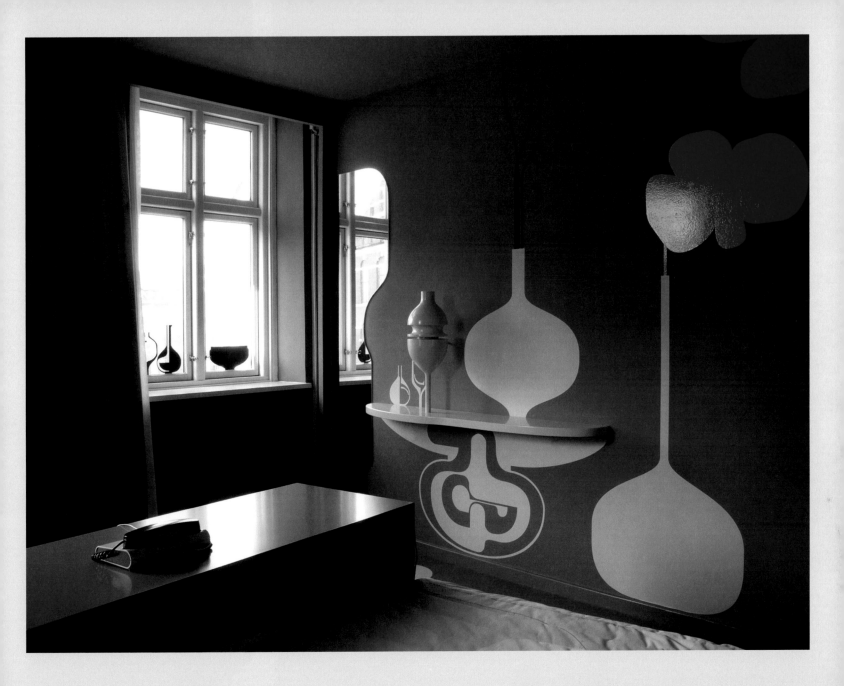

"Room 406: Shortcut"
Hotel Fox, an art hotel by Volkswagen
Copenhagen, Denmark, 2005

"The brief was very short: rooms for a creative hotel had to be designed. The solution had to be quick, new and original. With our rooms ‚Chance' and ‚Shortcut' we want people to go deep into our very own universe, to meet mysterious animals and detect mythological symbols. We applied vinyl foil to the walls and used a lot of machined wood with a polished lacquer finish."

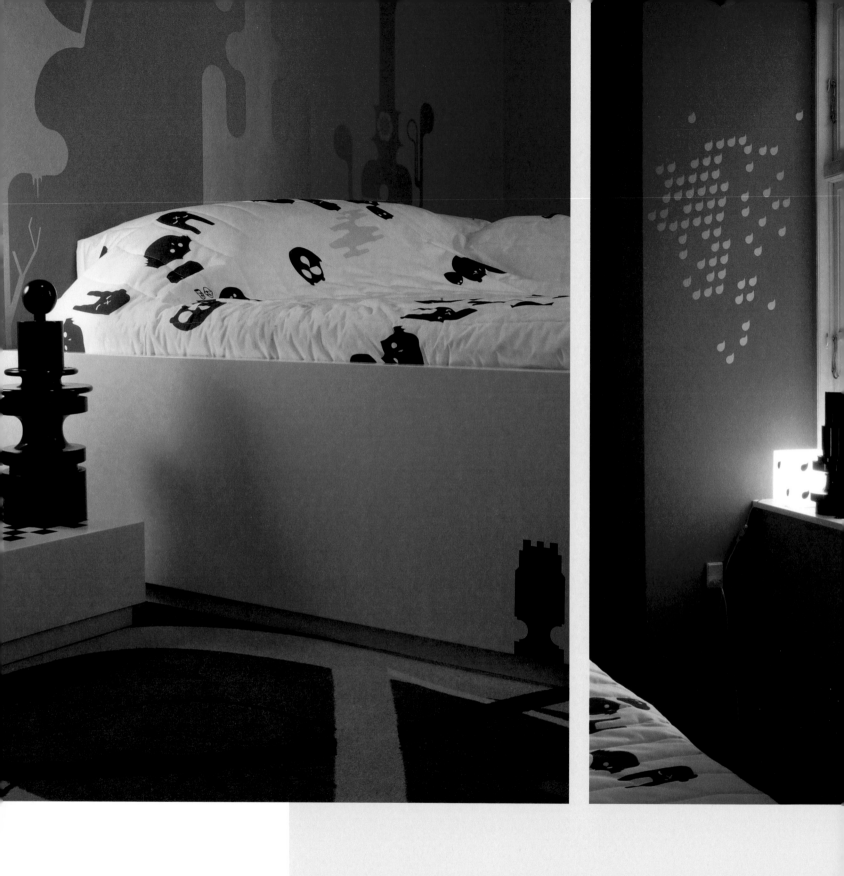

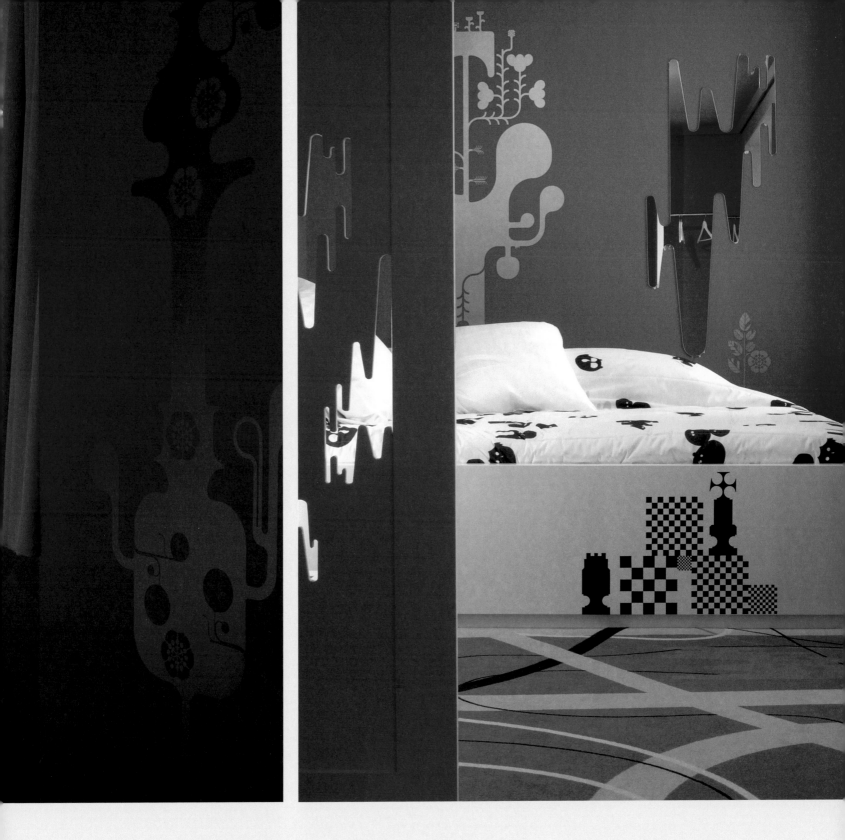

"Room 124: Spare"
Hotel Fox, an art hotel by Volkswagen
Copenhagen, Denmark, 2005

"In the room 'Spare' we graphically pointed out some form elements constituting the car theme, like they flashed in our minds when we were children discovering the world of cars. Besides inkjet prints for the wallpapers, curtains, carpet and the bedspread, we used simple black markers for the corridor walls. We got to know then that we definitely like to draw on walls ..."

GRAPHIC THOUGHT FACILITY

Graphic Thought Facility is a graphic design consultancy, producing both print and 3-D graphics for public and private clients. The directors - Paul Neale, Andy Stevens and Huw Morgan - agree that they all take delight in playing with expectations, *"those of the client, the public and perhaps even our own."* Accordingly, Andy Stevens' view on difficulties is to assess them: *"These are often the catalyst for a solution."* To conceptualize, he and his colleagues usually make basic real 3-D models in the studio. *"Normally, we only commission virtual models when we want them as an image in their own right, rather than for testing or visualizing."* To be in contact with the real thing includes being interested in the range of materials. *"We like going down to the printers and actually seeing the machines and how they do it and what the restrictions are"*, Paul Neale says. When he was still studying at Royal College of Art, he remembers, he spent a lot of time phoning up for samples: *"I used to get an incredible bag of samples every day."*

 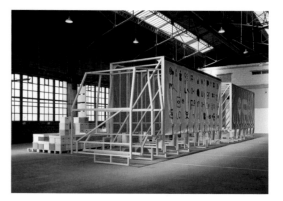

"THE/LE GARAGE"
Joint exhibition with Paul Elliman
Chaumont Poster Festival
Chaumont, France, 2004
Photos by Joel Tettamanti

"Along with Paul Elliman, we were invited as guest exhibitors at this international graphics festival. We needed to create a temporary exhibition of our own work in a space with no exhibition kit: an empty garage. We took the metaphor of a truck (from the space itself and from the work being transported from England) to create an exhibition structure. We used the internal volume of the truck to show our work palletized on a grid of MeBoxes - our own products, cardboard storage boxes with a labelling feature. Paul used the external coverings to display his work. Having to define our own parameters for the project turned out to be very tricky."

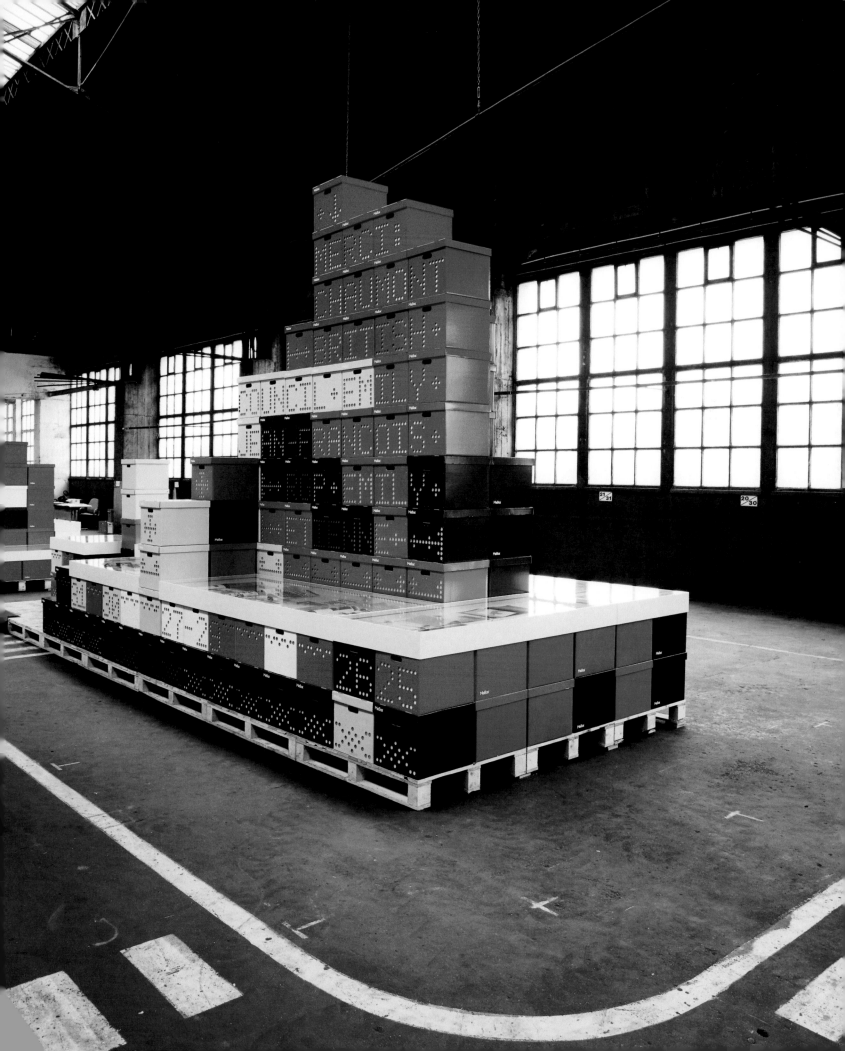

"Café Revive identity and graphics"
Marks and Spencer
Various places in the UK, 2004
Architecture by Urban Salon

"To create an original, contemporary and adaptable identity for the cafe, we took dozens of photos of cappuccino decorations we had made using chocolate dust and stencils, and assembled them as patterns. Along the way, we acquired the skill of making perfect frothy milk."

All the coffee we serve in Café Revive is chosen for its exceptional quality and is certified as Fairtrade.

By using Fairtrade coffee, we help communities in Ethiopia, Honduras, Peru, Indonesia and

It's taken us a long time to **perfect** our Fairtrade organic coffee.

Our unique **double** roasted espresso beans deliver a real intensity of flavour.

Your velvety smooth latte is being made by an expert. Our baristas have mastered the fine balance between

14 steps to your perfect latte...

Grind, dose, tam then **tap, twist, wipe** and **lock.**

Push, purge, stretch and **swirl.**

Tap, pour and **ser**

...ready for you to sip and enjoy!

FIRST FLOOR
SOMEWHERE TOTALLY EL
THE EUROPEAN DESIGN S
27 SEPTEMBER 2003—4 JA

SECOND FLOOR
HELLA JONGERIUS
5 JULY—26 OCTOBER 2003

WHEN FLAMINIO DROVE T
FLAMINIO BERTONI'S DES
1 AUGUST—12 OCTOBER 2

A CENTURY OF CHAIRS
UNTIL 26 OCTOBER 2003

DESIGN MUSEUM TANK
LIVING IN A TANK
A YEAR OF INSTALLATION

DESIGN MUSEUM
CAFE

DESIGN MUSEUM · DESIGNER OF THE YEAR

"Identity for Design Museum"
London, UK, 2002
Illustration by Kam Tang

"A strong identity can be very fluid. Since London's Design Museum is an evolving entity - as is design -, the new identity we created for the museum need not assume it will last for many years. We commissioned and art directed an illustration from Kam Tang to evoke all disciplines of design without featuring known objects or personalities."

157

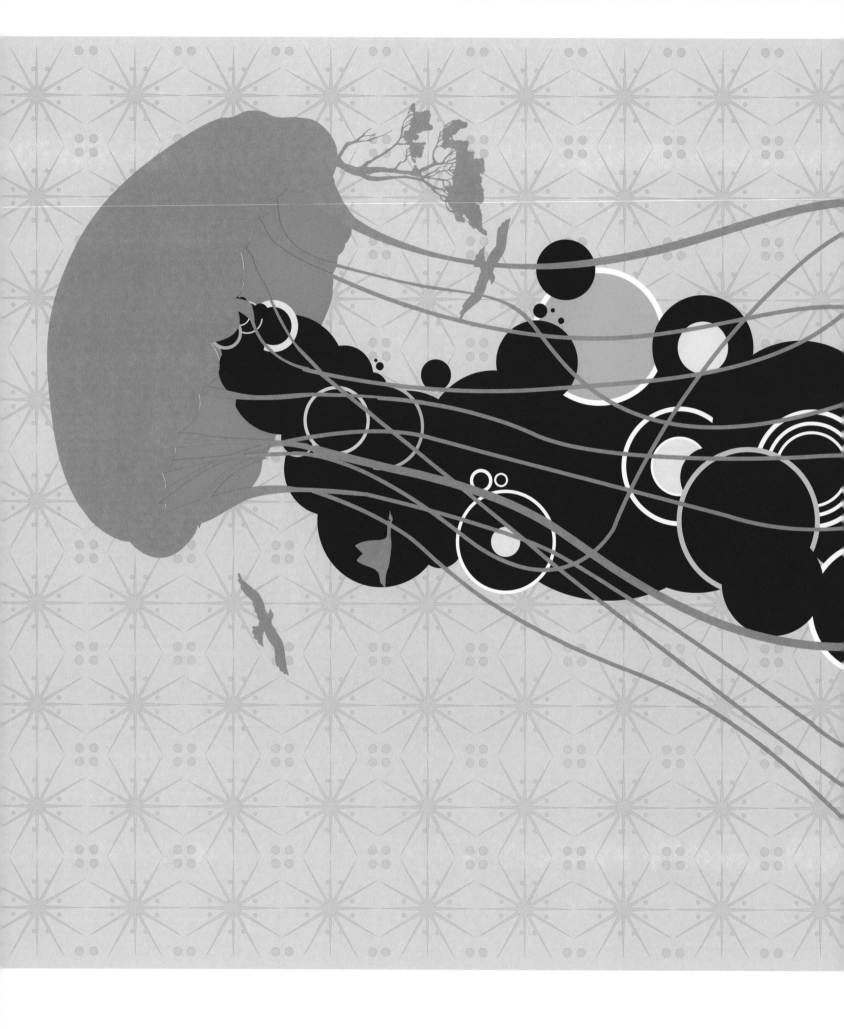

GALLERY

When graphics and illustrations move into the 3-D realm, their most important characteristic sometimes changes: The mass-distribution potential. They are suddenly originals and have a place to stand. That is what happens with the decoration of a café wall – fans of a particular mural can only hope that it will not be painted over by the next café owner.

This process of uniqueness becomes even more apparent when the object is in a gallery or a museum. Here it is in an art context – and so the beholder is conscious of it in a different way, even though it may be stylistically similar to its counterpart outside the gallery walls. For one thing the object is separated from possibly irritating accompaniments: It does not have to create a consumer-friendly atmosphere or blend in with the client's corporate identity. It is not just glanced at in passing; an audience comes to look and to receive. But it now underlies the laws of the art market: It is a topic of conversation, swathed in an elaborate code that has hundreds of years of definitions and questions on art theory as its base, and critics will desemble the object, if, indeed, they are interested in it at all.

The jump from public space to an art gallery is one of particular meaning for street artists. They may distance themselves from their original community when suddenly confronted with a world of middle-class collectors and gallery owners. But the fact that they come from a subcultural milieu is what makes them interesting for the art world – a phenomenon that became apparent with Andy Warhol, Keith Haring and Jean-Michel Basquiat. Artists have different ways of dealing with this: Dave Kinsey, presented in this chapter, is successful with his agency but at the same time works on artistic projects with socio-critical messages, which is what he did when he was an active part of the street art scene. Barry McGee, on the other hand, appears only briefly at his own openings, to then disappear with friends, tagging around the block. He is still in action with his street name "Twist".

Galleries could become interesting places for graphic artists in general, regardless of the element of authenticity demanded by the art world. For example, Steve Smith, with his agency Neasden Control Centre, does not just design snowboards and "Frame" covers, but has also built up a reputation with exhibitions and books, to the effect that the sale of originals has become one of his main sources of income. Market experts predict that graphic design could be the next big trend after photography. The new generation collector rates the intimacy between art design and pop culture, electronic music and skateboard culture, but also formal criteria like the high significance of collage and deconstruction. There are already a few large and many small galleries working together with graphic artists.

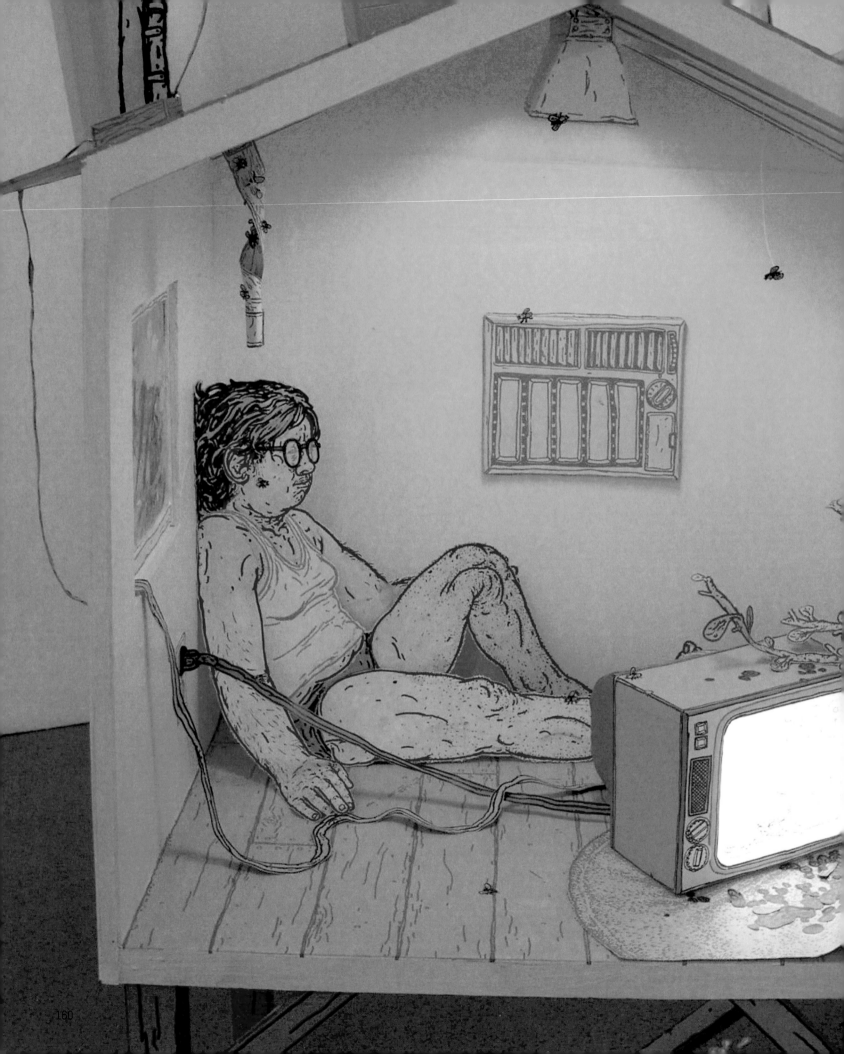

TAYLOR MCKIMENS

Some of Taylor Mckimens' works look like strange oversized card models. He combines materials such as wood, chipboard, and plastic, with hand-drawn paper cut outs. The objects reside somewhere between the second and third dimension, like graphics that have been reassembled into the reality they once were borrowed from. However, the stories they tell couldn't be more far from a cute little paper world. They usually play in low-class surroundings, like mobile homes equipped with shabby furniture, and the people in there don't look very lucky. When McKimens was a child, he always wanted to become a cartoonist some day, even though he didn't consider the Garfield type strips funny at any time. So when he discovered his cartoons were even less funny, he decided to become a penciller for comic books. After having taken illustration in art school, he finally chose to do the artwork he is known for now. He doesn't think descriptions would be in line with his works: *"Visual art has to be experienced by looking at it rather than to being described by words."*

161

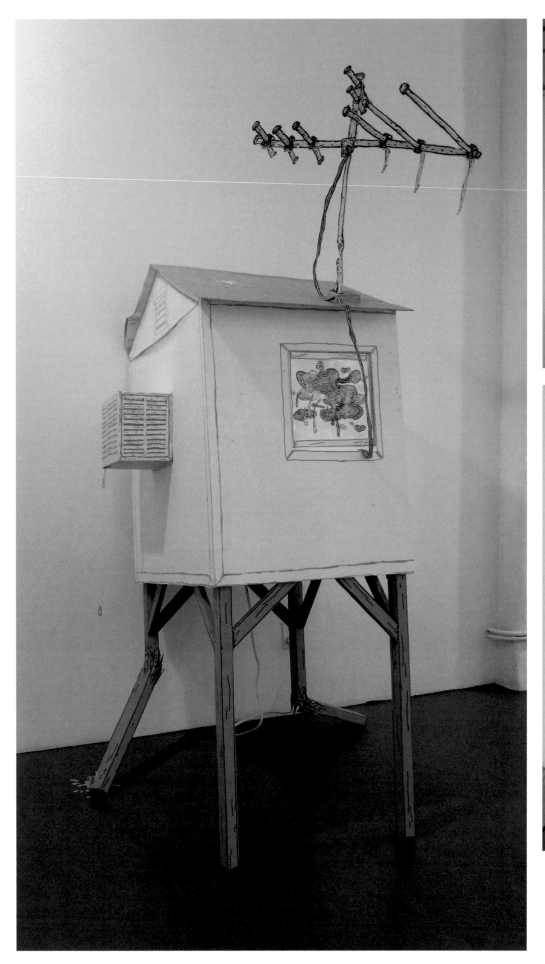

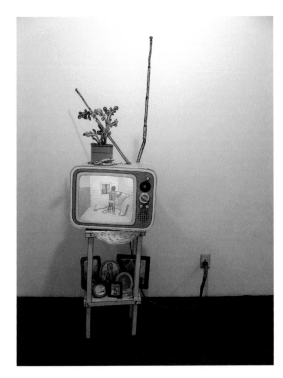

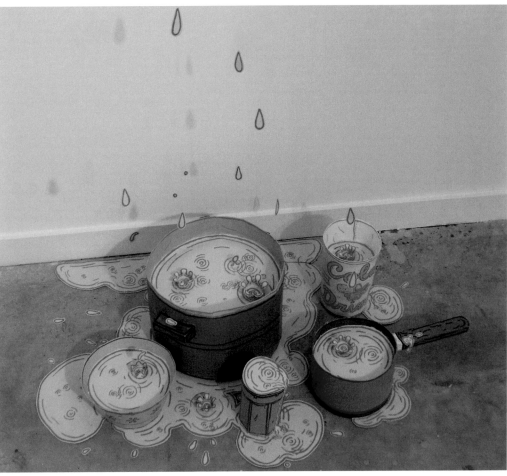

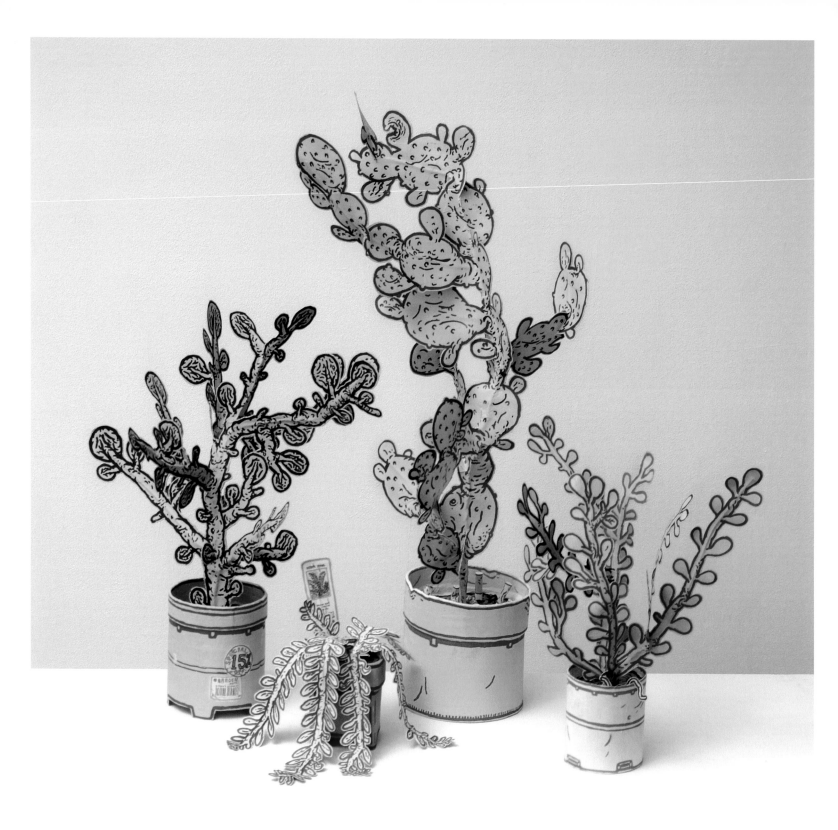

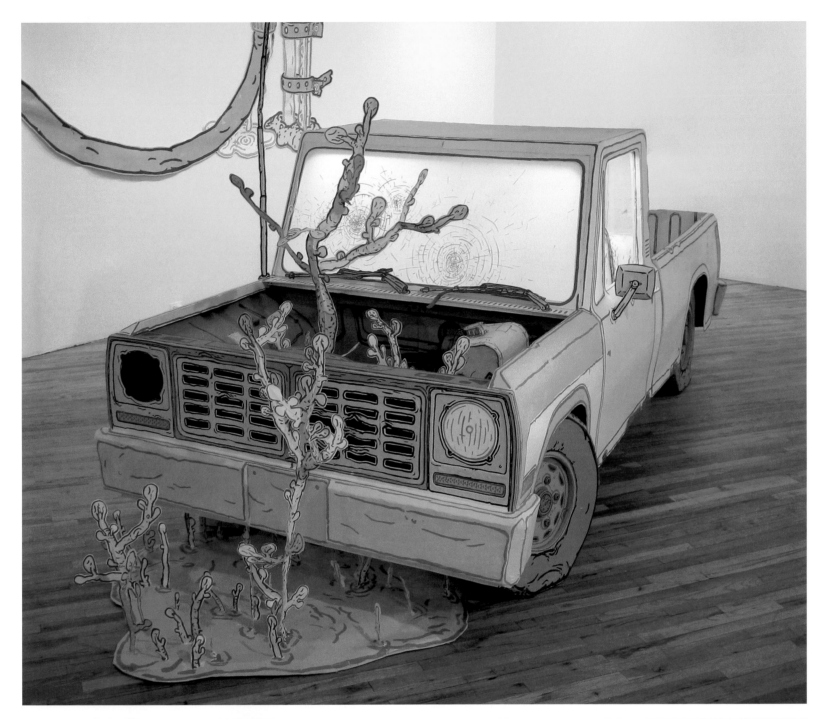

DAVE KINSEY

Though Dave Kinsey feels part of a *"growing dimension of urban influenced artists"*, he does not like to be labelled as a skateboard or graffiti artist. However, his fine art and product patterns still reflect the kind of illustration he acquired in the urban milieu, combining social commentary with a stylish sign language. His fine art has long since been featured by prominent galleries, and his creative agency BLK/MRKT has become a high-ranked address for anyone who wants to reach out to the youth market.

Kinsey still studies his surroundings intensively and transforms his impressions into pieces of art. *"To paint on fabric or wood allows me to express my thoughts and emotions that are to a great extent stimulated by my daily environment."* He frequently uses the term *"unlearn"* to articulate the concept he tries to convey with his design and art pieces: *"Its objective is to push people into seeing a perspective other than their own - and to question the origin of what is considered normal and tolerable."*

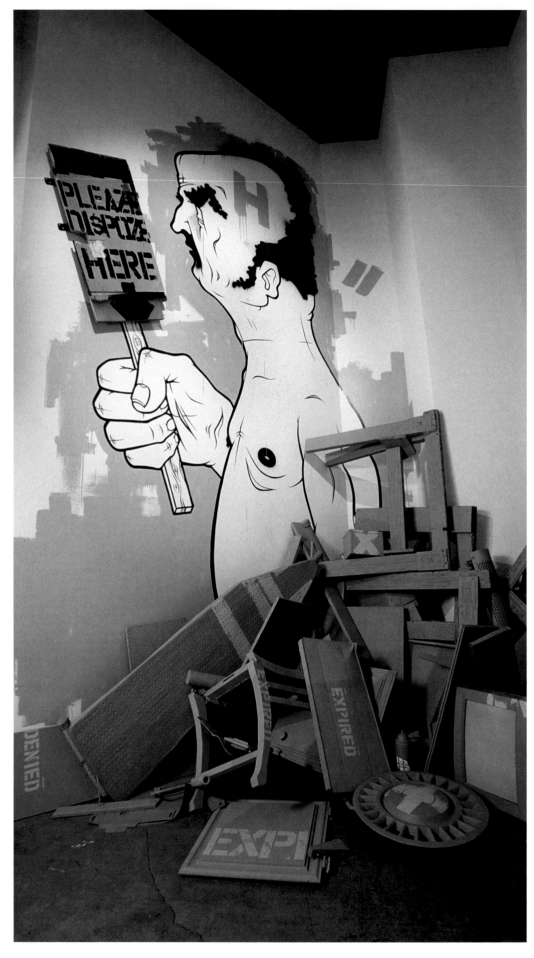

"Expired ,03"
Multimedia installation, 2003

"This floor-to-ceiling installation I created for the BLK/MRKT Gallery exhibition in 2003 was made up of found objects and built on-site. I explored many L.A. alleys and junkyards to find what I needed to complete my vision."

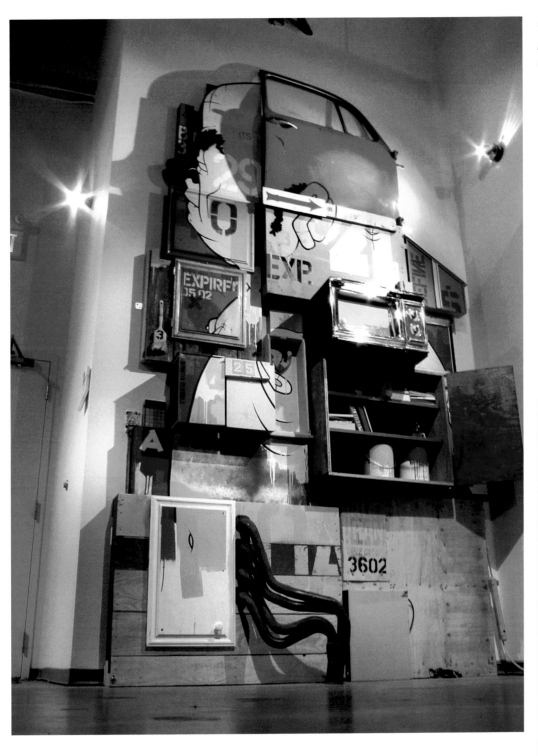

Paper & wheat paste, Paris, France 2000

"Sculptural Mural .03"
Acrylic, spray enamel and oil paint
on found objects

BARRY MCGEE

In 1984, Barry McGee did his first graffiti under his street name Twist, soon developing a style people could recognize instantly. While his art meanwhile fills the galleries, he views graffiti as a lively means of communication, and has never stopped practicing it. After all, he claims to prefer graffiti over art. *"It's illegal. People get upset about it, you know? It's the one thing people really hate. I think tags are the most beautiful things in the world."*

As a graffiti writer he is best known for the characteristic baffled-looking large heads via which he left his mark all around San Francisco. When acting in the more conventional art context, he still includes variations of these characters, as well as graffiti gestures and styles in his occasionally room-filling installations.

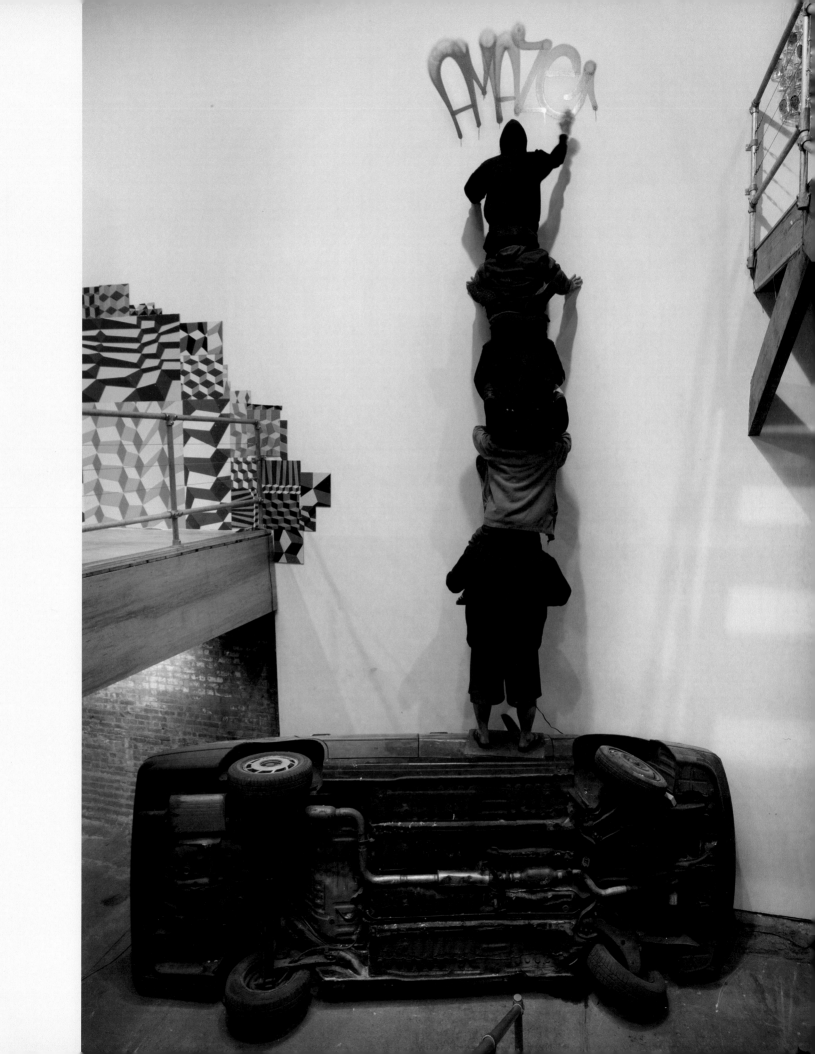

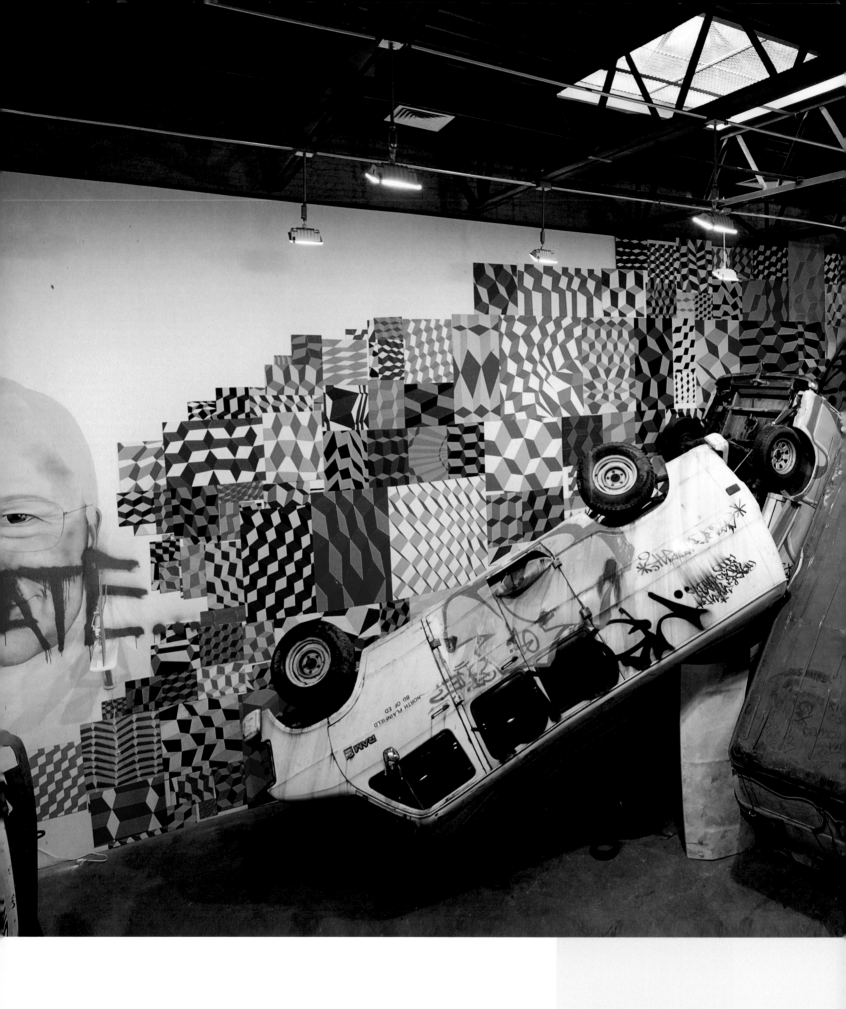

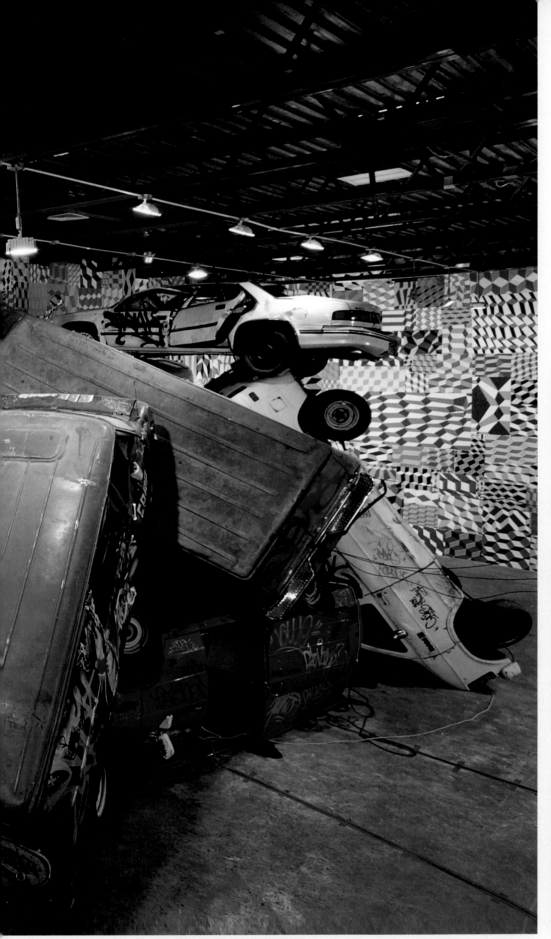

Courtesy Deitch Projects

171

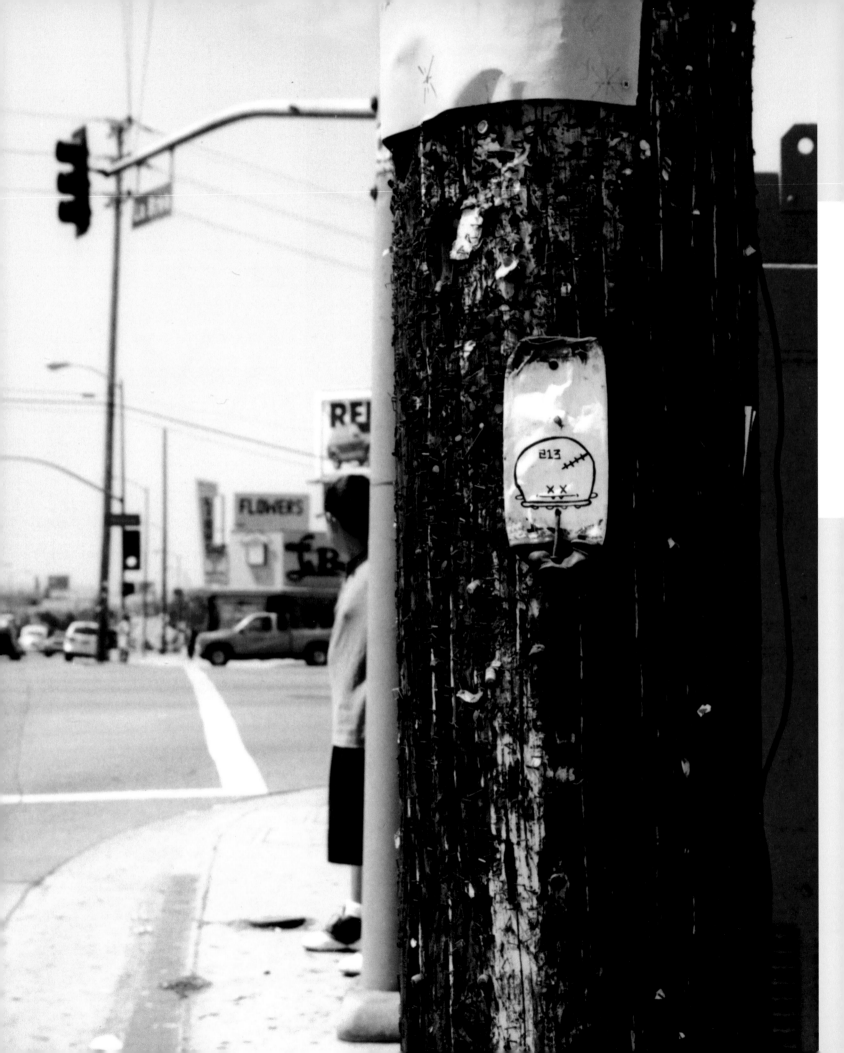

BUFFMONSTER

The Buff Monster has co-designed Los Angeles' cityscape for years now. His street art, mostly big-sized posters and installations, is also known beyond his homebase - it has been sighted in many other cities, such as San Francisco and even Tokyo. Work in the public space is of particular interest to him: *"It's interesting for me to transform or enhance a 'real' environment rather than a gallery. To do site-specific work in public usually inspires me a lot more than redesigning the four white walls of a gallery."* Maintaining his presence on the streets is what he considers as his day job, but to earn money he works in Beverly Hills as the Creative Director for BPM, a magazine related to electronic music and DJ culture. In his works he merges form characteristics of cultural phenomenons as close to each other as porn and ice-cream. Imagine a theme park consisting of his typical pink mound figures: *"Creating my own world, like Disneyland, would be amazing. 3-D shapes made of fibre glass, painted pink and white and silver, squirting and flowing through the whole land. We'd have sweets and ice cream available throughout. Everyone attending would end up getting wet at some point. I would love to have the budget to do a project like that."*

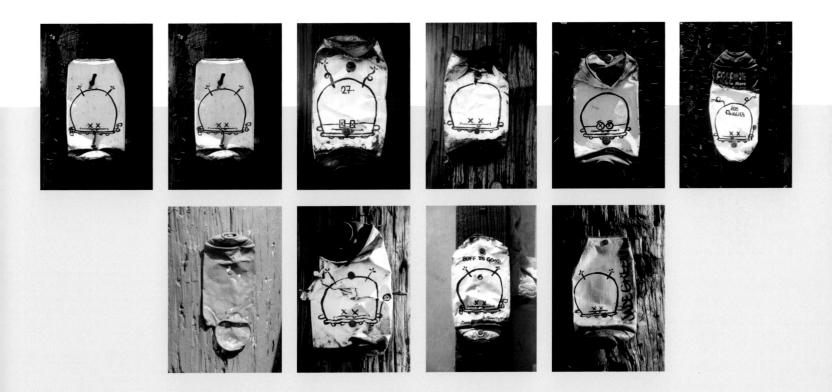

"Buff Monster Cans"
Street installation, Los Angeles, California, 2001

"The project was to get the drawings of the characters out in public in a very permanent way. Most street art is ephemeral, and I really wanted to create something that could last for a long time.

At first, I used flattened spray paint cans, primed with latex paint, the characters drawn with a permanent marker. I did many pieces in Los Angeles and San Francisco and then I made this new series. I drew the characters with Marsh ink, the most permanent ink that is sold here. All the cans are installed with 24-inch nails.

I learned that small installations can be very effective, and that the cans are much easier to remove than I originally conceived. I am in the process of creating a new series of cans to install in the street."

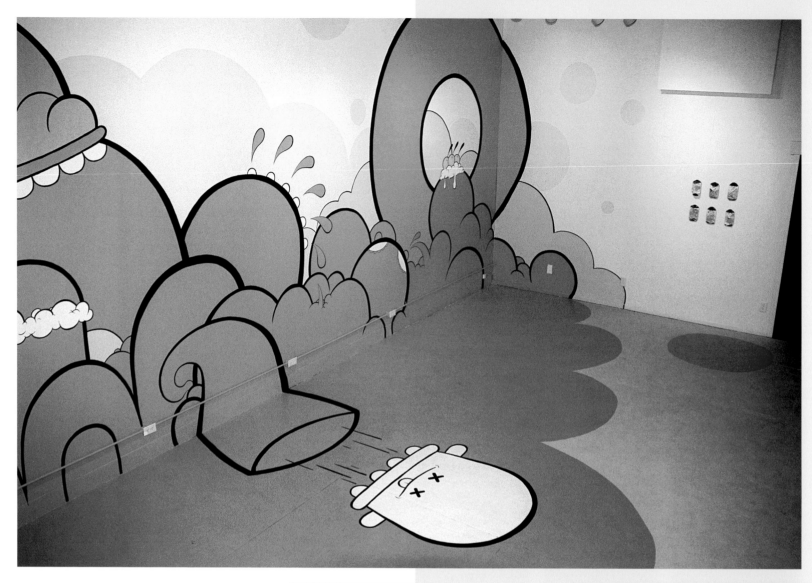

"Sweet Indulgence"
Exhibition, walled city gallery
San Pedro, California, 2003

"At the time, this was the biggest painting I had accomplished in my style. As usual, I wanted to offer the audience an amazing sight. I used latex paint and Marsh ink. We used paint on the whole wall and floor and outlined everything with the Marsh ink. During this project I learned how to seamlessly recreate a small drawing on a big wall, with a very short deadline. Besides Marshall, the gallery director, my brother Xtra was the only one who helped, and he did a great job."

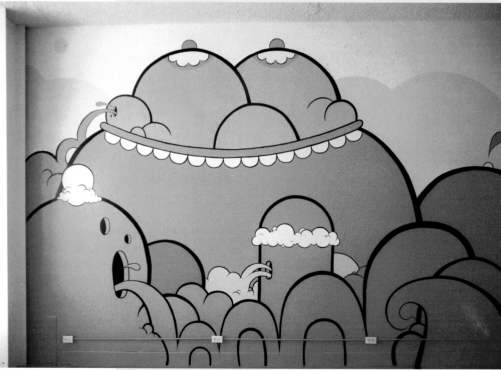

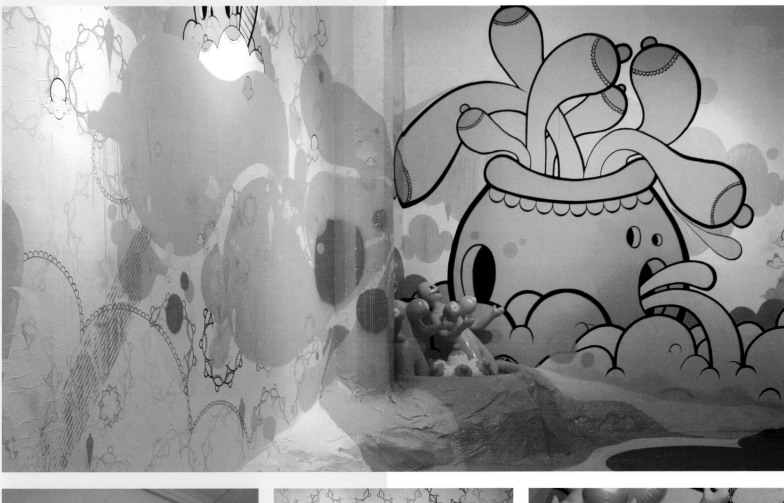

"Lick It Up"
Exhibition, Transport Gallery
Los Angeles, California, USA, 2005

"My intention with this art installation was to offer the audience a whole new look at my work and the ideas behind it. It consisted of silk-screened posters (pulled by hand), latex paint, acrylic paint, silk-screen ink directly on the wall, Xerox cut-outs, spray paint and Marsh ink, a thick black ink manufactured for industrial jet printers. The 3-D work was made with newspaper and a rubber pool with a wood structure underneath it. We added blow-up dolls and a custom made a fountain. We made silicon moulds for the boobs and nipples and then assembled them and painted them with latex paint.

I learned all about silicon moulds and casting quick-set plastic. I also learned how to manage a whole crew of people to get this project accomplished on time."

NEASDEN CONTROL CENTRE

Neasden used to be a place in a London borough. At present, Steve Smith locates it "between London and Barcelona". Anyway, it is the home of Neasden Control Centre, the place where he and his colleagues do their famous graphics. Their edgy and home-made style is appreciated by many for its devil-may-care-attitude, a spirit often linked to Punk or Grunge. Smith mixes hand drawings and written text with photography, figures and an impressive array of found objects. Though you may detect traces of contemporary artists in his works, don't ask him about that, as he usually rejects *"influence questions"*.

"Crossed"
Installation, Centre de Cultura
Contemporània de Barcelona, Spain

"We were asked to make an installation for the ‚Crossed Circuits' exhibition, which focused on the crossovers between art and design. We built a wooden typeface entitled ‚Who loves the invisible man?'."

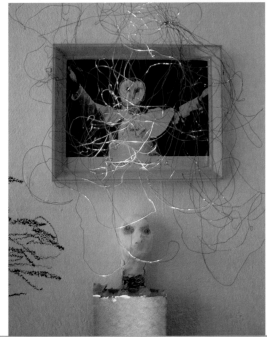

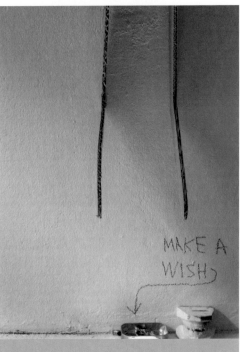

"Filesharing"
Filesharing Showroom, Berlin, Germany, 2003

"We built this Trojan horse from cardboard in two days, together with a wall installation and a mini ramp."

"55DSL"
Installation, Action Sports Conference
San Diego. 2002

"Street wear brand 55DSL asked us to help them create an installation for a conference. At the 55DSL stand we created a 20 foot poster and collage from material made before the trip. We then invited visitors to join in and paint a glass window with us. Other material designed exclusively for this event was postcards, stickers and a limited T-shirt."

177

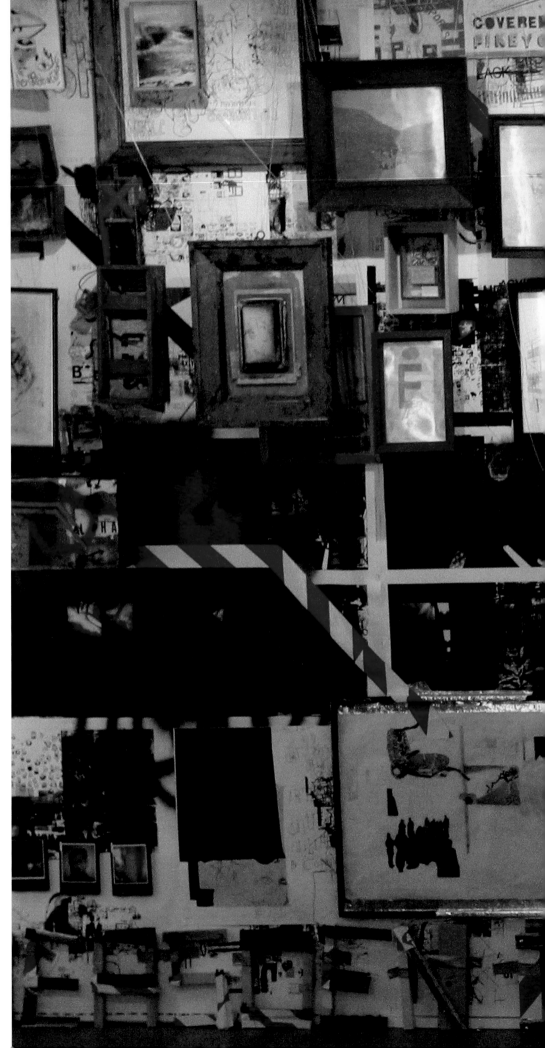

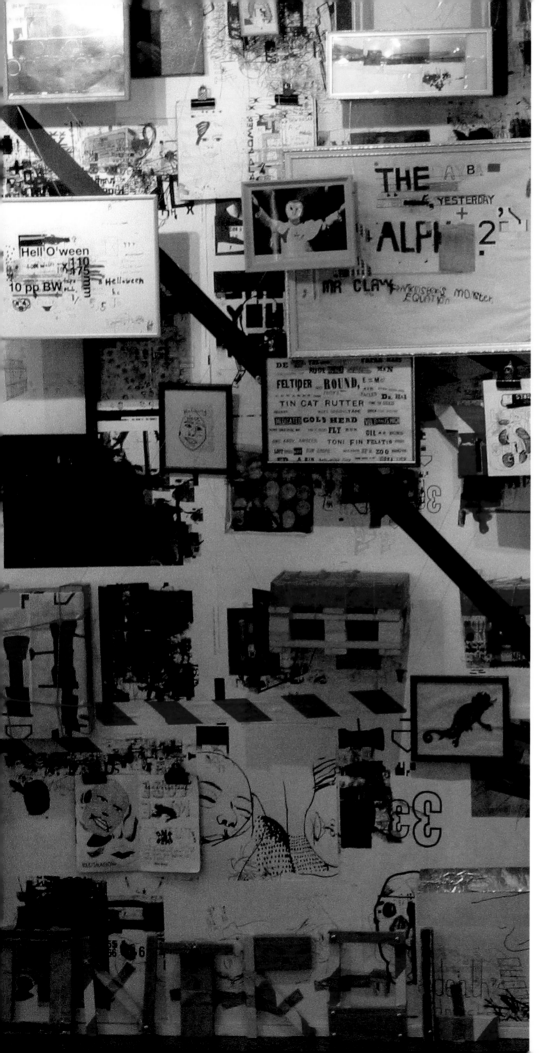

"Magma"
Magma Clerkenwell Bookshop, London, UK, 2003

"The exhibition marking the publication of our book featured a large collection of our work, such as posters, paintings, 3-D objects and notebooks, plus new pieces we created exclusively for the show."

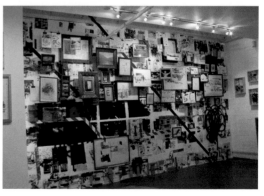

179

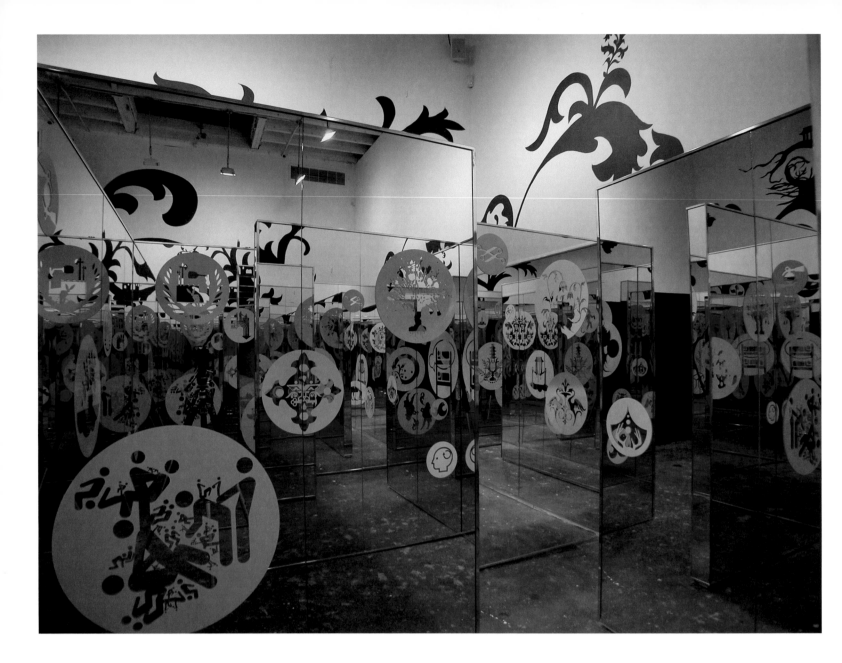

RYAN MCGINNESS

The works of Ryan McGinness are likely to be seen hanging in galleries as well as covering book pages. While his methodology often resembles that of a graphic designer - highlighting shapes and colours, assembling layers -, his general approach is distinctly artistic. He samples and mixes elements of various iconographies, whether official or vernacular, and thus reveals or changes their underlying meanings.

For him, art and design are not to be equalled. Though he is interested in pondering the meanings of mass-produced products in comparison to unique artefacts, he says he does not take the word ‚art' too lightly. *"I like products, because they're accessible, and I like paintings, because they're not."*

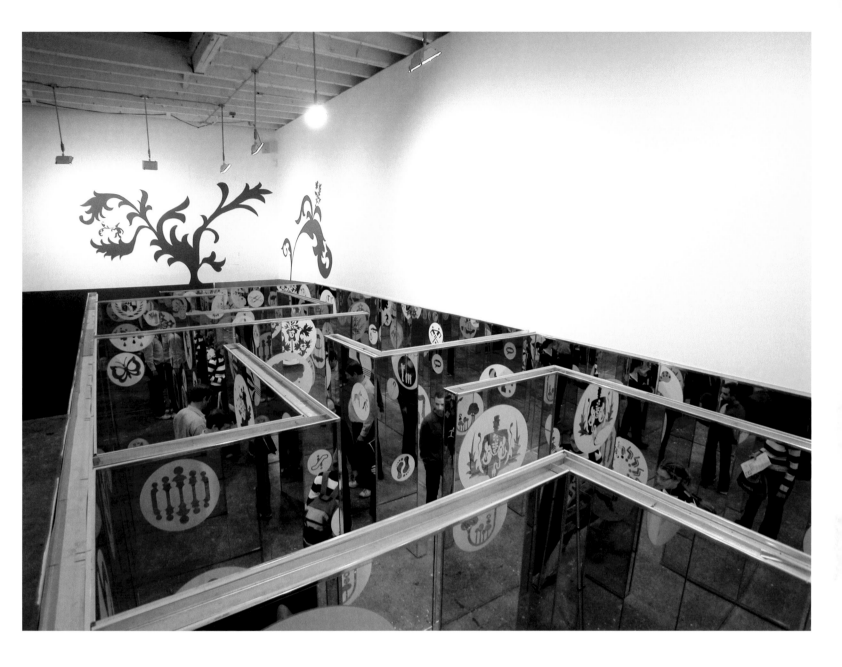

"Worlds within Worlds"
Mixed media, site-specific installation
Courtesy Deitch Projects, New York, 2003
Photos by Tom Powel Imaging

"The layered silk-screen compositions inside this mirror maze installation are about a fractal-based, ‚worlds within worlds‘ structure that mirrors the parallel-dimensions model of the universe."

"Dream Garden"
with Julia Chiang, Mixed media
site-specific installation
Courtesy Deitch Projects, New York, 2002
Photo by Tom Powel Imaging

"I am interested in our desire to make sense of chaos and give meaning to seemingly abstract forms. With my work, interpretations are not absolute, but guided, allowing the viewer to bring to the work his own history, memories, and knowledge to find a personalized meaning."

"Pain-Free Kittens"
Installation view, Quint Contemporary Art,
La Jolla, Courtesy Quint Contemporary Art, 2005
Photo by Roy Porello

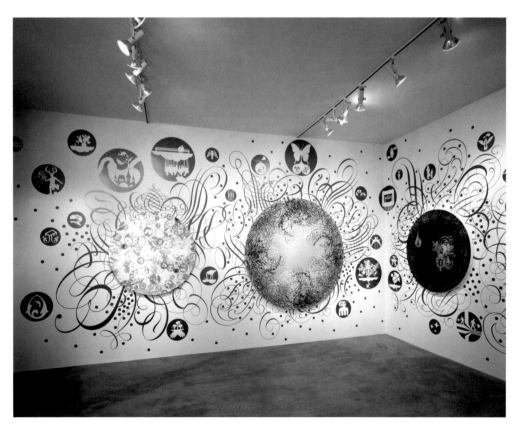

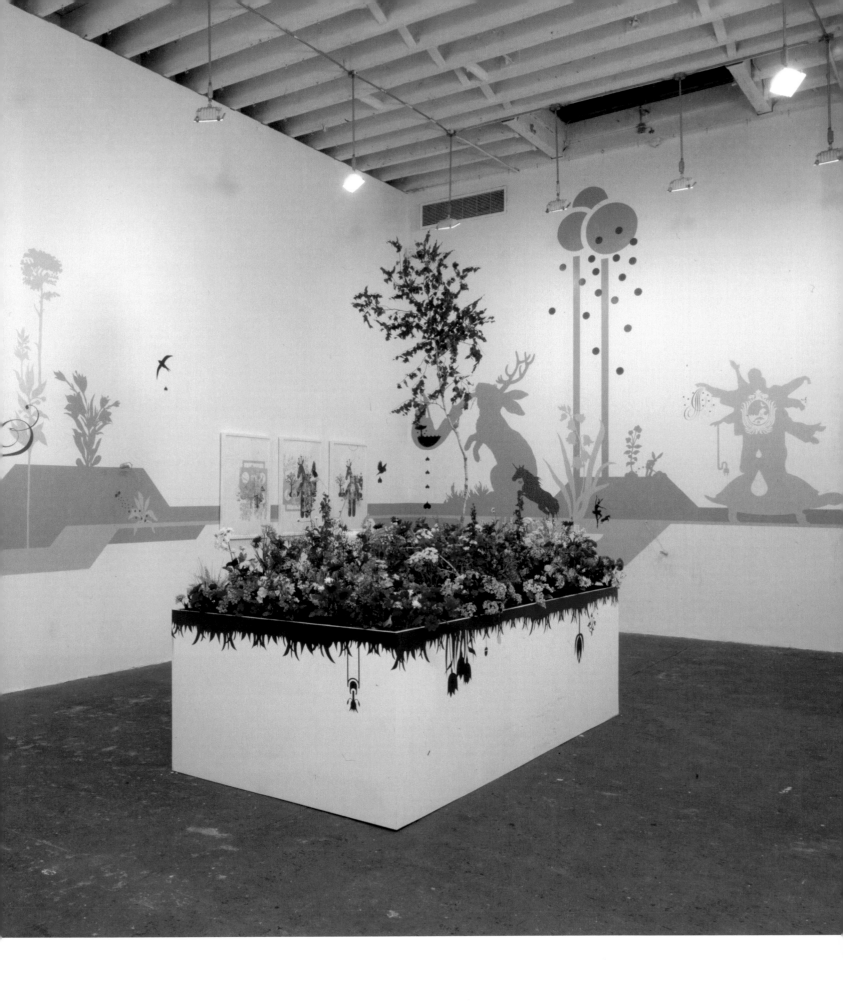

DAVID ALTMEJO

Horror and glamour meet in the work of Canadian born fine artist David Altmejd who now lives and works in Brooklyn. Critics have called his sculptures opulent, complex, grotesque and evocatively incongruous. Jeffrey Kastner went even further and described one of Altmejd's pieces in an article in Artforum International as a *"disco sarcophagi for broken werewolf corpses"*. The werewolf is indeed a continuous element in Altmejd's work and his use of mirrors, jewellery, flowers and lighting creates an almost unbearable theatrical effect for the beautiful beast.

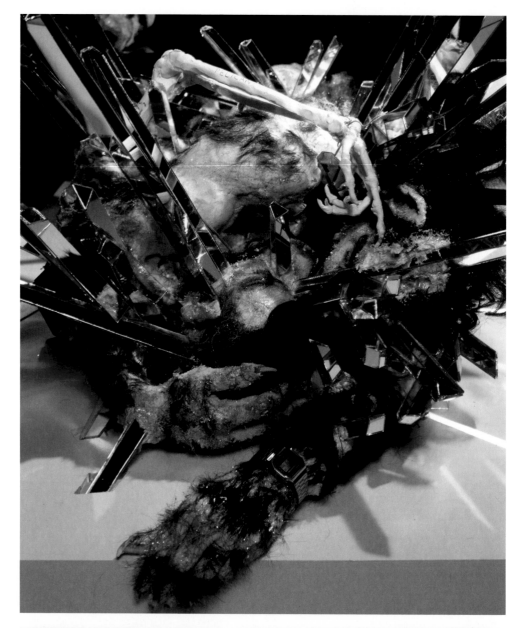

"The Settlers"
wood, plexi glass, glue, mirror, synthetic hair, glitter, clay, wire, foam, electric light
127x183x305 cm, 50x72x120 ins
2005

"The University 2"
wood, paint, plaster, resin, glass, mirror, Plexiglas, wire, glue, plastic, cloth, synthetic hair, jewellery, glitter, minerals, paper, beads, synthetic flowers, electricity, light bulbs
272x546x640 cm, 107x215x252 ins
2004

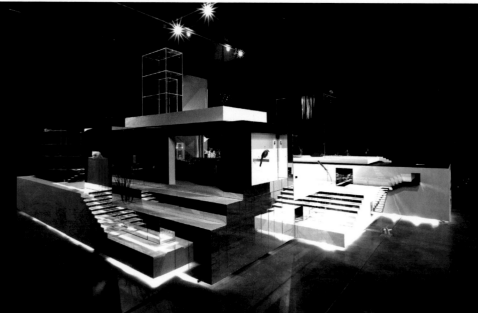

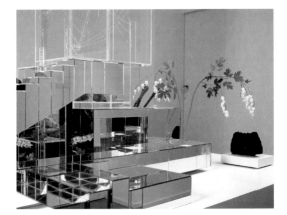

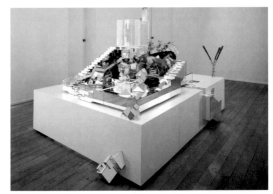

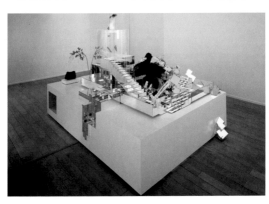

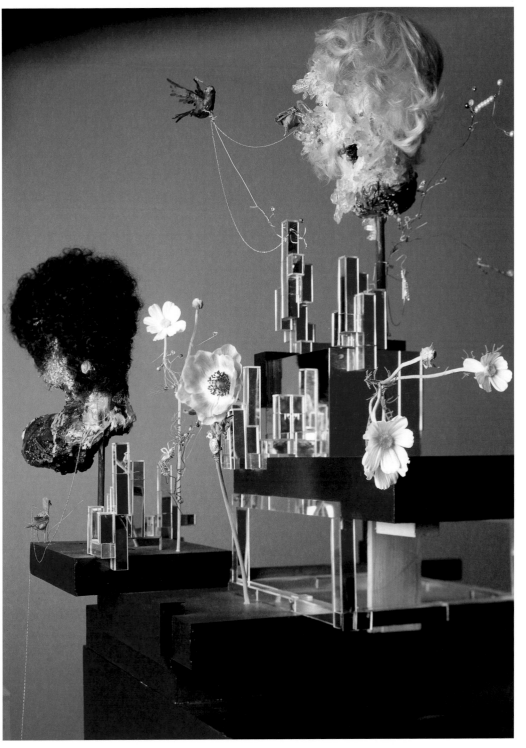

"The Builders"
wood, glass, mirror, Plexiglas, Magi-sculpt,
foam, synthetic hair, synthetic flowers, jewelry,
feathers, paint, lighting system, minerals
183x193x259 cm, 72x76x102 ins
2005

"Delicate Men in Positions of Power"
wood, paint, plaster, resin, mirror, wire, glue,
plastic, cloth, fake hair, jewellery, glitter
244x488x457 cm, 96x192x180 ins
2003

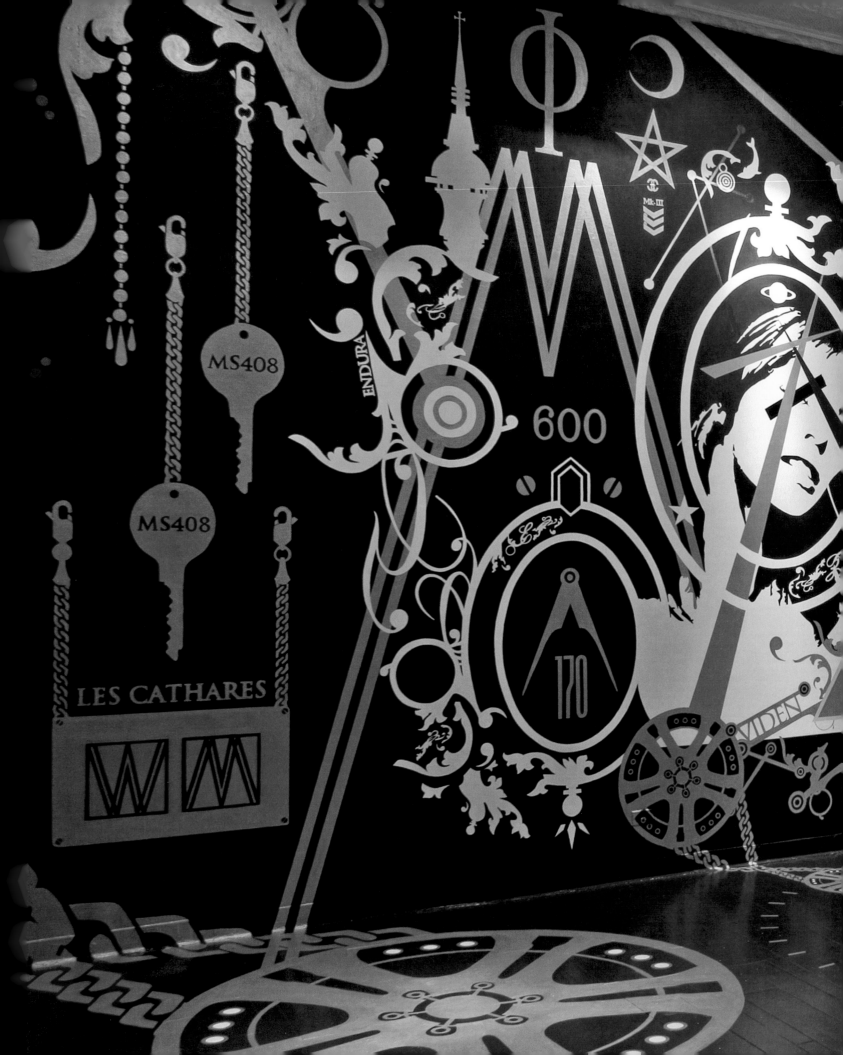

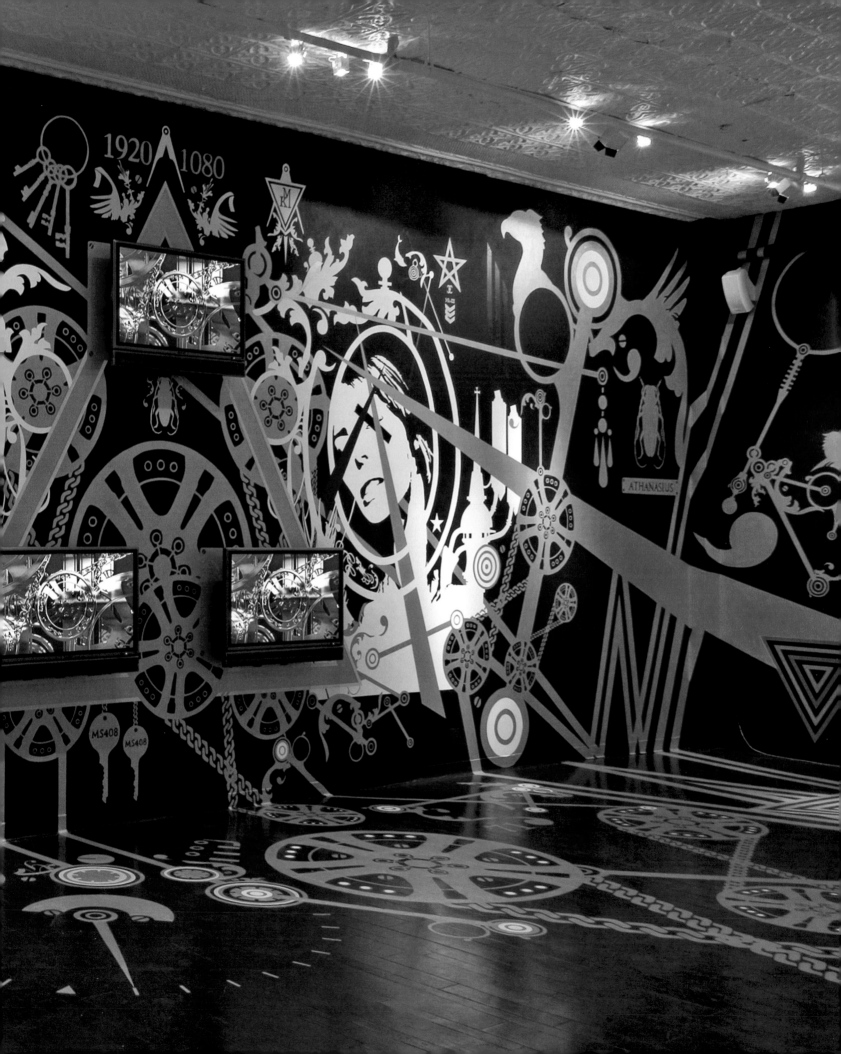

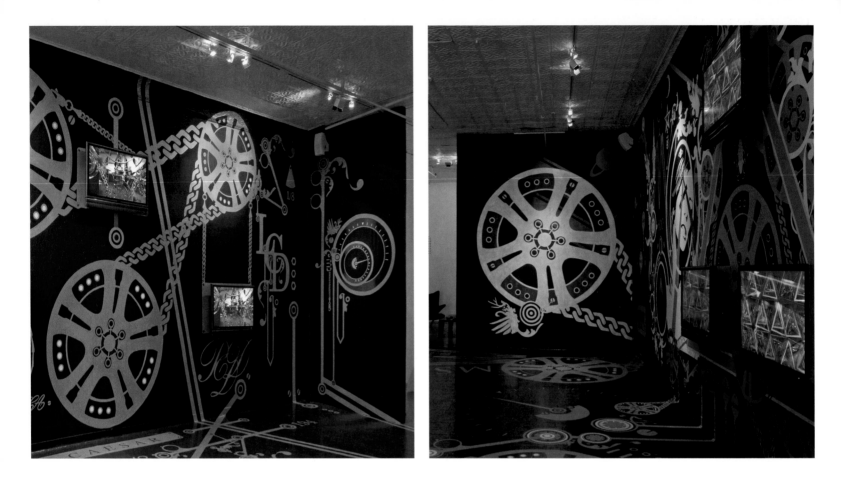

KENZO MINAMI

Kenzo Minami started doing graphic design while developing titles for the short movies he shot. Maybe that is why some of his works generate a highly dynamic impression, as if the elements they consist of are on the point of exploding. *"Any piece starts in my head 3-dimensionally"*, he says, *"sometimes it is a movement in space, a nuance I want to capture, or just a feeling I want to convey."* The next steps are usually sketching it out on paper and building a paper model in the actual proportions. *"This helps me to catch the feeling of the finished space much better than a 3-D computer program would do."* But there are exceptions when he just takes buckets of paint and brushes and goes for it.

After all, the texture of the surface he is working on, and how it reacts with the materials he is using, is a crucial point for him. *"It's very important to first know your materials and how they behave. Especially when it comes to large pieces that take days to be completed, even small details may require a lot of time. Also, a different method you might be forced to use can slow down the process seriously. It could lead to piling up extra hours or even days. And most of the time, I cannot afford such extra time."*

One of the elements Kenzo Minami always focuses on is the movement his pieces induce in the particular space. *"I like to test how much I can go against the site's general spatial struc-*

ture. The sense of space is confined by the floor, walls, ceiling and how they all meet. I like to play with it, to tweak the sense of dimension." Doing so demands keeping in mind the actual architectural layout of the space. *"Only then do I lay out my piece according to it, asking myself: ‚How will certain elements in my piece capture the audience and guide their eyes to a particular direction?‘ ‚May they be led to another element as I want them to?‘ This is basically the same with most of the arts - but especially graphic design and architecture. All the elements are specifically where they are to manipulate how people access and interact with the information they find."*

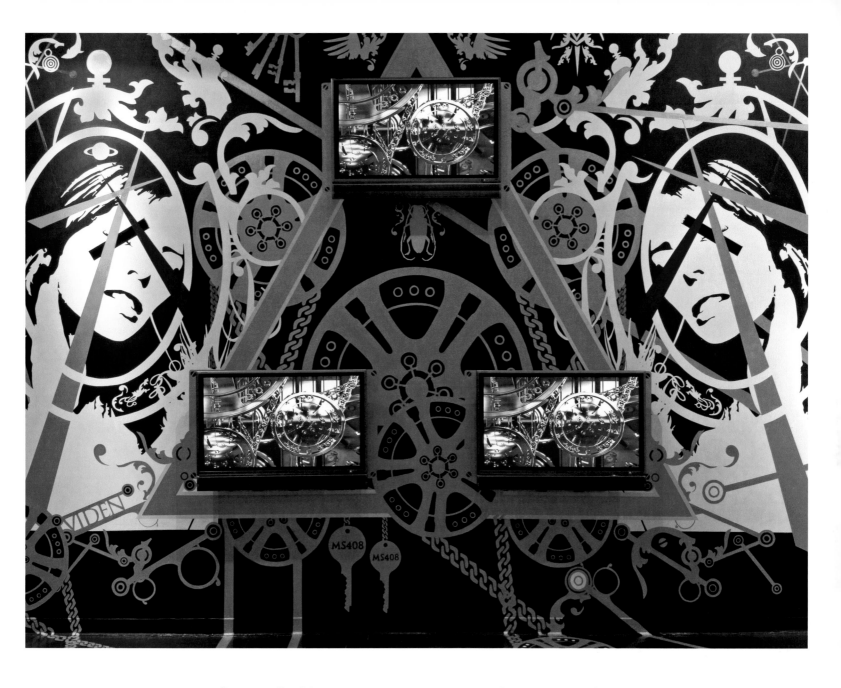

"CODEX 408"
Mural painting, video installation
Nike Art Space (now Nike iD Space)
New York, USA, 2004

"This piece was an occasion to intensely train my skills and to develop my very own technique which I still use. Though I had done large pieces before, none of them had been as large as this one. Also, when I was just about to start, the quality of the surface turned out to be not as good as I had been told. So I had to make drastic changes in my planning. I had only eight nights to complete the entire space: two large walls, the floor and part of the ceiling. Since I was working on some other project in the daytime, I painted from 8 in the evening until 5 or 6 in the morning, slept a few hours and went to my studio to work again. Above all, I learned to be adaptive to quick changes in environment and situation."

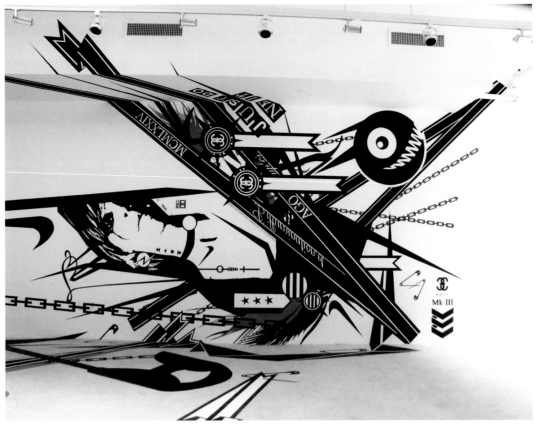

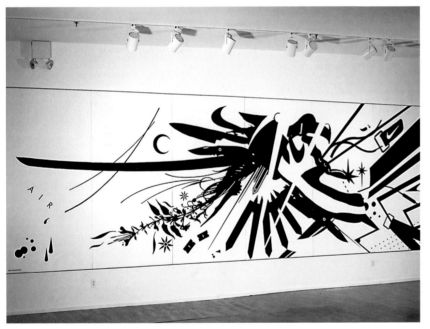

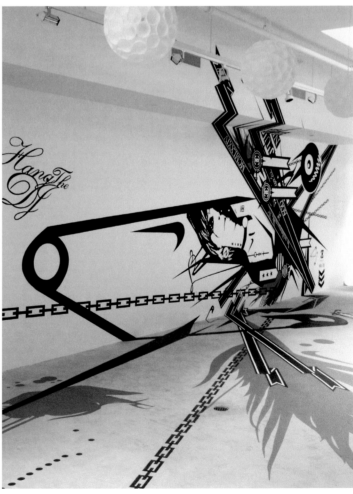

"Dissect"
Acrylic paint on wood, Nike store, USA, 2003

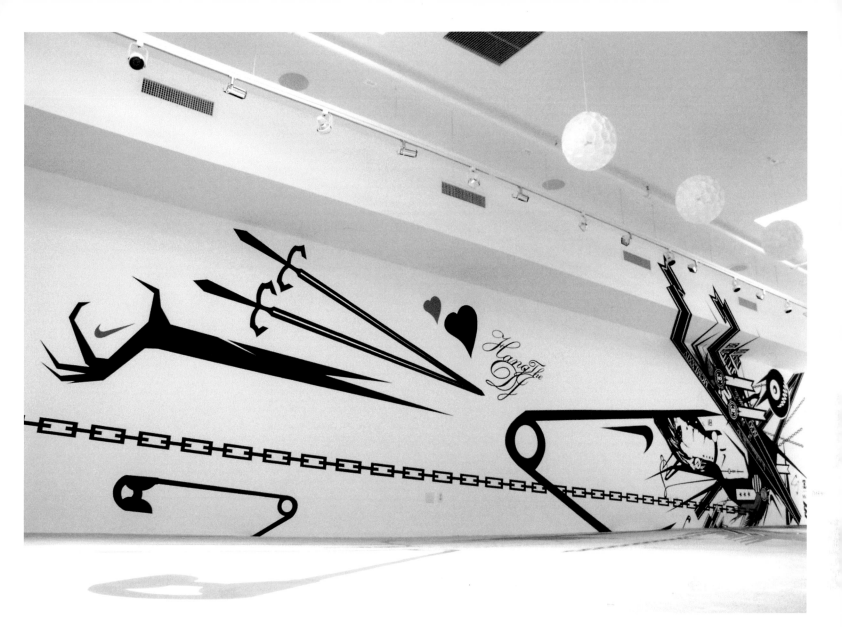

"Reconstruct"
Acrylic wall paint, Nike Store, New York, USA, 2003

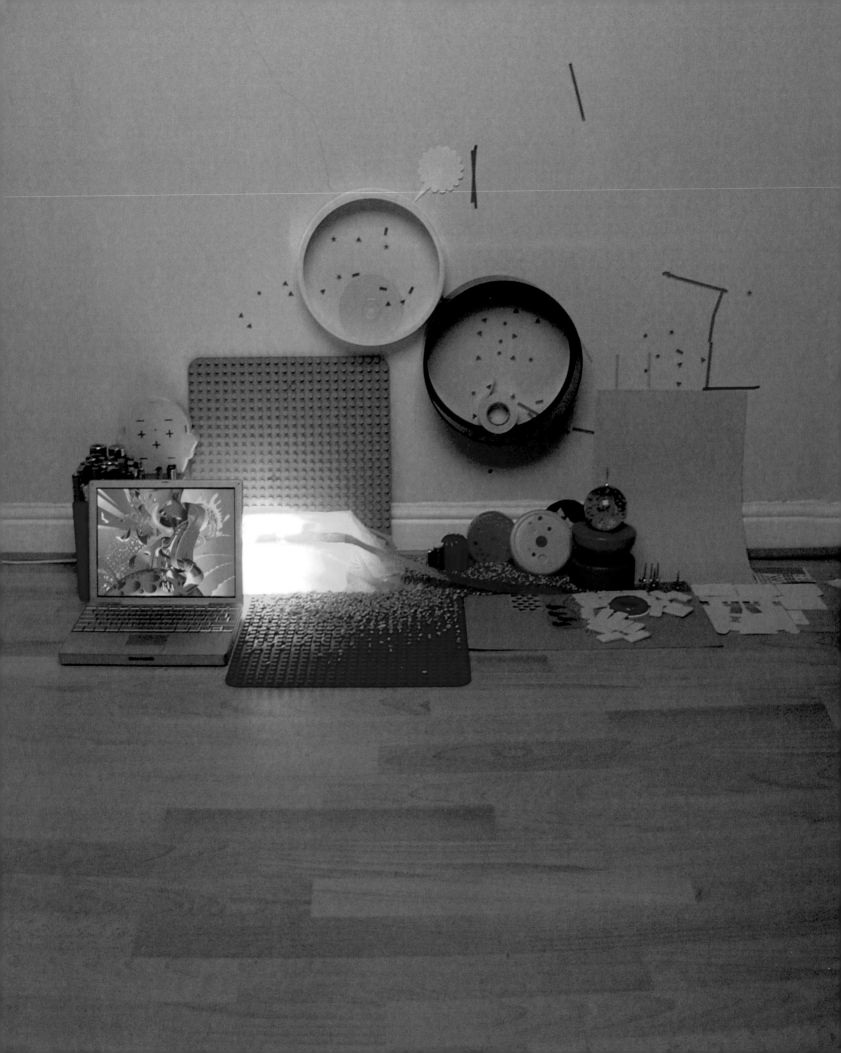

UNIVERSAL EVERYTHING

Ever since Matt Pyke (formerly The Designers Republic) founded the creative studio Universal Everything, he has aimed to live up to its name. A modular team of graphic and sound designers, programmers and image animators is constantly occupied with - to put it in Pyke's words - *"pushing all mediums"*. Emphasizing its interdisciplinary approach, it is only natural that 3-D design and art disciplines are of great importance to him. Among others, he references the artist Tom Friedman, who is known for transforming household materials into playfully crafted installations, and the Dutch architecture and urban design office MVRDV. Like them, he tends to look at things as a whole: A space he has always been impressed by is the view from Mam Tor, a high peak in Derbyshire, and his favourite project would be to do *"a landscape art project viewable from space"*. But that doesn't absolve him from caring about tricky details. *"When shooting my installations in low light, the power savers on all the devices create headaches to light the compositions!"*

"Everything We Liked on 22nd
November 2004 at 12.36pm"
Draft_1 magazine, Sheffield, UK, 2005

"The brief was to create unseen personal work for a new creative magazine. We intuitively arranged everything we liked on the day the brief arrived, and kept hold of it with one single digital shot. Impulse is king."

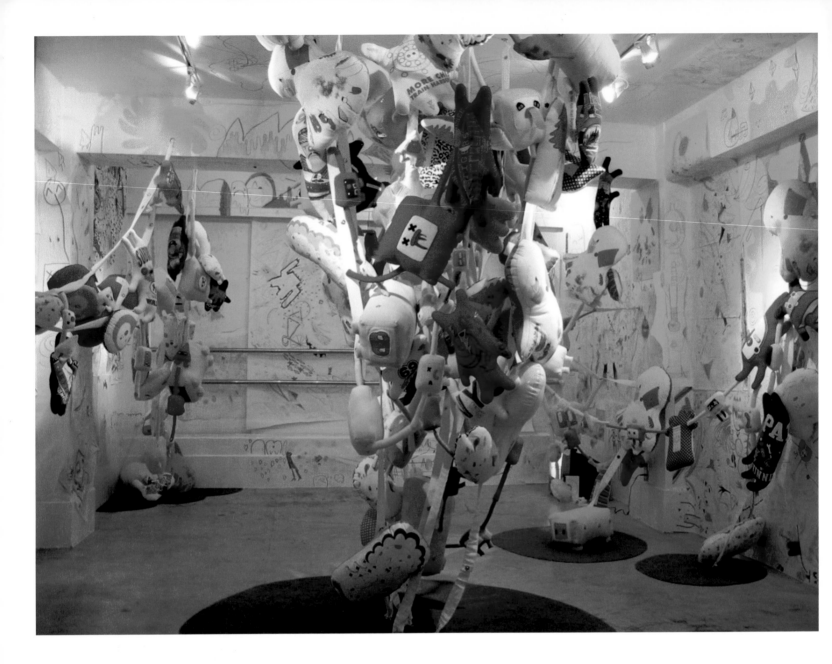

FRIENDS WITH YOU

"If it's not fun, we wouldn't be doing it", Sam Borkson says. *"We consider all art we make as fun and playful."* Together with his buddies Mel and Tury he forms Friendswithyou, a designer group that became famous especially through their plush dolls and other toy figures, building a little universe with characters like King Albino and The Red Flyer. Meanwhile being familiar with all kinds of fabrics and plastics, they of course care a lot about the materials: *"They make up everything and dictate how the final outcome will look."* Like probably any artist, Sam Borkson loves projects with a comfortable budget. *"That's why it was great doing the Volkswagen projects Hotel Fox and Artcar. We were provided with positively everything we wanted. It was absolutely close to fully being a realized dream."* He hopes for more projects like this, with even greater budgets so that their ideas can correspondingly get bigger: *"I would love to work on some giant installation, like to take over an entire building and give it a face lift, or make a gigantic sculpture with many people participating!"*

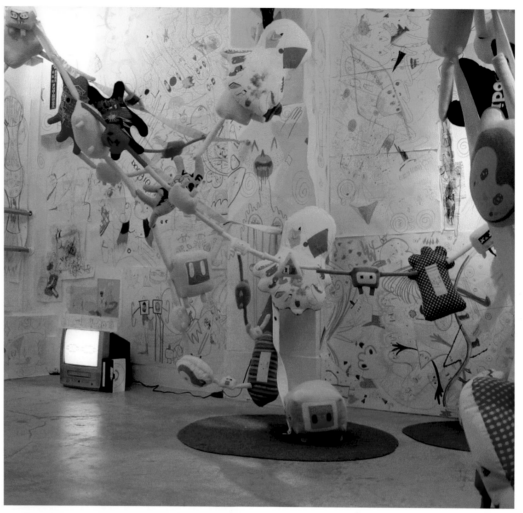

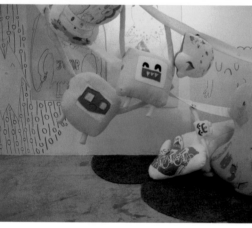

"Aqui Uzumaki" ("Here is the vortex")
Tokyo, Japan, 2004

"We combined forces with Mumbleboy aka Kinya Hanada and Julian Gatto (Gaga Inc.) to create a world of cutie chaos. A swirling vortex of dolls by the hundreds all holding hands and filling the space of the gallery. We created a magical vortex and summoned a monsoon to Tokyo. And it worked, raining all night. But that didn't stop the fun.

All the items are dolls, made from various materials and connected by a strap system with buttons. The walls were a series of drawings completely saturating the whole interior.

We sold out the entire show in the first night. Japanese people buy art faster than you can blink."

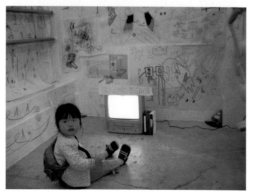

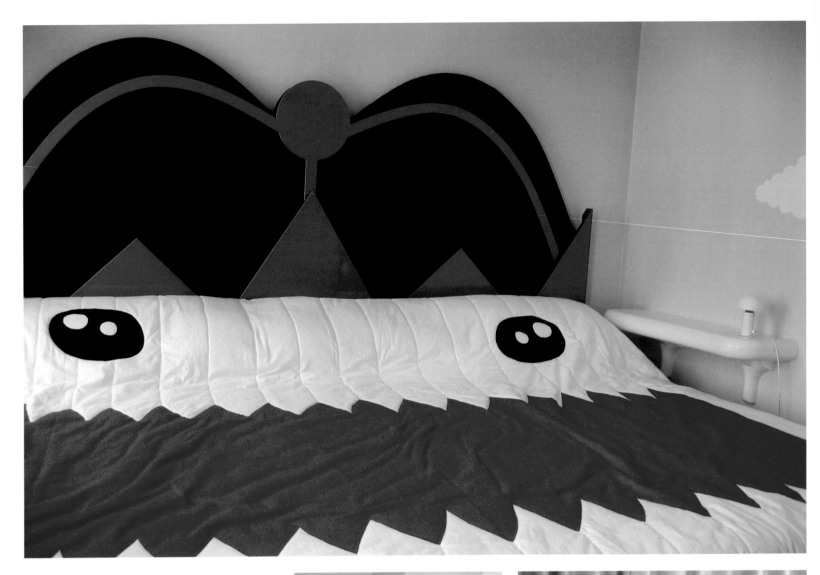

"Room 102: King Albino"
Hotel Fox, an art hotel by Volkswagen
Copenhagen, Denmark
Photos by friends with you
and diephotodesigner.de

"Welcome to the magical world of Friends with you. We are delighted to have you as our guest and will make your stay an adventure. Rest comfortably inside the lurking jaws of, his majesty, King Albino and realize that you are safe as a fluffy cloud. Here is a place to harness good energy. Regain your youthfulness and rest blissfully."

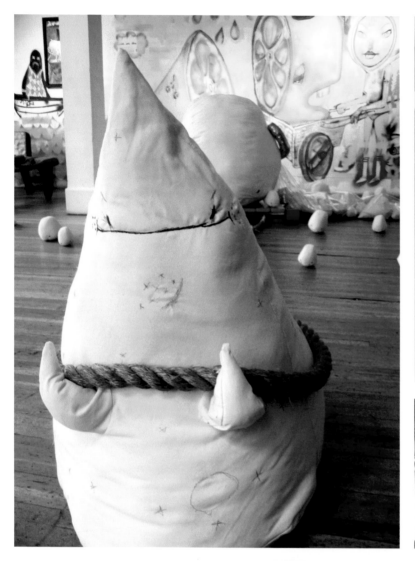

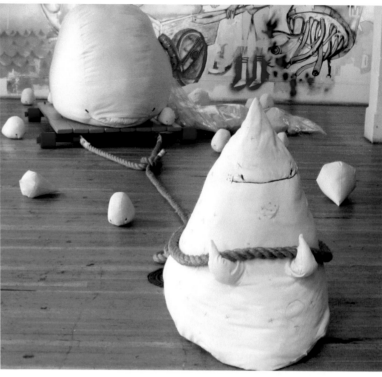

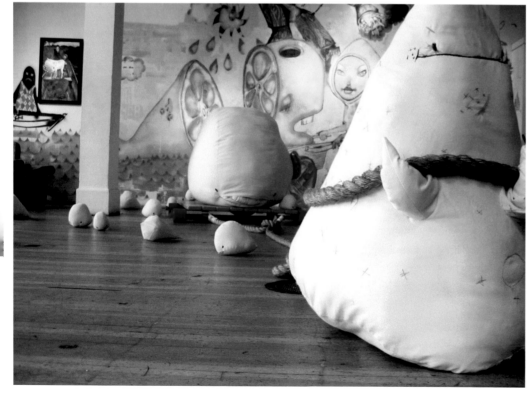

"The Treasure Whale"
with David Choe
Minna Gallery, San Francisco, USA, 2003

"'The treasure whale' is a story about a whale who is carried by the wizard (or whoever is lucky enough to find one) on a toy wagon until he has finished his journey. At this point the whale will burst and spill his hidden treasure: tons of diamonds and rubies, baby whales and a single golden horseshoe. Then the cycle begins all over again."

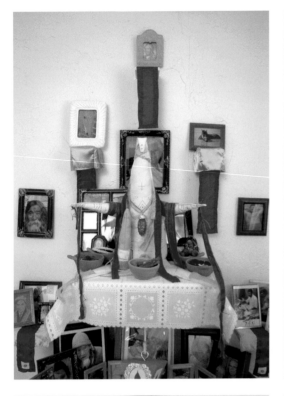

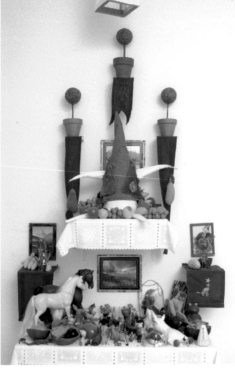

"Get lucky"
Miami/Los Angeles, USA , 2004
Photos by Sebastian Gray

"'Get lucky' is an adventure into a modern ritual. We provided a quick wish response system, face to face time with god, and multiple sub gods to accommodate the aspects of our lives that we strive to better. No more wasteful prayers, no more disappointments. We advised the visitors to bring an offering so they would be rewarded greatly.

We used plenty of techniques in this project: from paintings and special dolls to embroider-ing and wood working. We also included trigger activated pull cords, so when people pulled on coloured blocks that hung from the ceiling they triggered a sound and were able to communicate with the giant furry god!

We learned the power of making art that involves people and has them interacting with us, putting them well inside the experience instead of just bearing witness to the spectacle."

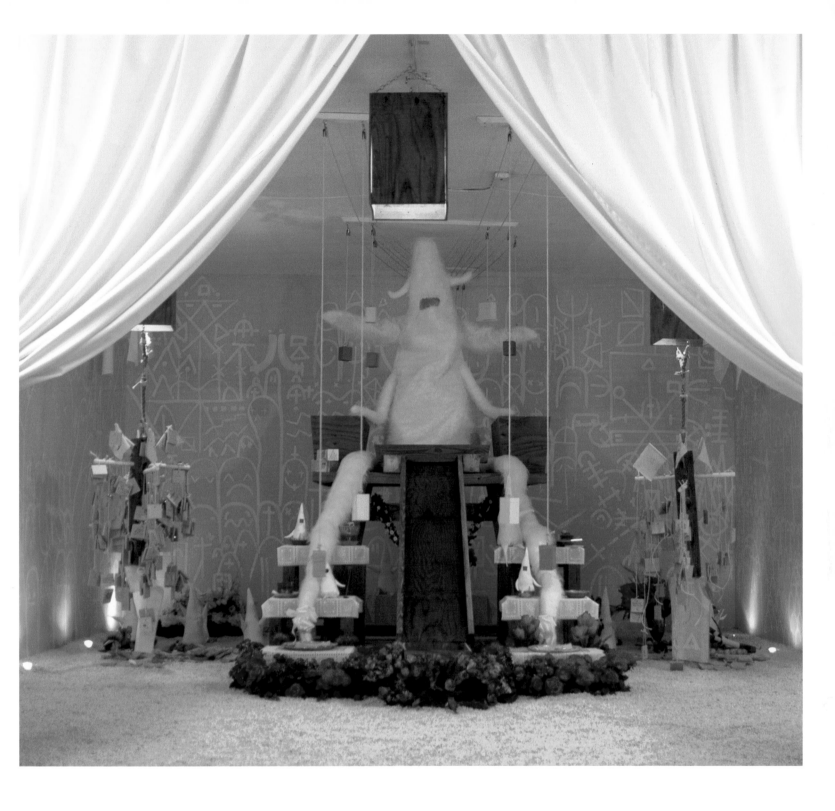

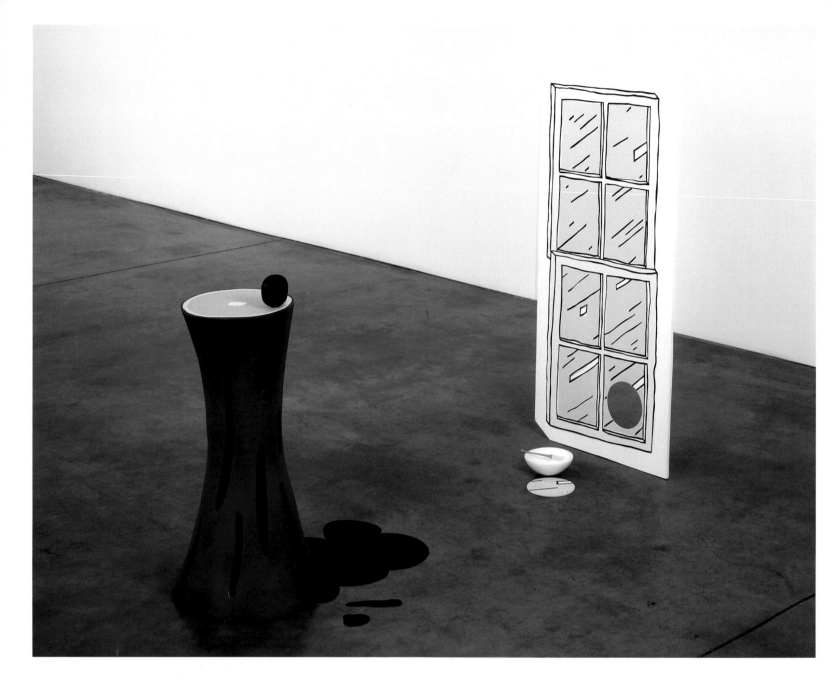

MATTHEW RONAY

Matthew Ronay was born in Louisville, Kentucky, *"where you can eat Kentucky Fried Chicken on top of the grave of the man who invented it"*, as he puts it. Living in Brooklyn now, he currently creates sculptures that a naive viewer would classify as surrealist - ordinary objects, situated in strange contexts - while Ronay explicitly prefers to call them ,super-realist'. His

sculptures, he says, *"run parallel to an energy that exists socially in the universe"*.

Before he assembles one of his pieces, he makes a lot of drawings. He describes them as coming from a place *"that is not self-conscious, though it is not free of sensibility. From those drawings an editing process is shaped by a combination of formal, social, interpretive criteria."*

What may sound like a scientific occupation can in fact be simply playing. *"If play means that I unexpectedly find the meaning of what I do, in contrast to willing myself to come up with something really clever, then yes, play is important. I think at this point the people that are ,trying' to be progressive should read more novels."*

"Transformation to Evil"
61 x 25 x 43 1/4 inches, MDF, wood, paint, 2004

"The project was called ,A Possible New Order In Reconsiderings'. It outlines the result of the reconsidering of what future generations will do with the extra time they have as life become longer. The main thing that will be reconsidered is what will replace capitalism. Capitalism is being put out of balance by all types of fundamentalists. Fundamentalism will not replace capitalism because there isn't the illusion that everyone can be powerful in it (only the Pope, the Imam, the leader of a group that blows up abortion clinics, etc). So the thing that people will realize is that an amalgamation of fundamentalism and capitalism will be the new order. This new order is the true embodiment of evil. The project traces the transformation in four steps. This piece is the last in the transformation where evil infiltrates even the plant kingdom, so when you are cutting a cucumber or a watermelon instead of clear juice you get black putrid evil."

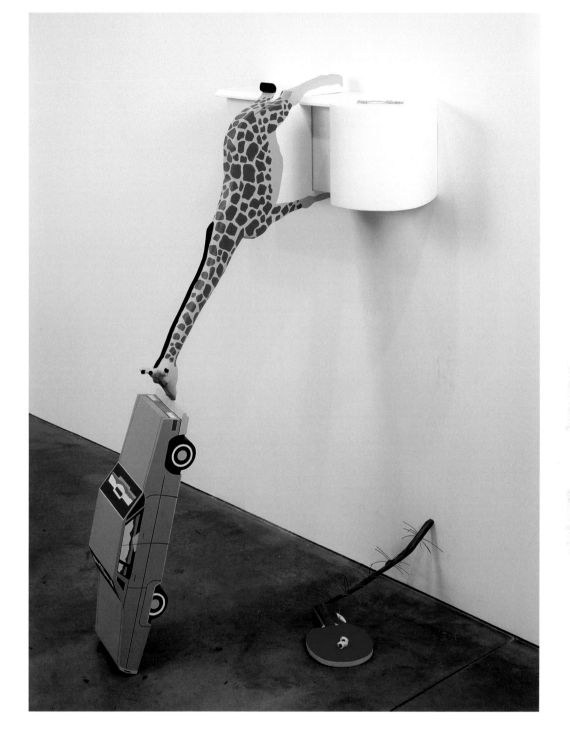

"Vince Neil, lead vocals"
50 1/2 x 27 x 31 inches, MDF, steel, paint, 2002

"This also comes from ,Outlaw Biker Gang'. It is the result of the ransacking of the lead singer of Mötley Crüe Vince Neil's apartment. The biker gang decided that because Mötley Crüe appropriated bikerness for their music video they would break into Mr Neil's apartment and steel his stuff (Since Mr Neil is an art collector they decided to steal a site specific sculpture). What you see is the stolen sculpture reinstalled in the biker's pad around Christmas time, hence the joint hanging off the tree branch over a piece of bloody popcorn on a ping-pong bat."

"Psychedelic Death Organ"
48 x 57 x 19 5/8 inches, MDF, wood, paint, 2002

"The project was called ‚Outlaw Biker Gang'. It was an investigation of anarchy as it relates to biker gangs, this piece being the bikers' version of William S. Burroughs ‚Dream Machine'. The Dream Machine is a device that induces a psychedelic state without LSD or other chemicals and plants. You play the organ in a specific arpeggio and it vibrates the musket which discharges the psychedelic ooze. Looking at the ooze gives the experience (which in their case is associated with sex and death.)"

"Irreversible Algorithm"
33 1/2 x 63 x 22 1/4 inches, MDF, wood, paint
copper and string, 2003

"The project was a model of a 70s funk concert. This is one of the audience members who doubles as a cultural moment from the 70s. The moment is the redesigning of the French fry to cause humans to lose their inhibitions and eat senselessly like animals who have an excess of food at their disposal. What the piece shows is the new French fry being tested in reverse on animals which turns them into humans."

WORK INDEX

ADDRESS INDEX

HIDDEN TRACK

HOW VISUAL CULTURE IS GOING PLACES

Cover and Chapter Introductions based on Illustrations by eP

Edited by Robert Klanten and Sven Ehmann
Text Edited by Mirko Driller
Layout by Matthias Hübner
Production by Martin Bretschneider
Translations by Galina Green and Ashley Marc Slapp
Proofreading by Ashley Marc Slapp
Printed by Offizin Andersen Nexö, Leipzig

Published by Die Gestalten Verlag, Berlin 2005
ISBN 3-89955-084-6

Bibliographic information published by Die Deutsche Bibliothek
Die Deutsche Bibliothek lists this publication in the Deutsche Nationalbibliografie;
detailed bibliographic data are available in the Internet at http://dnb.ddb.de.

For more information please check: www.die-gestalten.de

Respect copyright, encourage creativity!